In the Garden

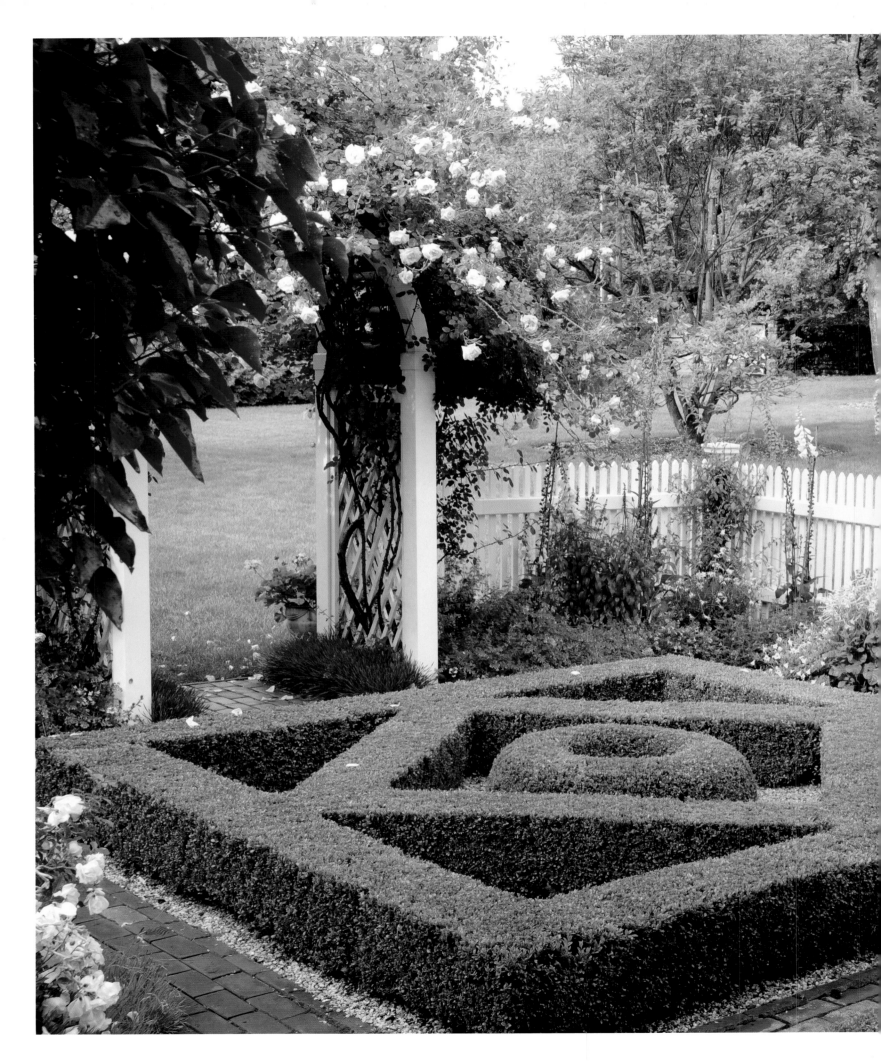

In the Garden
Stacy Bass

With essays by **Suzanne Gannon**

MELCHER
MEDIA

Produced by

**MELCHER
MEDIA**

124 West 13th Street
New York, NY 10011
www.melcher.com

Distributed by Perseus Distribution

Publisher: Charles Melcher
Associate Publisher: Bonnie Eldon
Editor in Chief: Duncan Bock
Production Director: Kurt Andrews
Production Coordinator: Daniel del Valle

Design by Andy Omel

10 9 8 7 6 5 4 3 2 1

Printed in China

ISBN 978-1-59591-073-8

Library of Congress Control Number: 2011943387

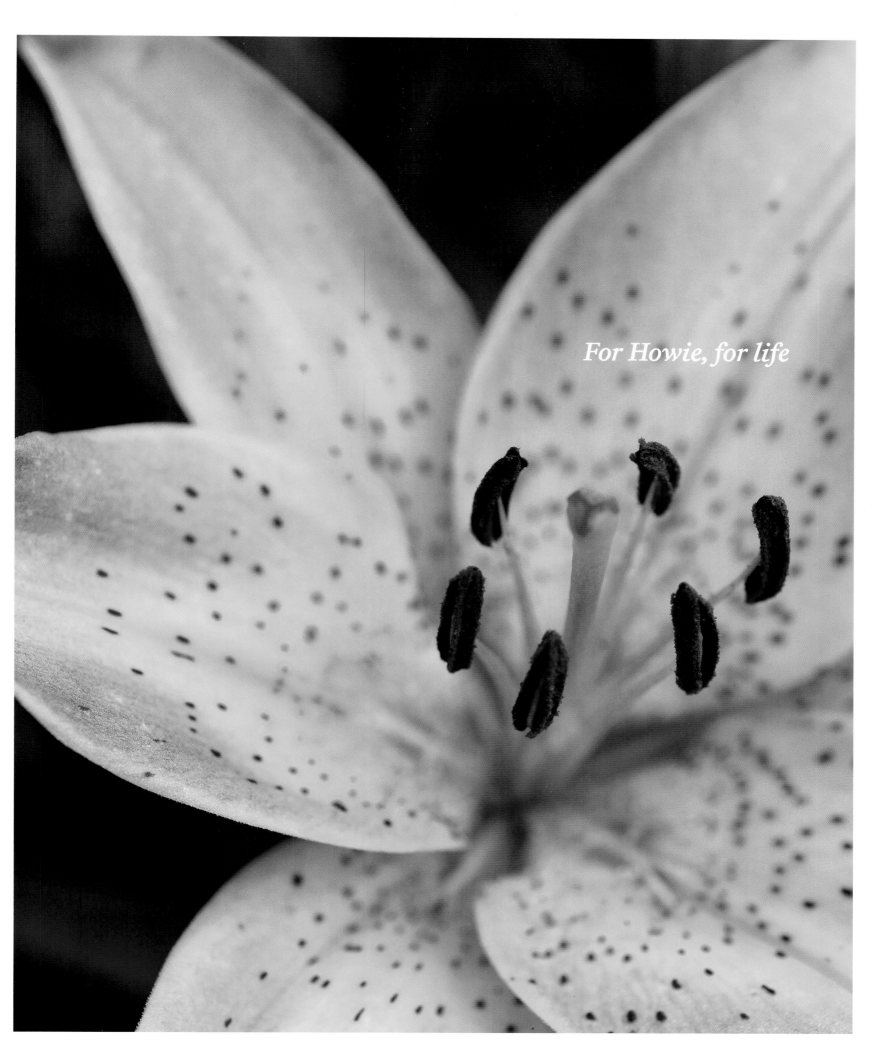

For Howie, for life

Contents

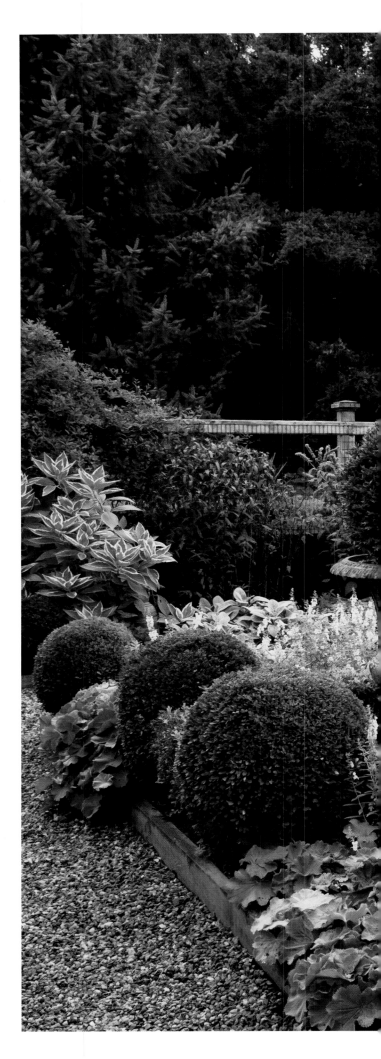

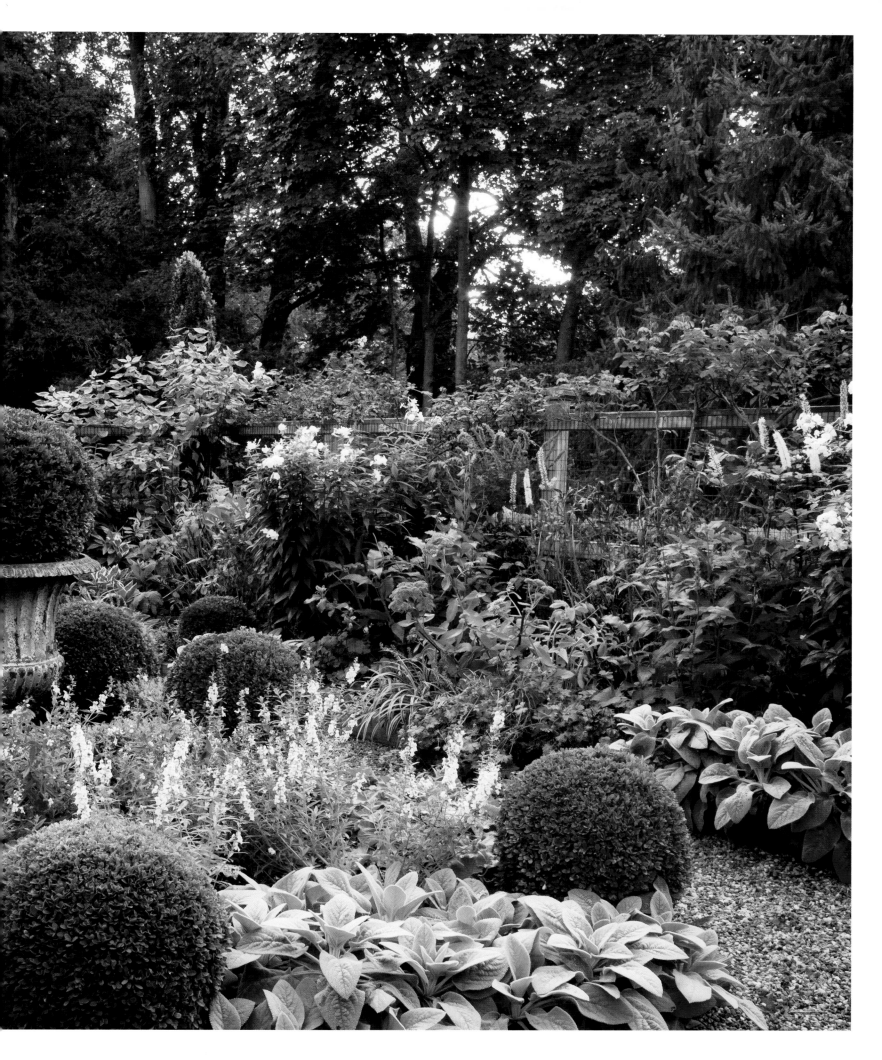

> "All photographs are memento mori. To take a photograph is to participate in another person's (or thing's) mortality, vulnerability, mutability. Precisely by slicing out this moment and freezing it, all photographs testify to time's relentless melt."
>
> —Susan Sontag, *On Photography*

A S A YOUNG PHOTOGRAPHER, I was fascinated by color, light, and gesture and the way they played with one another. I found myself drawn, time and again, to pattern, shape, and texture and quickly fell in love with trying to frame what I saw. My early work featured architectural abstracts, more hardscapes than landscapes, but I was enchanted by nature and the vibrancy and fragility of its many forms. I am often asked how I came to be a garden photographer, and the answer, as is often true of many of the best things in life, is that it happened by chance. I have felt lucky about that ever since.

In 2004, as our youngest child was about to enter kindergarten, I decided it was time to reinvigorate my passion for photography and perhaps transform that passion into a viable and thriving career. I set out to get editorial assignments—thus satisfying both my interest and drive to be a photographer and my obsession with magazines.

A link to my newly launched website found its way to the inbox of a (most) talented art director, Amy Vischio, and in time, she offered me an assignment—to photograph the landscape and gardens at a beautiful, stately home, high on a hill, overlooking the Long Island Sound.

On that very first shoot, I was using a rented Hasselblad and shooting film, and I think I can now confess that I was not completely confident in my technical prowess. I was nonetheless quite taken with the subject matter. There was something very precious about wandering alone in a magnificent garden; discovering new and surprising "rooms" and vignettes with every turn and path. It left me transfixed and wanting more.

From that beginning, one clear and sunny day in June, I've had the opportunity to photograph more than 50 gardens. Each one has not only been unique but has also evoked a different feeling. My memory of my experience in each and every place remains strong and distinct.

Very early on, my technique began to be defined by my decision to shoot at dawn whenever possible. While I have at times questioned that decision, and while my family and my sleep patterns have often been disrupted in the spring and summer, there remains a magic about those precious, fleeting moments as the sun is ready to rise. I look forward to the opportunity to witness and capture that subtle transformation from ordinary to extraordinary. That sweet and gentle light, coupled often with a morning mist or fog, has proven so seductive that it's hard to resist. The stillness and quiet of the morning brings me a serenity that is at once calming and inspiring.

Although it remains a challenge to capture what I am seeing before the sun is too high in the sky and the shadows disrupt my canvas, I so enjoy watching how the light illuminates the color and forms of the garden in surprising ways. Often I am greeted by the homeowner with an offer of coffee or simply a warm and welcoming smile and sometimes a fascination with what might motivate me to be up so early and already hard at work. Memorably, while I made the image on the cover of this book, the gar-

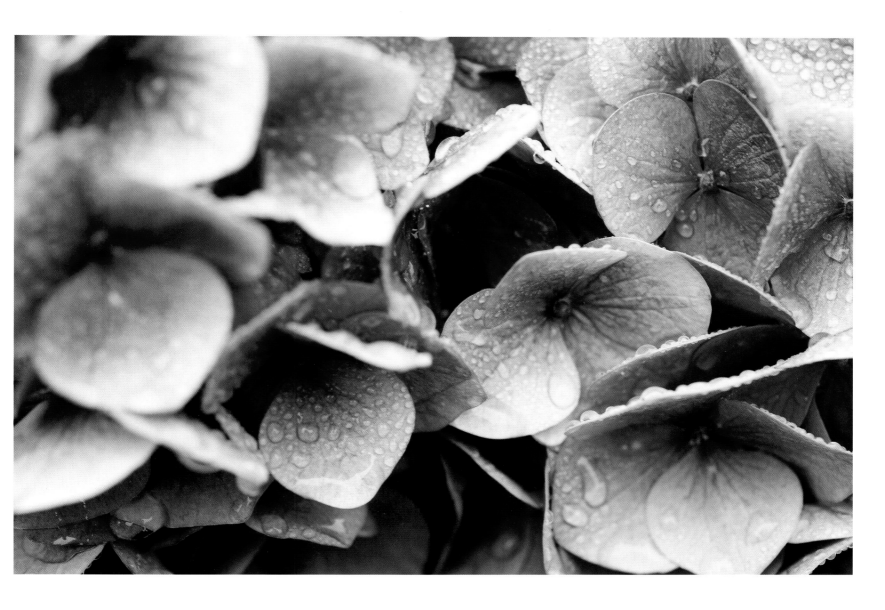

den was filled with the moving sounds of a Puccini aria. The music further enhanced what was already an exquisite morning and remains one of my favorite experiences. Having an opportunity to connect with these passionate and interesting people—the homeowners, landscape designers, caretakers, and gardeners—has been a bonus and has made my experiences even richer.

I have had the good fortune to photograph beautiful gardens all over the world, many of them, including the 18 featured here, in my home state of Connecticut. It was a difficult task to choose from among so many exquisite gardens. Every garden has been special in its own way and has never disappointed in providing me with a stunning array of photographic moments. Perhaps I will have a chance to highlight the many others in another book sometime soon.

It is my hope that you, the reader, will be delighted by what you see in *In the Garden,* and that I will have succeeded in sharing more than a glimpse, perhaps a study, of some of the astonishingly beautiful places I have been and the details I have found there. From the broader sweeps of a formal English garden to a tight abstract of a peony or a rose, every moment captured and memorized by the camera stands alone and offers perfect and immutable beauty.

Stacy Bass, FALL 2011

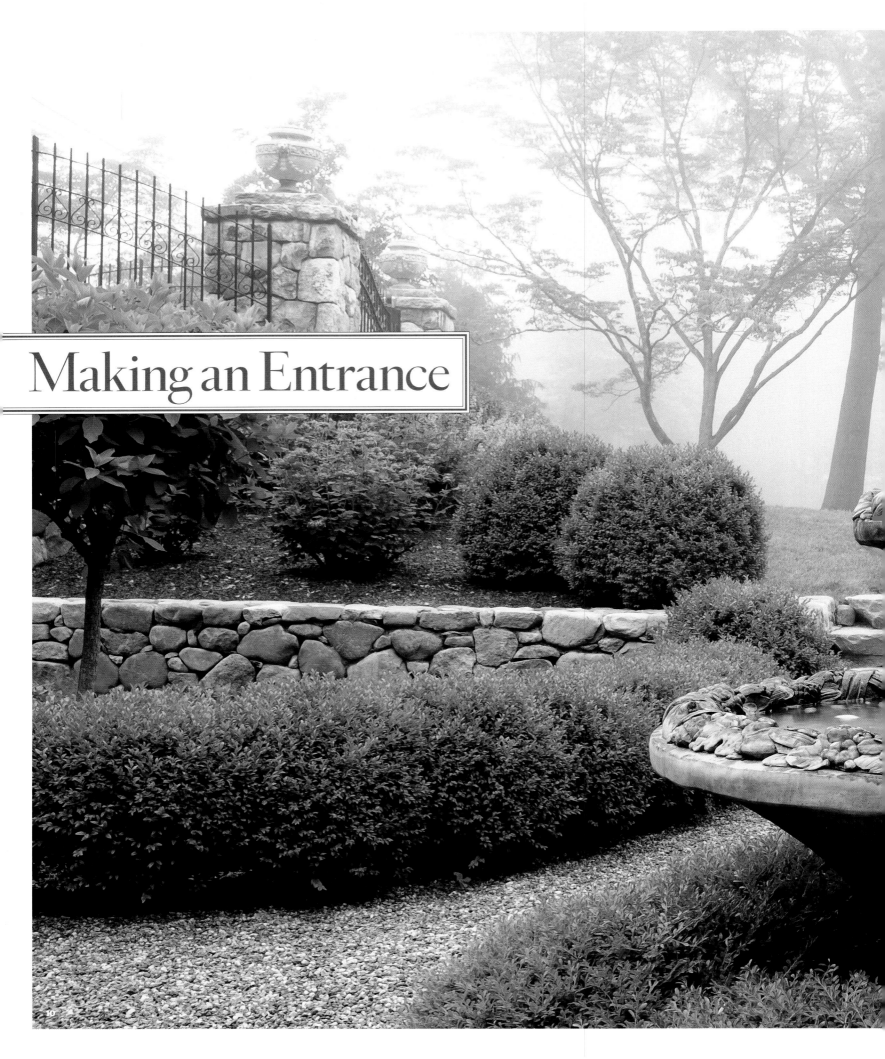

Making an Entrance

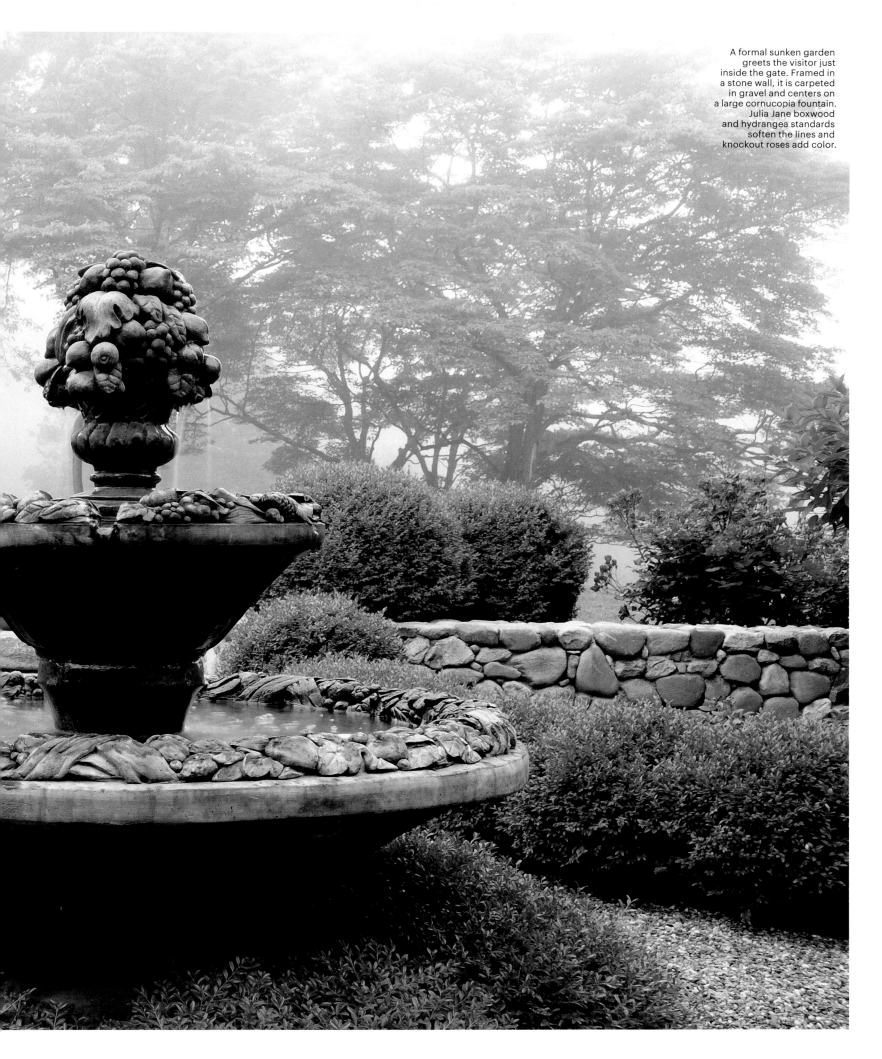

A formal sunken garden greets the visitor just inside the gate. Framed in a stone wall, it is carpeted in gravel and centers on a large cornucopia fountain. Julia Jane boxwood and hydrangea standards soften the lines and knockout roses add color.

IT'S NO SURPRISE that Carol Seldin once made her living in the theater. On the grounds at her home in New Canaan, everywhere you look there's evidence of her directorial hand at work.

A passionate master gardener who mowed the lawn at her childhood home in Wellesley, Massachusetts, in her curlers until it became "too humiliating," Seldin says she approached the design of her property—six acres encompassing an elevation change of nine stories—as a stage set, alternating with ease between formality and rustic naturalism.

Up top there's a sunken "room" carpeted in gravel and centered on a multitiered fountain ringed by neatly cropped boxwood and hydrangea standards, and knockout roses for color, while on the gentle descent to the pool there's a shady allee of white pine underplanted with hosta, rhododrendron, and five types of ferns—lady, tassel, ostrich, Japanese painted, and autumn—that she calls her garden of "organized chaos."

Seldin believes that gardens are for sharing and keeps at the ready a basket of rubber garden clogs for guests. She says she's consumed by keeping things in tune with the seasons and giving her arrangements "pop."

Like an architect, she practices the techniques of procession and transition and compression and re-lease, always mindful of point of view and deliberately directing the eye toward the big reveal. From a formal gate flanked by planters brimming with foliage, the eye meanders down a slope planted with 3,000 daffodils and quirky old dogwoods that give the property its name, Dogwood Hill, to an orchestrated view of her home, a majestic Georgian manse. From the chaotic garden under the pines one crosses through a wrought-iron arbor covered in wisteria to find the "Serenity Garden," which features a faux-bois bench and a bubbling fountain planted with succulents.

With the help of garden designer Heather O'Neill, Seldin mixes tropical plants with natives and specimens in pleasantly surprising combinations—fan palms, banana leaves, elephant ears, and canna lilies with dahlias, David Austin roses, and clematis—and uses objects like ornaments, urns, and statuary as organizing principles. A pair of Chinese garden stools ensconced in delicate ferns invites contemplation, the two-faced head of Saturn hidden in the grove of rhododrendron and hosta invokes worship, and the life-size sculptures of Apollo and Diana greet the guest who processes off the terrace through a whispering walk of white birch.

Seldin, whose newest project is a woodland garden along an old farmer's walking wall, says she's never done. Indeed. It hardly seems this is her final act. ∎

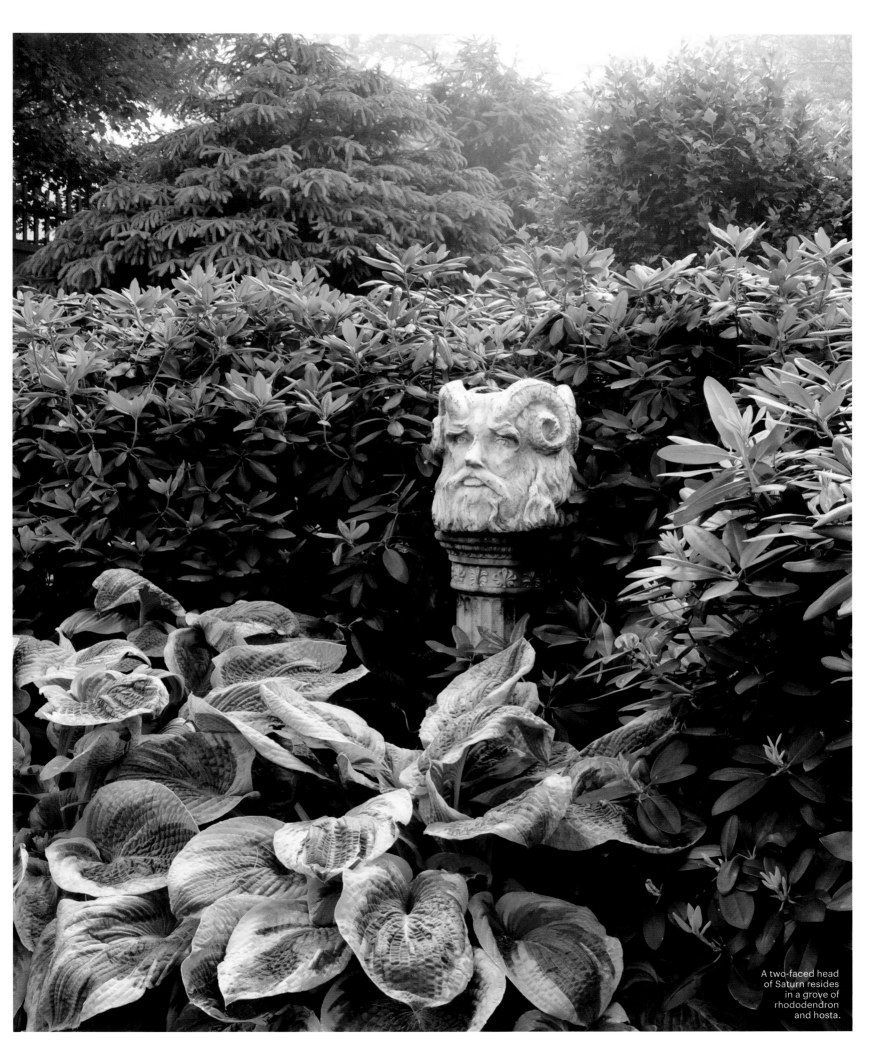

A two-faced head of Saturn resides in a grove of rhododendron and hosta.

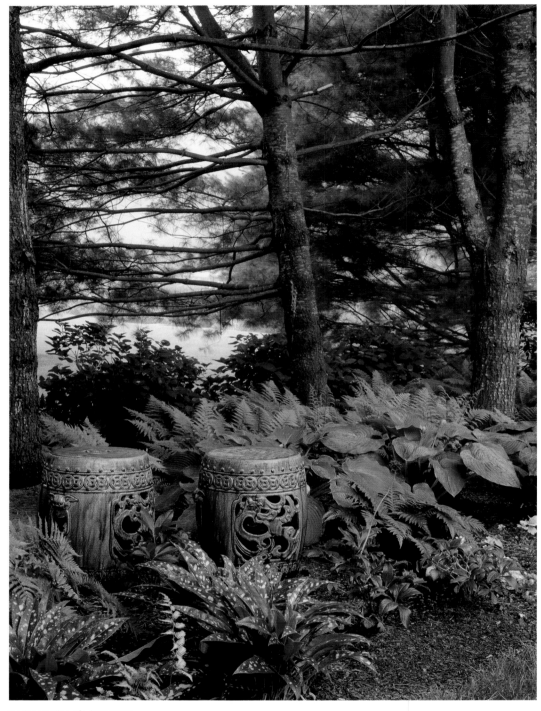

Under an allee of white pines, garden stools are nestled among ferns and hostas, providing a venue for quiet contemplation.

Globemaster allium ▶
in bloom.

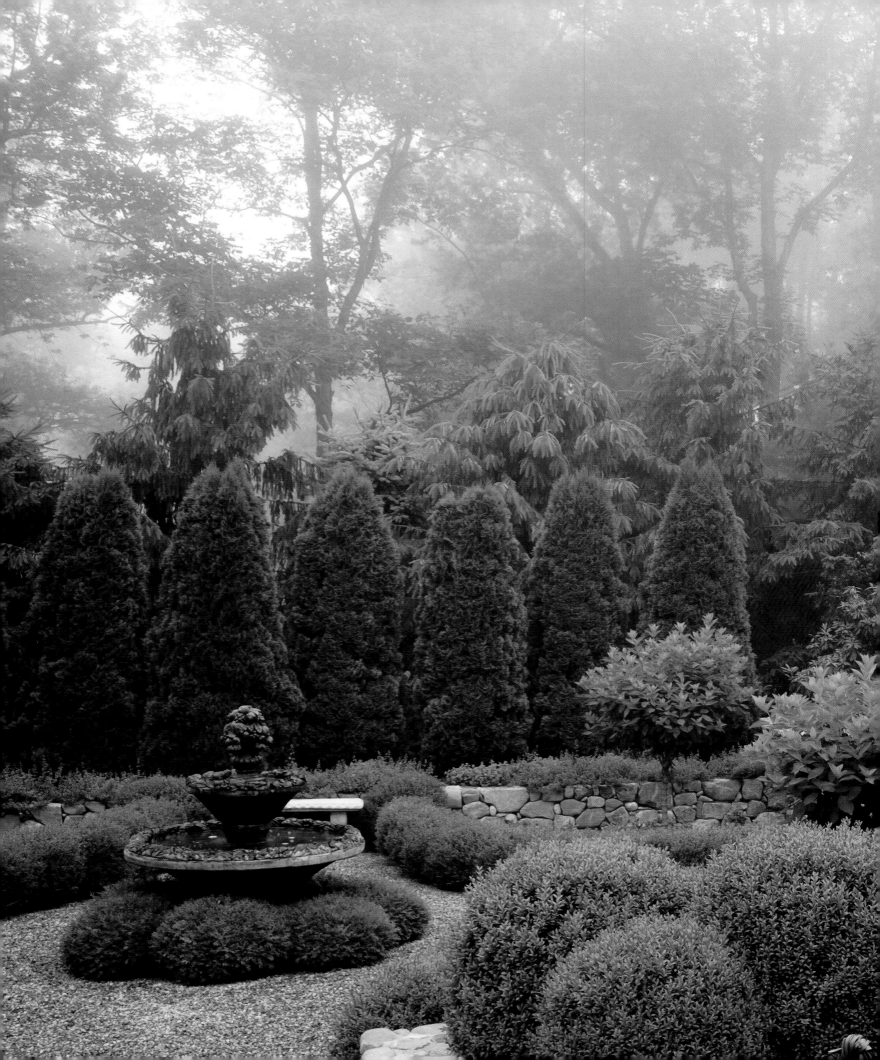

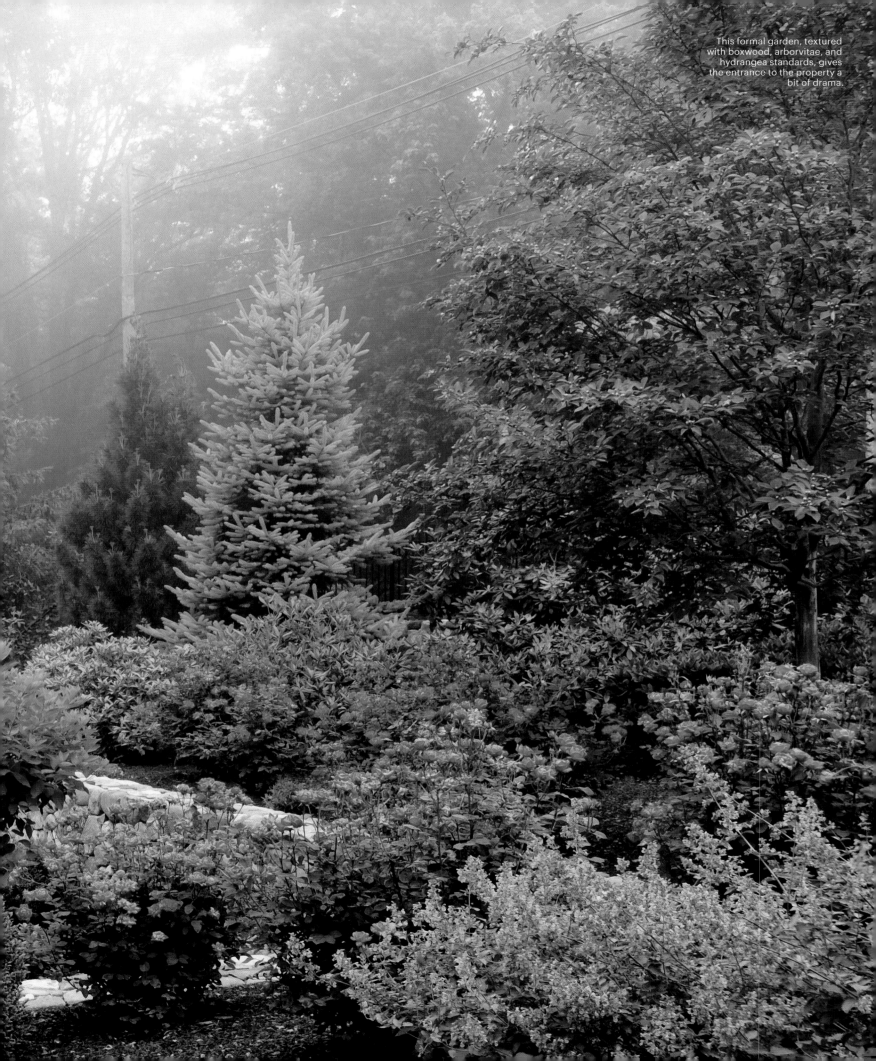

This formal garden, textured with boxwood, arborvitae, and hydrangea standards, gives the entrance to the property a bit of drama.

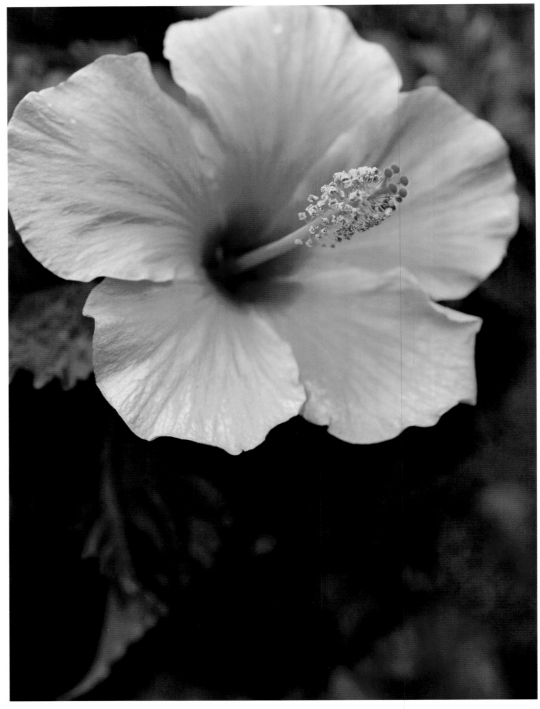

Hibiscus.

Through a walk ▶
lined in white birch
one spies a
statue of Apollo.

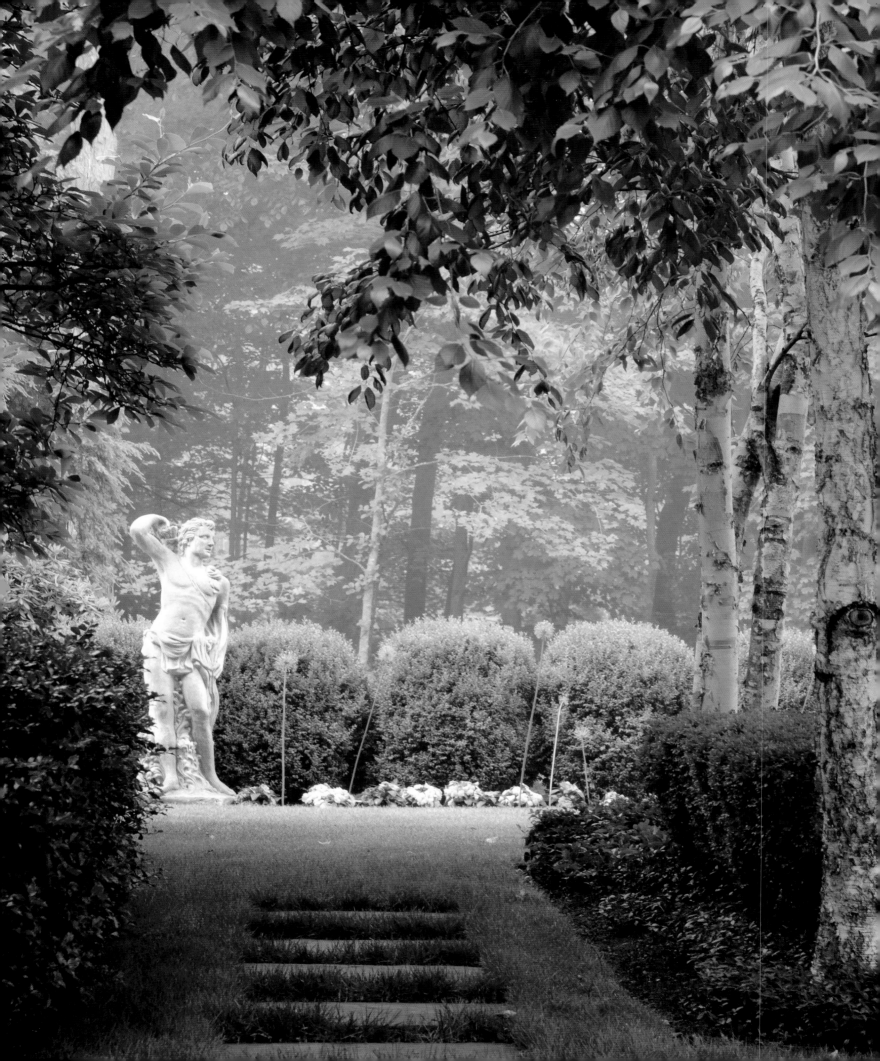

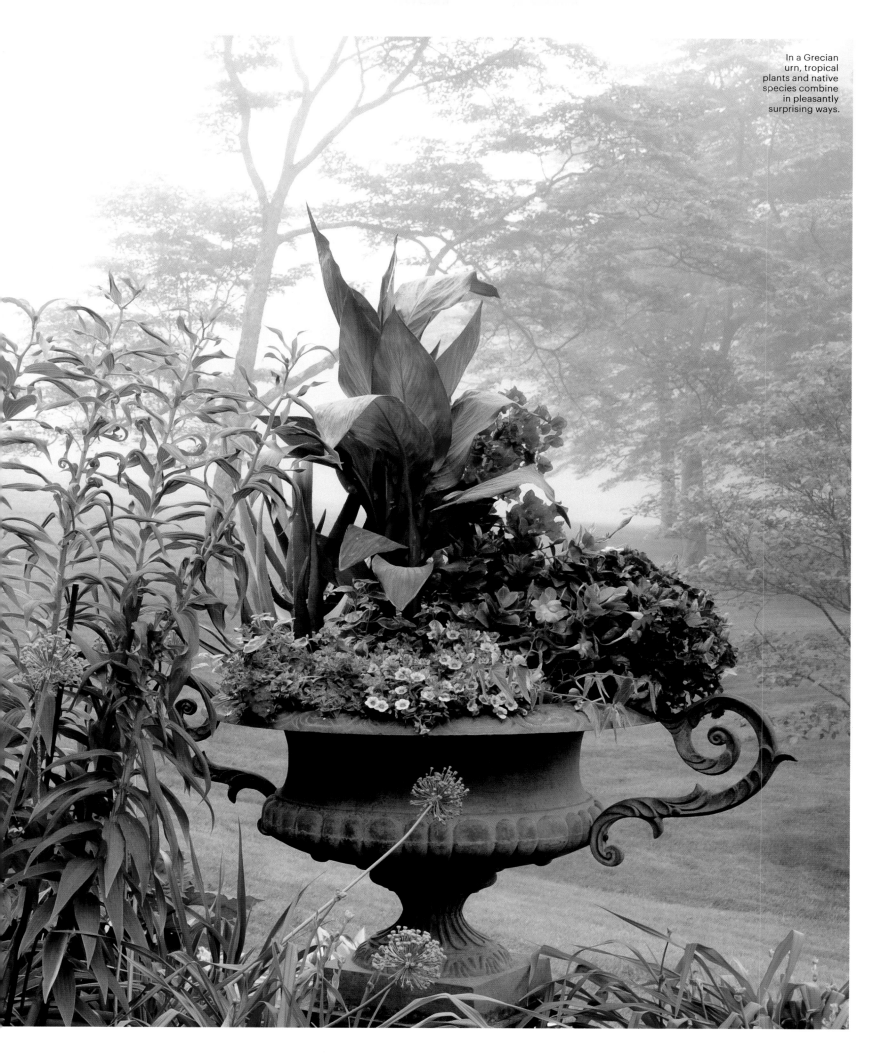

In a Grecian urn, tropical plants and native species combine in pleasantly surprising ways.

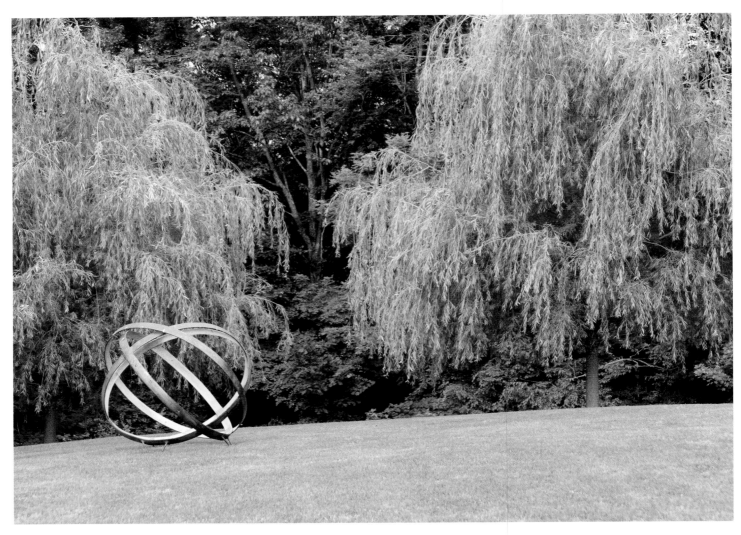

The silhouettes
of two weeping
willows echo the
contours of a
rolling lawn and
a steel orb.

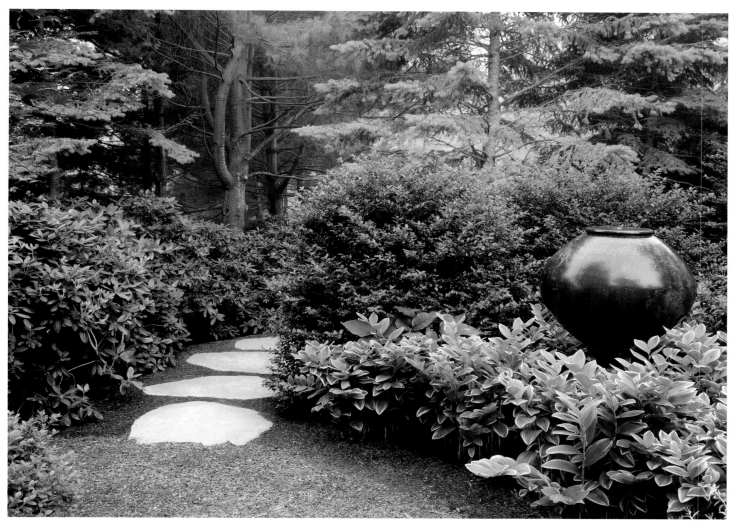

A stone
footpath leads
the way to a
secret garden.

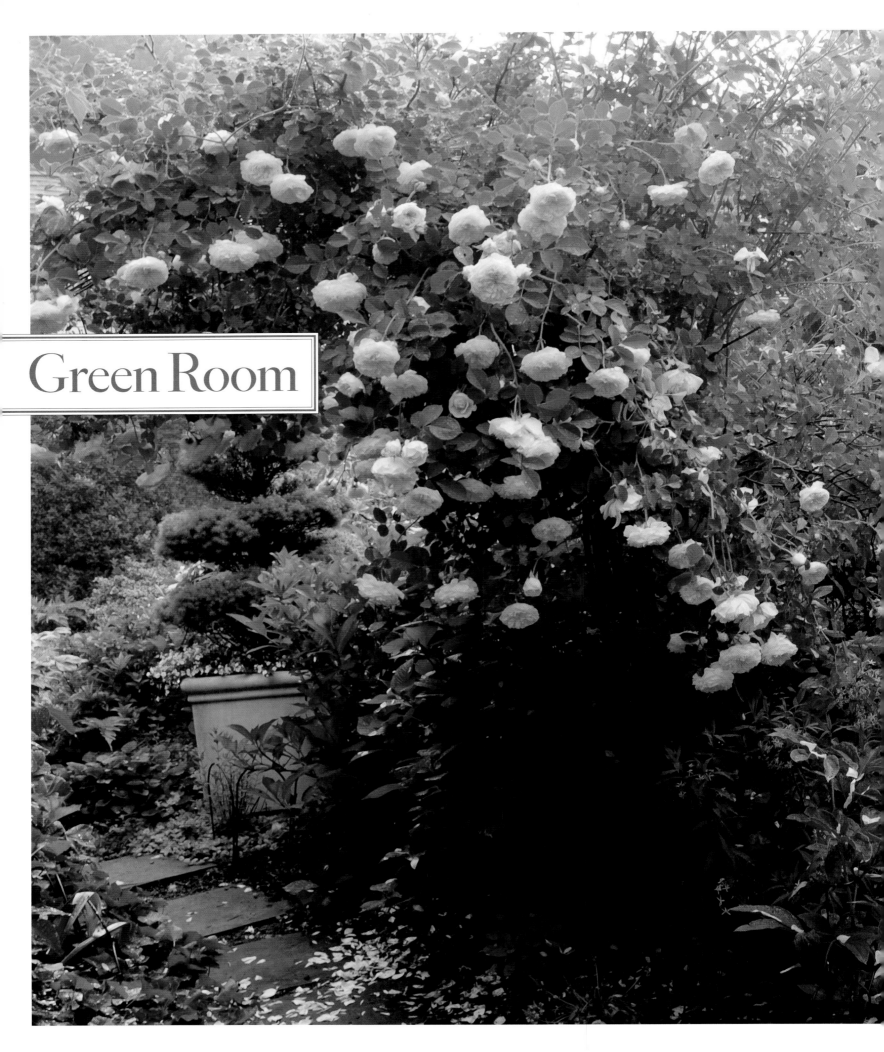

Green Room

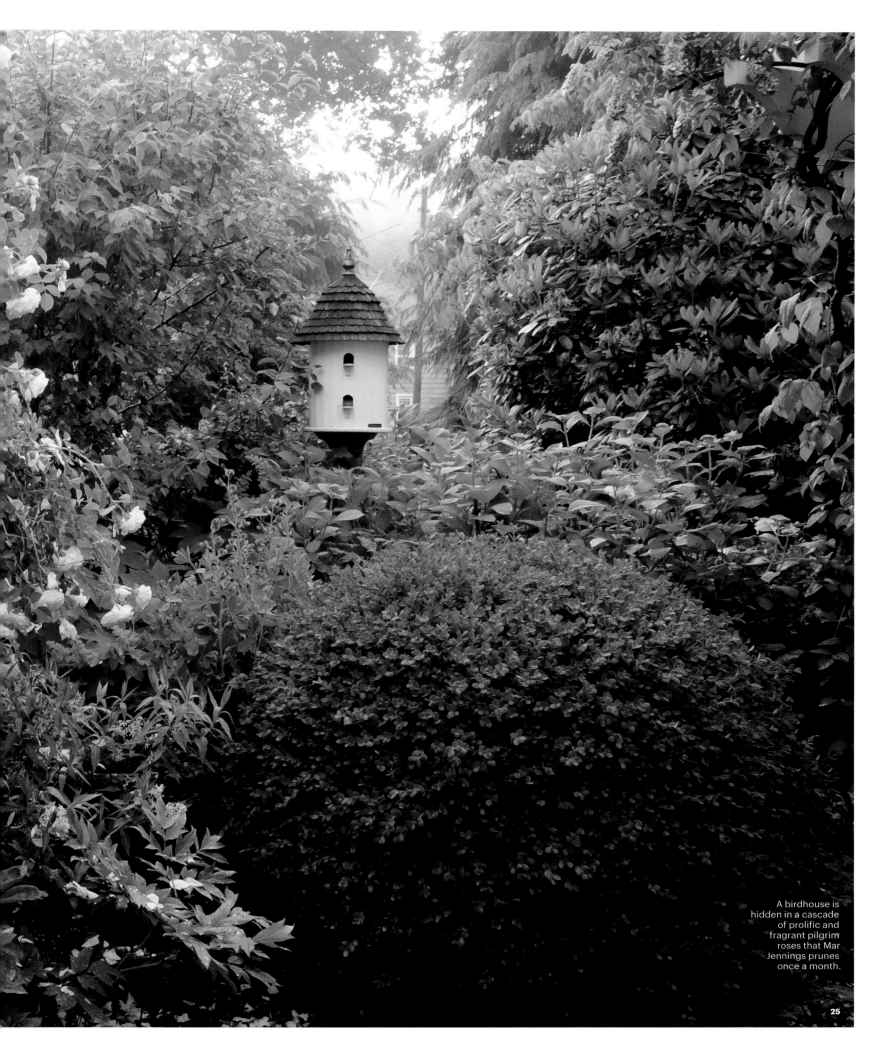

A birdhouse is hidden in a cascade of prolific and fragrant pilgrim roses that Mar Jennings prunes once a month.

WALKING THE QUARter acre in the sleepy quadrant of Westport that Mar Jennings calls home—or, actually, Rosebrook Gardens—is like touring a miniature garden museum with a very passionate and knowledgeable docent.

Jennings, a self-styled home and garden expert who is the energetic star of his own multimedia empire in the making, dispenses tips—via books, the Web, and TV appearances—on festooning urns with draping ivy and transforming trellises of summer roses into wintry displays of evergreen and holly, using all four of his yards (back, front, left, right), and sometimes the neighbor's, as both his outdoor laboratory and his foliage-filled film set. For props, he relies on two sheds full of clay pots, lanterns, watering cans, and trowels, as well as other objects to which he assigns multiple uses such as a gravel driveway that does double duty as an outdoor dining room with seating for 100.

Upon moving in, in 1996, Jennings transformed the builder's spec house into an expression of his own style, installing architectural details such as copper flashing, dental moldings, a Belgian-block driveway apron, and working shutters. Then he addressed, or just dressed, the land. He installed seven new trees and took four away, shaped white-flowering aristocrat pear trees into the lollipops that line the Champs-Elysées, planted more than 500 boxwoods, trained two types of wisteria to populate a pergola, and taught three kinds of vines—clematis, ivy, and wisteria—to inhabit his arbors.

There's not an inch of space Jennings, a former banker and professional figure skater, has left untouched. Inside the picket fence is a boyish statue of Pan, ensconced in a boxwood hedge while playing his flute and guarded by spires of sky pencil boxwood. Around the foundation, Jennings has planted Peegee hydrangreas, and along a stone footpath, a purple-flowering ground cover of vinca minor forms a fertile bed for allium, irises, peonies, and roses. In a sunny corner, Jennings, whose mother describes him as a frustrated hairdresser, has given a Bradford pear tree a makeover with a shapely new 'do, while in a side garden he has planted a lush jungle of tulips, allium, ferns, tardiva and endless summer hydrangeas, white lilac, and a blousy butterfly bush.

The property is alive with color—pink peonies, white magnolia blossoms, purple bearded irises—and filled with ornaments like birdhouses, armillaries, finials, and urns that comprise a layered landscape of orchestrated yet intimate spaces that make it look far larger than it is. As the TV personality himself would say, "and there you have it." ∎

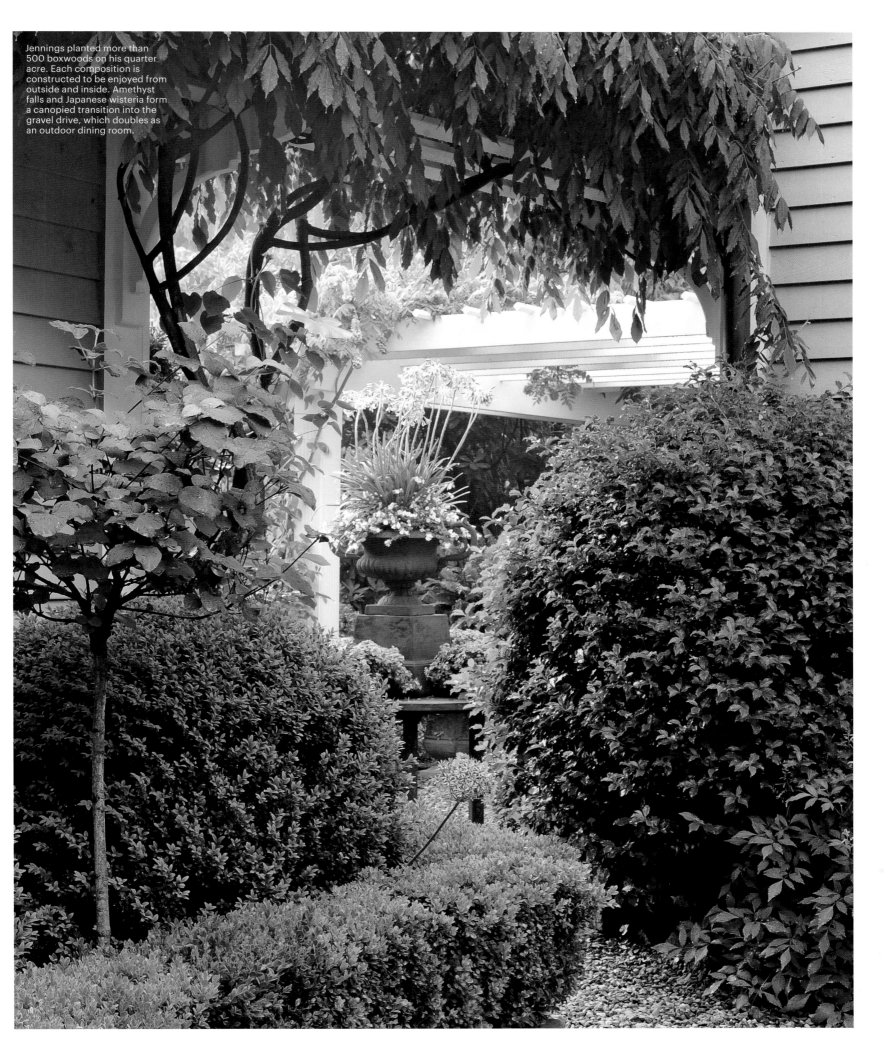

Jennings planted more than 500 boxwoods on his quarter acre. Each composition is constructed to be enjoyed from outside and inside. Amethyst falls and Japanese wisteria form a canopied transition into the gravel drive, which doubles as an outdoor dining room.

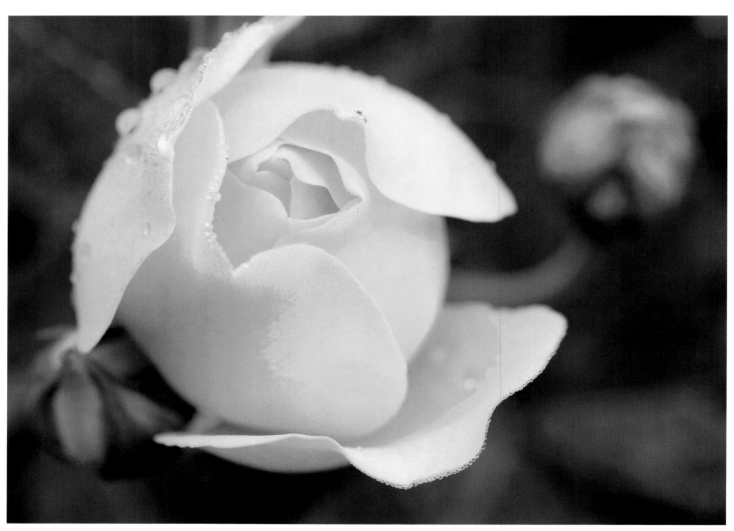

A pilgrim rose.

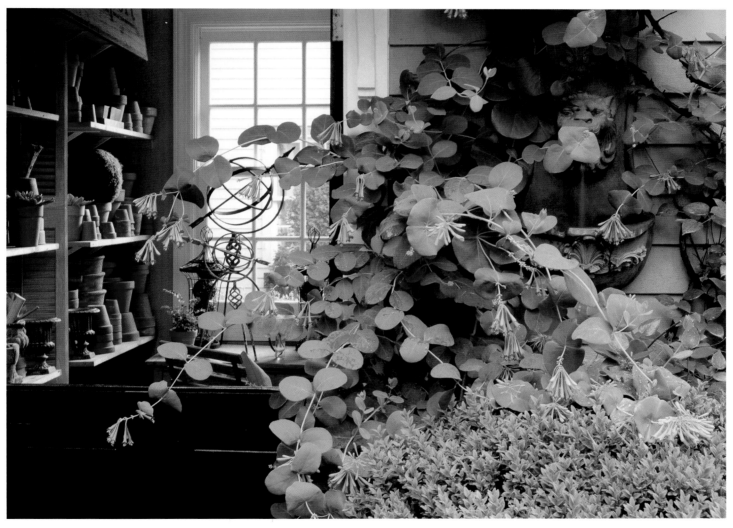

Jennings furnishes
props for his TV
segments from the
garden studio he
built in his garage.
A voluminous
honeysuckle climbs
the exterior wall.

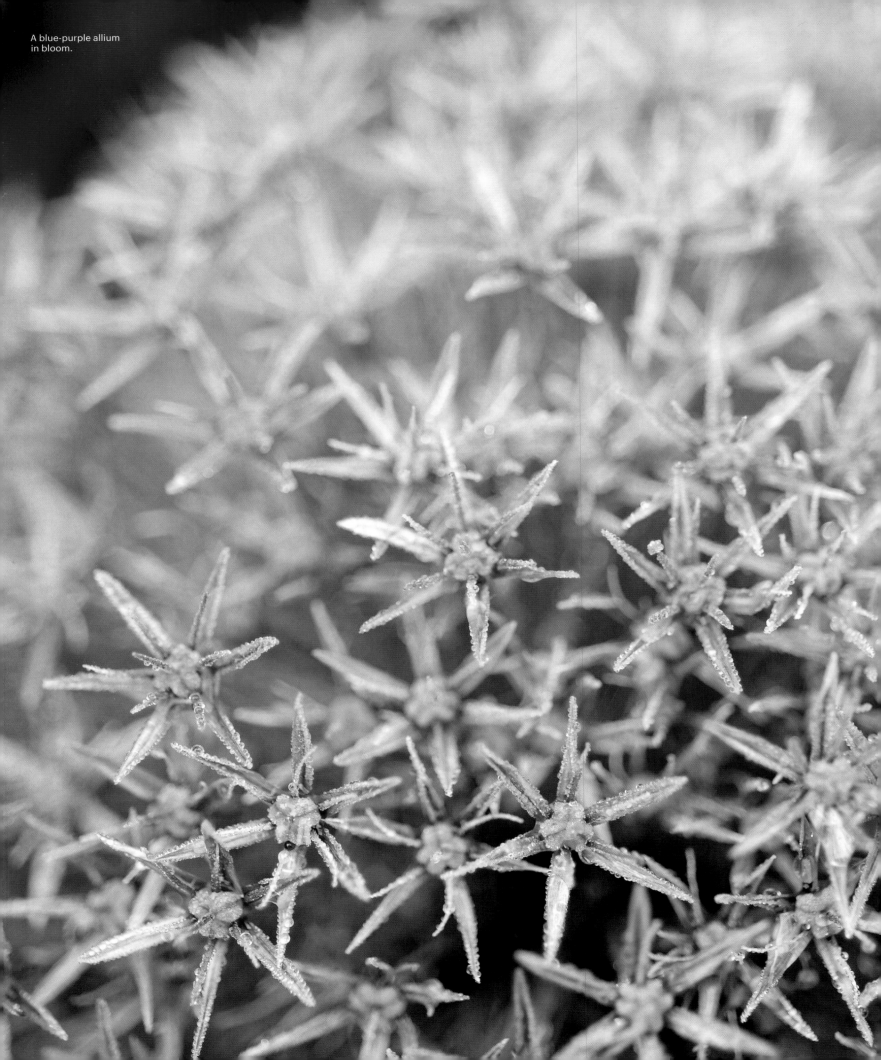

A blue-purple allium
in bloom.

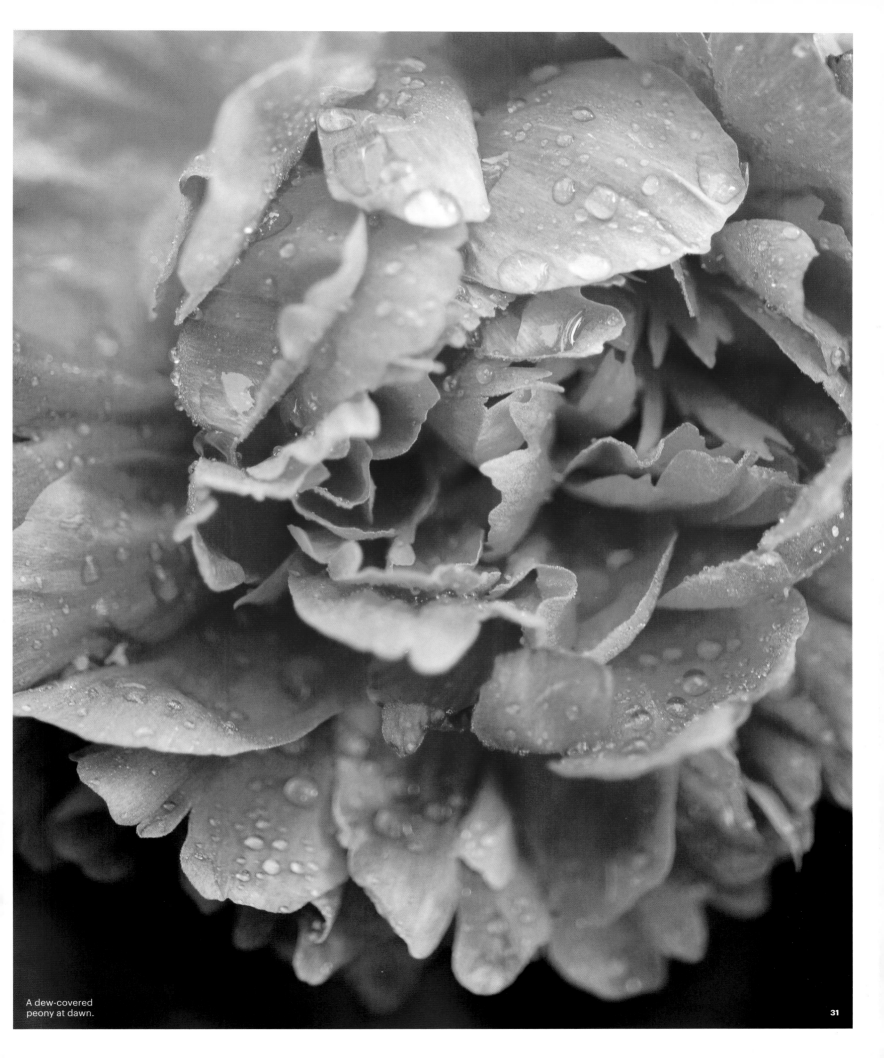

A dew-covered
peony at dawn.

Jennings dresses
up a side yard with
a bed of boxwood
balls centered on
an armillary.

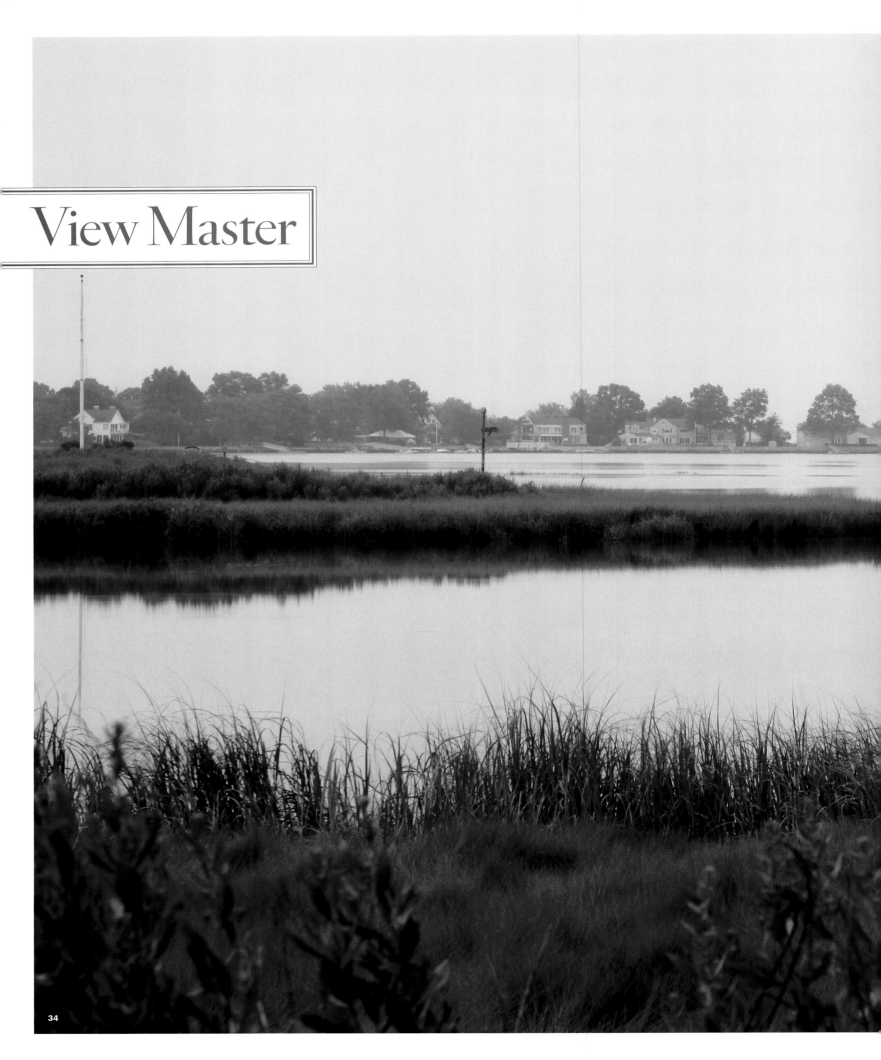

View Master

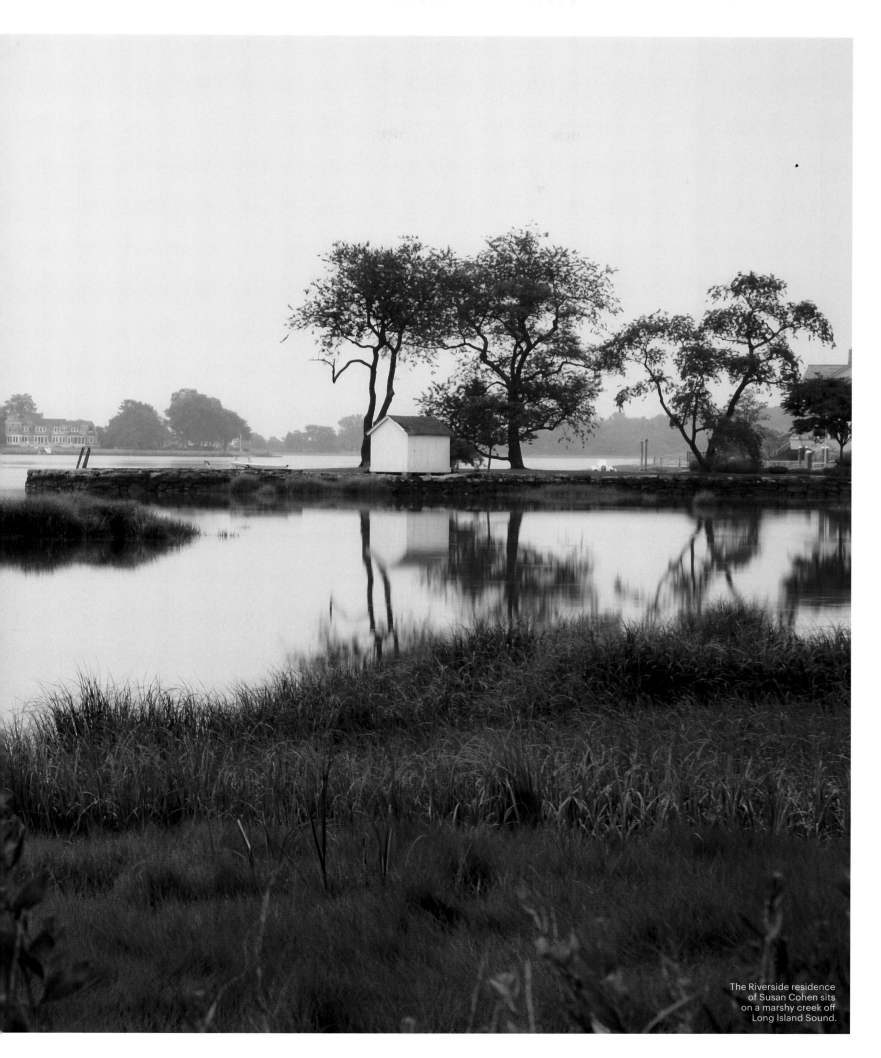

The Riverside residence
of Susan Cohen sits
on a marshy creek off
Long Island Sound.

BACK IN 1973, when Susan Cohen was studying landscape architecture, most of the gardens that inspired her were in places that required many hours of air travel and a local guide who spoke English. These days, due in part to her thriving practice and the active educational role she plays for the New York Botanical Garden, the Riverside resident is surrounded by photo-worthy landscapes and people who want them.

Her own property is in many ways her experimental station where she works as much with paving, walls, and the anomalies of grade as she does with living components. Her beds and borders are in a constant state of flux as she tinkers with scale, color, and texture, all the while learning new concepts she can put into practice. The one principle that never wavers, however, is her conviction that her garden should reflect the soft curves of the cove in which it sits.

Flanking the slope that rolls gently toward the water are two borders each with a dual purpose: to direct the eye toward the marsh (and Long Island Sound beyond) and to act as aesthetically pleasing composites in their own right. Cohen planted the far border with species that uphold a green-and-cream color scheme—hosta, Cornus controversa (whose variegated leaves evoke the layers of a wedding cake),

yellow and white daylilies, and, as ground cover, miscanthus and poufs of Japanese forest grass—because blues and purples would have turned to black in the distance. Hidden in this jungle of underbrush are two stone totems, Korean guardian figures that seem to protect the garden while sleeping.

On the opposite side of the slope, nearer to the house, Cohen had more leeway with color. There she planted Japanese irises, Betty Corning and Polish spirit clematis, asters, monk's hood, phlox, salvia, petunias, ageratum, and silvery Russian sage.

Up top, on the high part of the slope that served as her sons' sledding hill, Cohen spotted an opportunity for creativity with a European flair. In a space where a stone-walled boat house stood when the area supported an active oyster industry, she installed a fountain grotto, replete with a stone bench circled by a high hedge of euonymus Manhattan that from the bottom of the hill looks like a wingback chair with its back and arms upholstered in foliage.

But the spot that makes her feel lucky every day is an elevated stone terrace with a lily pond and two teak chaises where she can take in the sunrise and the reflection of a sunset that lights up the houses on the other side of the creek.

Her design strategy, she says, is twofold: keep it simple and respond to the site. In this instance, she has excelled at both. ∎

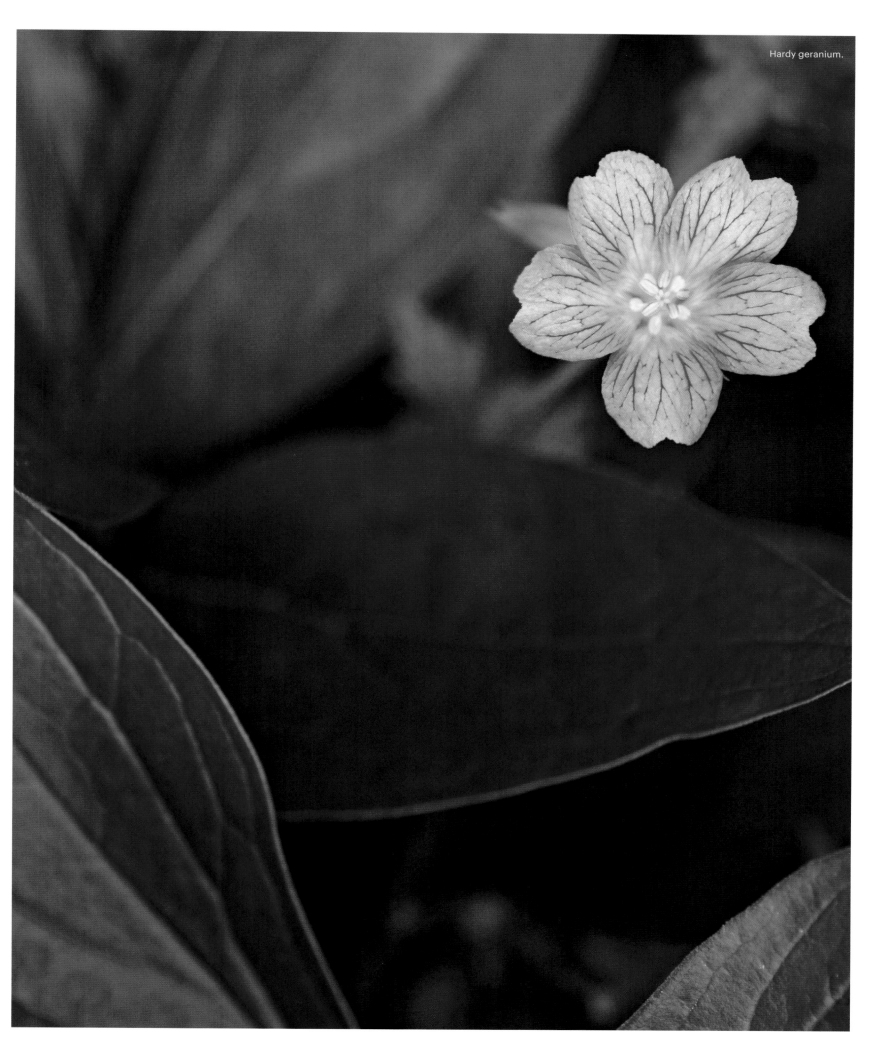

Hardy geranium.

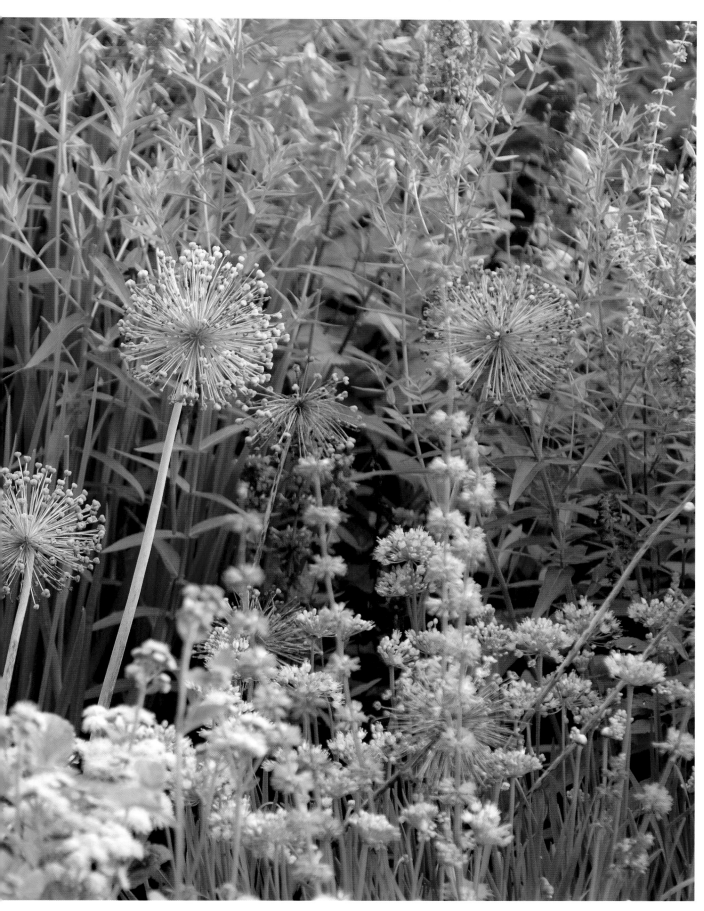

A border garden of perennials and selected annuals including Japanese irises, Betty Corning and Polish spirit clematis, asters, monk's hood, phlox, salvia, petunias, ageratum, and the silvery Russian sage is layered and textured.

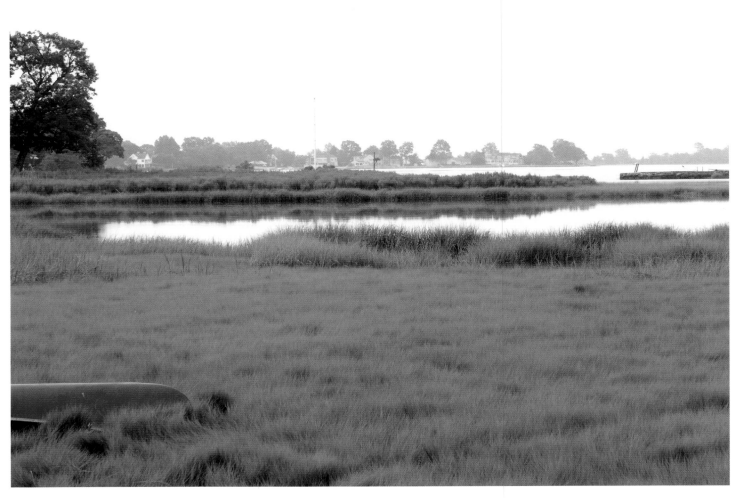

Cohen says her
intention in designing
her garden was to
respond to the gentle
curves of the cove.

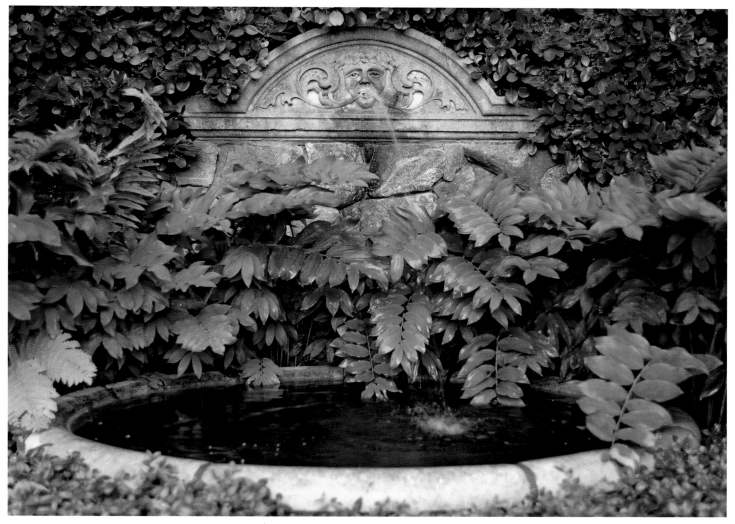

Cohen evokes the
fountains of Europe with
her own grotto planted
with Solomon's seal,
ostrich fern, and myrtle.

In a garden with a uniform color scheme that is easy on the eyes, two stone figures stand guard.

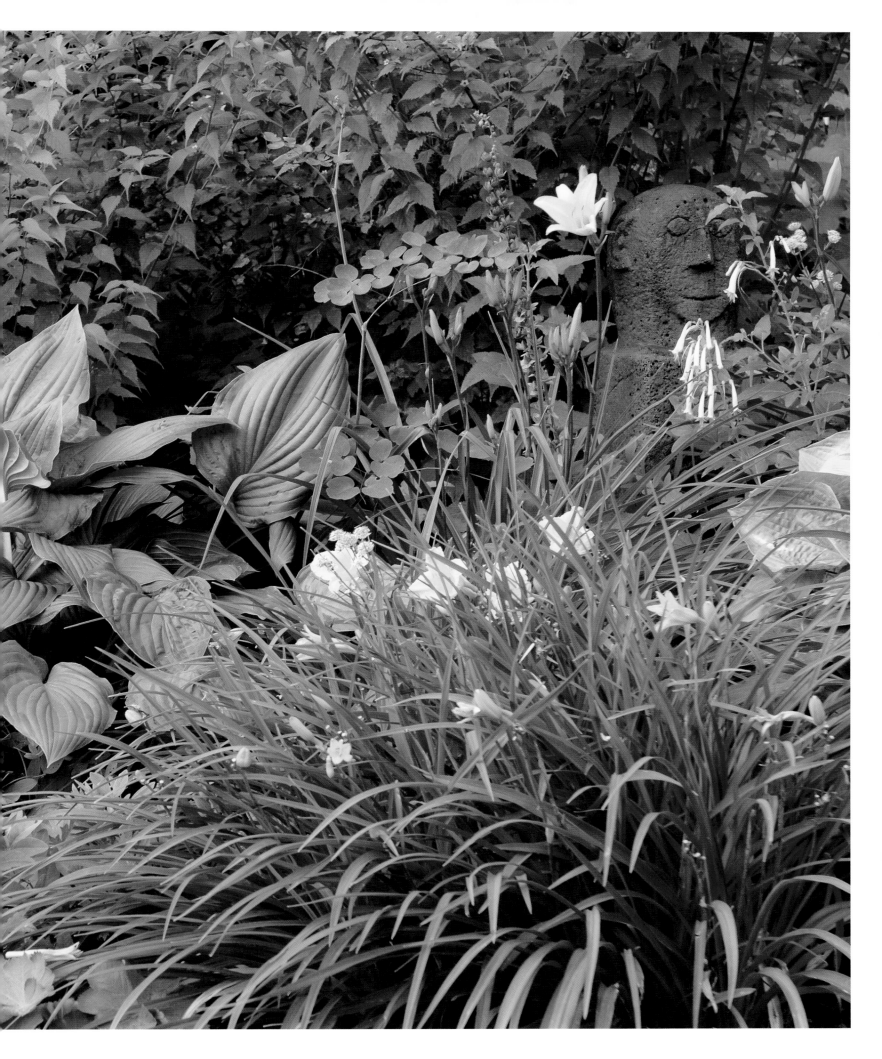

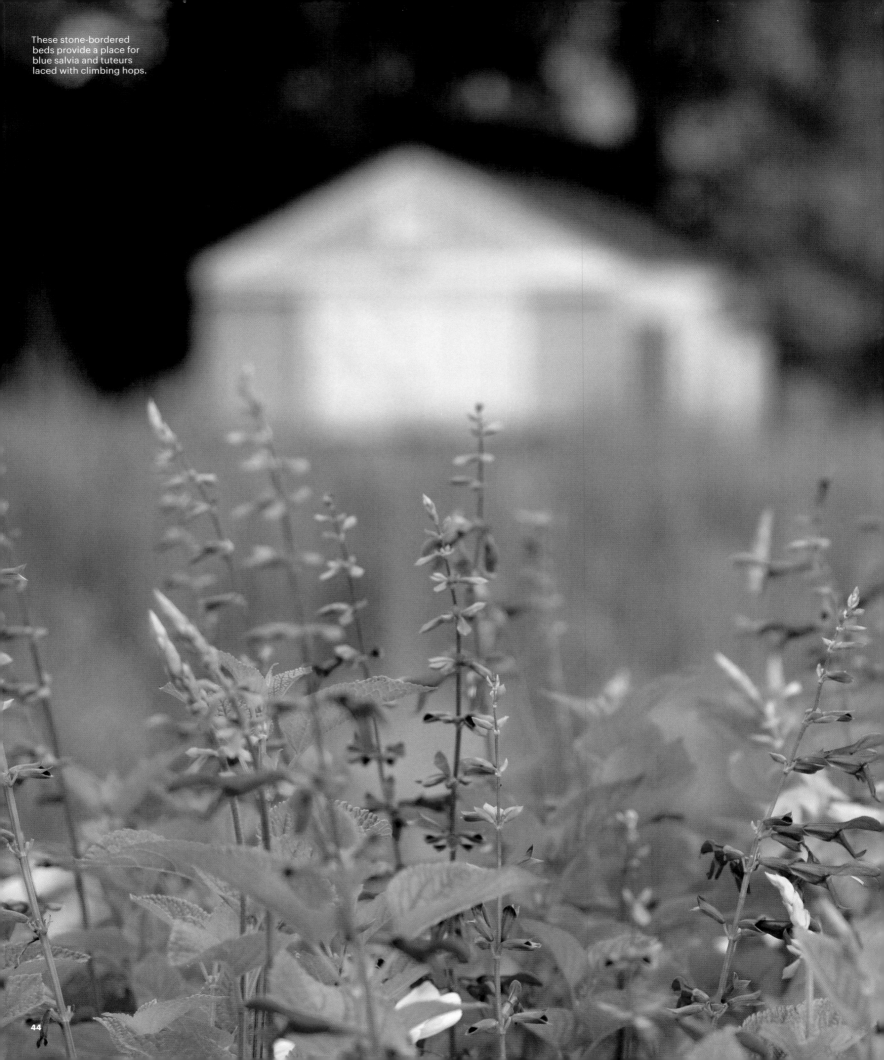

These stone-bordered beds provide a place for blue salvia and tuteurs laced with climbing hops.

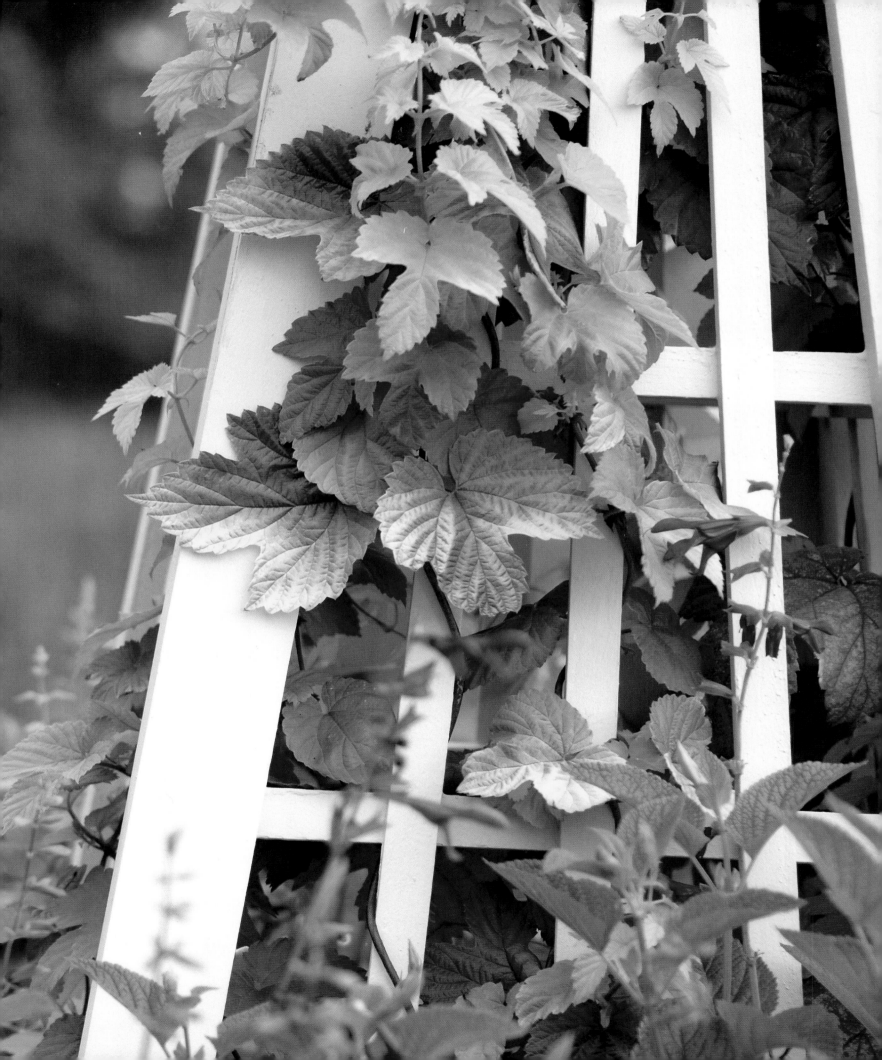

Garden of Earthly Delights

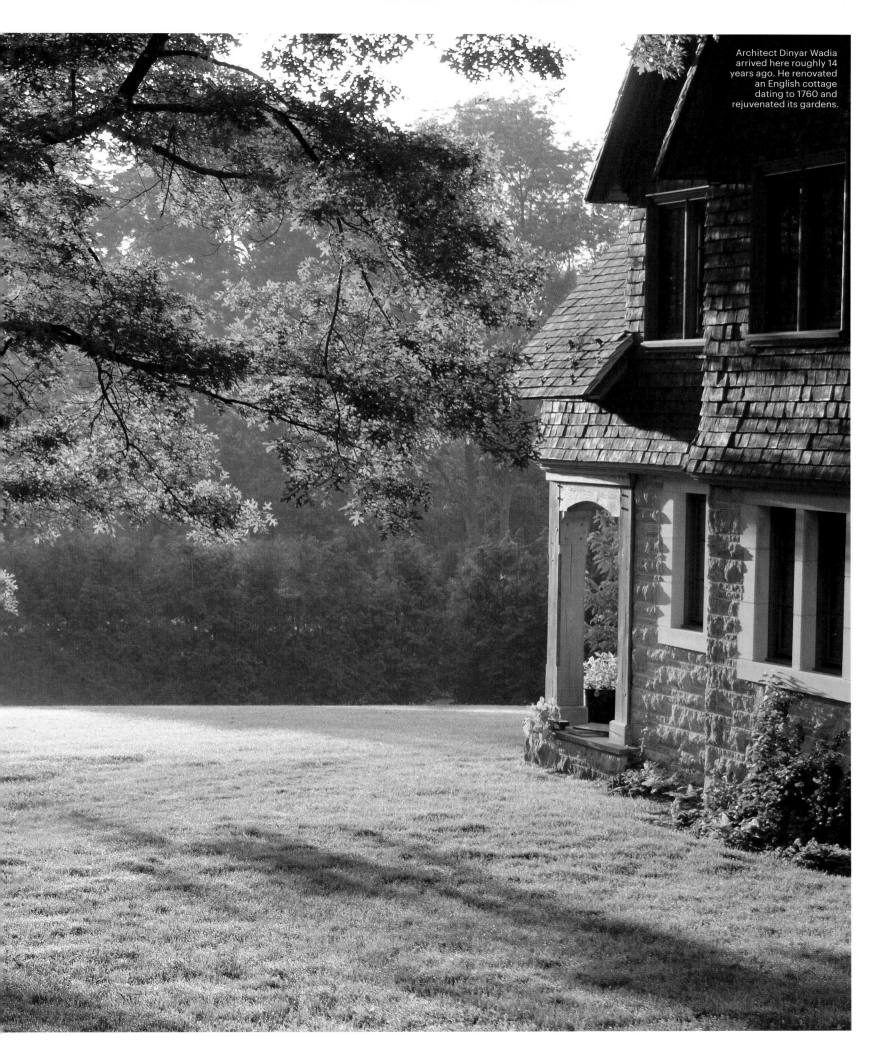

Architect Dinyar Wadia arrived here roughly 14 years ago. He renovated an English cottage dating to 1760 and rejuvenated its gardens.

FORTY-ONE DEGREES north of the equator, 72 degrees west of the Prime Meridian, and 800 feet above sea level one doesn't expect to find a paradise of vegetation so lush it leaves you longing for a necklace of marigolds and a cup of jasmine tea. But down a narrow road in New Canaan, on the ten undulating acres that classical architect Dinyar Wadia calls home, where, interspersed among ho-hum species like arborvitae, boxwood, and rhododendron, sprout clusters of large waxy leaves and brightly colored phallic flowers you've spotted only in the tropics, you'll be convinced that your spur train from Stamford took a wrong turn and wound up in Nirvana.

As he strolls around the property, hands loosely clasped behind his back, his two collies in tow, it becomes apparent that the soft-spoken and self-effacing Wadia, born in Bombay and now successfully moonlighting in landscape architecture, has indeed created his very own Shangri-La. The only difference is he calls it Gitanjali.

Among his more glorious innovations, which have required the assistance of a full-time groundskeeper, is an enveloped sliver of quiet he calls his "Boxwood Walk"—a lawn flanked by layers of towering rhododendrons, endless summer hydrangeas, and the small-leafed shrubs that gave the allee its name. It terminates in a diminutive, slate-roofed teahouse that's framed by a forest as if in a painting.

His deft hand is everywhere in decorative embellishments that revere their surroundings, including the 1760 English cottage he renovated 14 years ago. There are Chinese chestnut trees, old oaks, 100-year-old pines, ginkgos, magnolias, and graceful beeches with low sweeping branches that recall the swoops of Victorian skirts. There is the fragrant Miss Kim lilac he grafted onto the stock of an old apple tree; the pleasing view of the "Summer Border"—thick with beardtongue, fuschia, orange peel, golden pineapple sage, and too many others to name—that is best enjoyed from the loggia at early-morning tea because after seven the sun is too strong. There is the cobblestone courtyard where he's softened the view with a cornucopia of potted plants and hanging flowers like mandevilla, banana leaves, giant papyrus, and hibiscus, and, hidden between two brick walls, an enchanted haven he calls "Our Little Garden," where gas-lit lanterns flicker, fountain-water trickles, and the heart skips a beat.

Wadia seems to have a knack both for moving discontented shrubs and trees to new places where they thrive—his trick is to sing to them—and for cultivating the exotic.

And although he says his personal horticultural pursuit—which he likens to the frenzied back-and-forth of horse-trading—tries his patience, he is clearly in his element.

Apparently, regardless of the hemisphere, good things come to those who wait. ∎

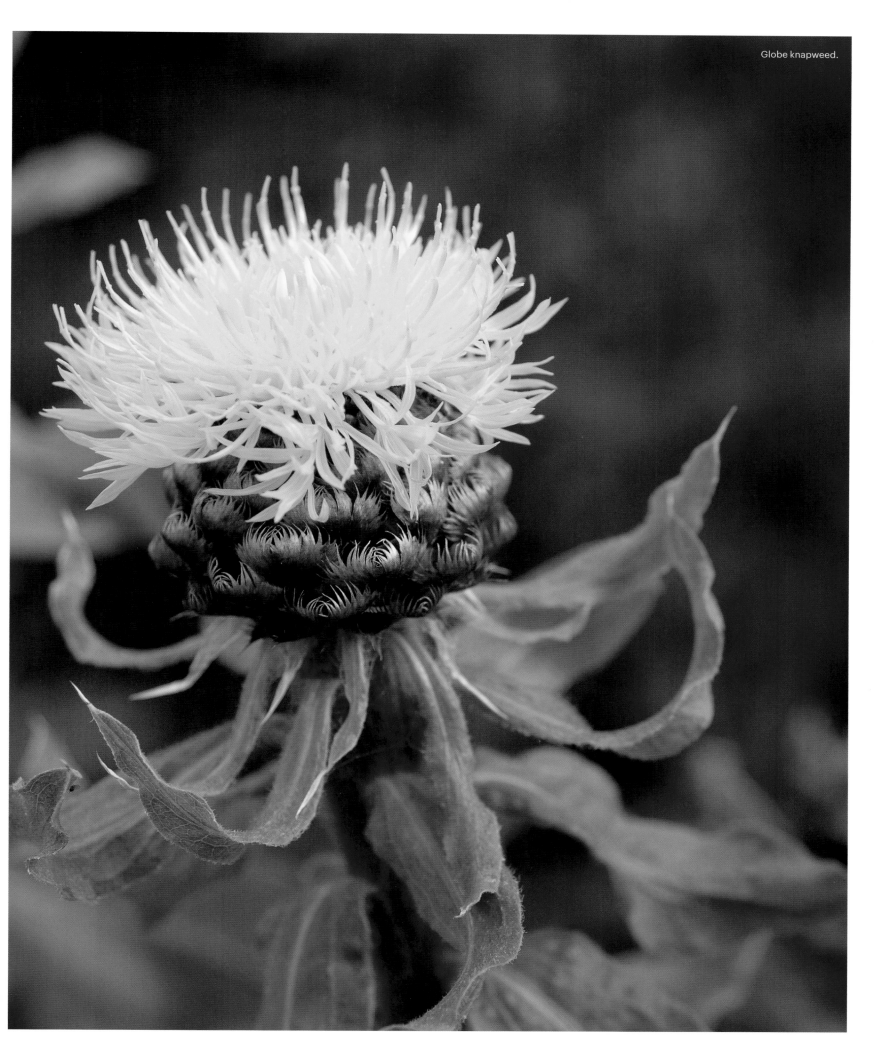

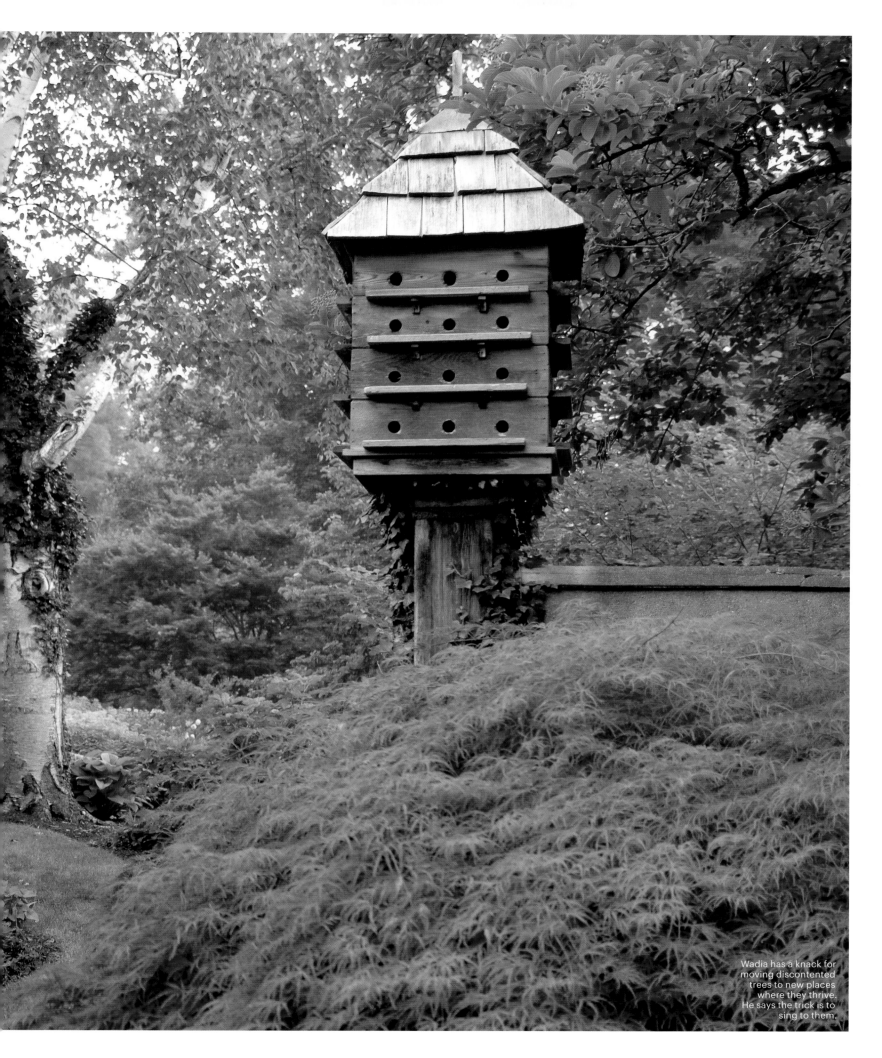

Wadia has a knack for moving discontented trees to new places where they thrive. He says the trick is to sing to them.

A slate-roofed tea
house sits at the foot of
the "Boxwood Walk."

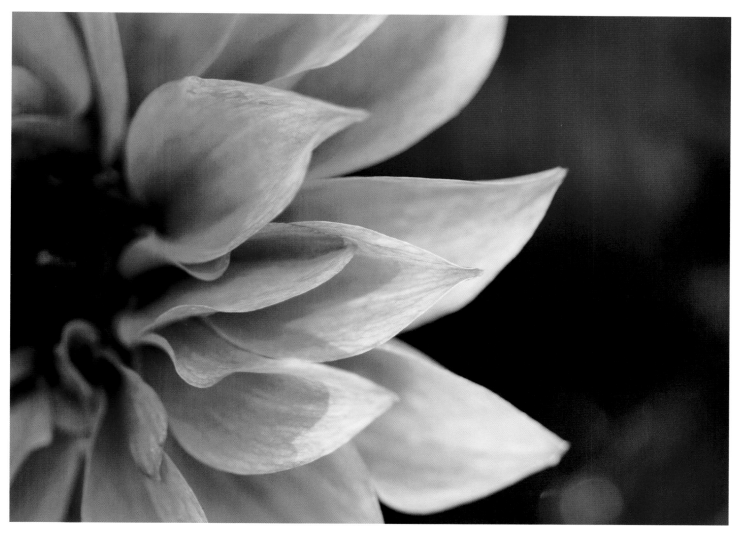

A dahlia.

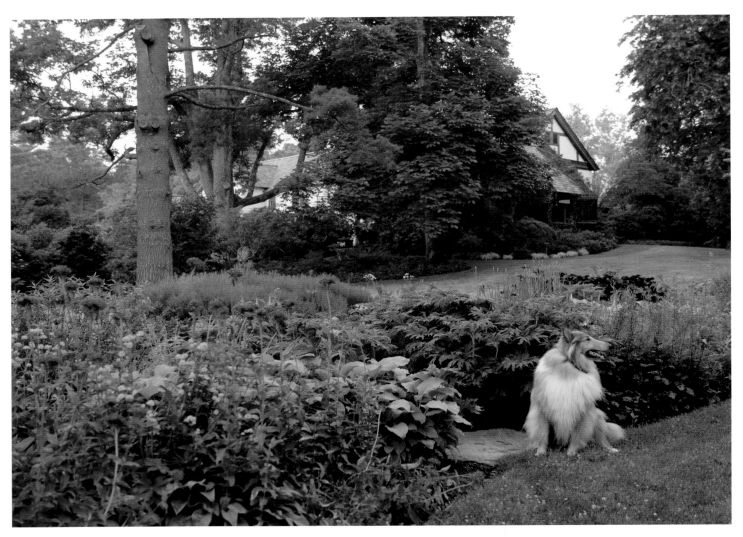

The property includes
numerous old trees such
as Chinese chestnuts,
oaks, ginkgos, magnolias,
beeches, and pines.

A Maltese cross. ▶

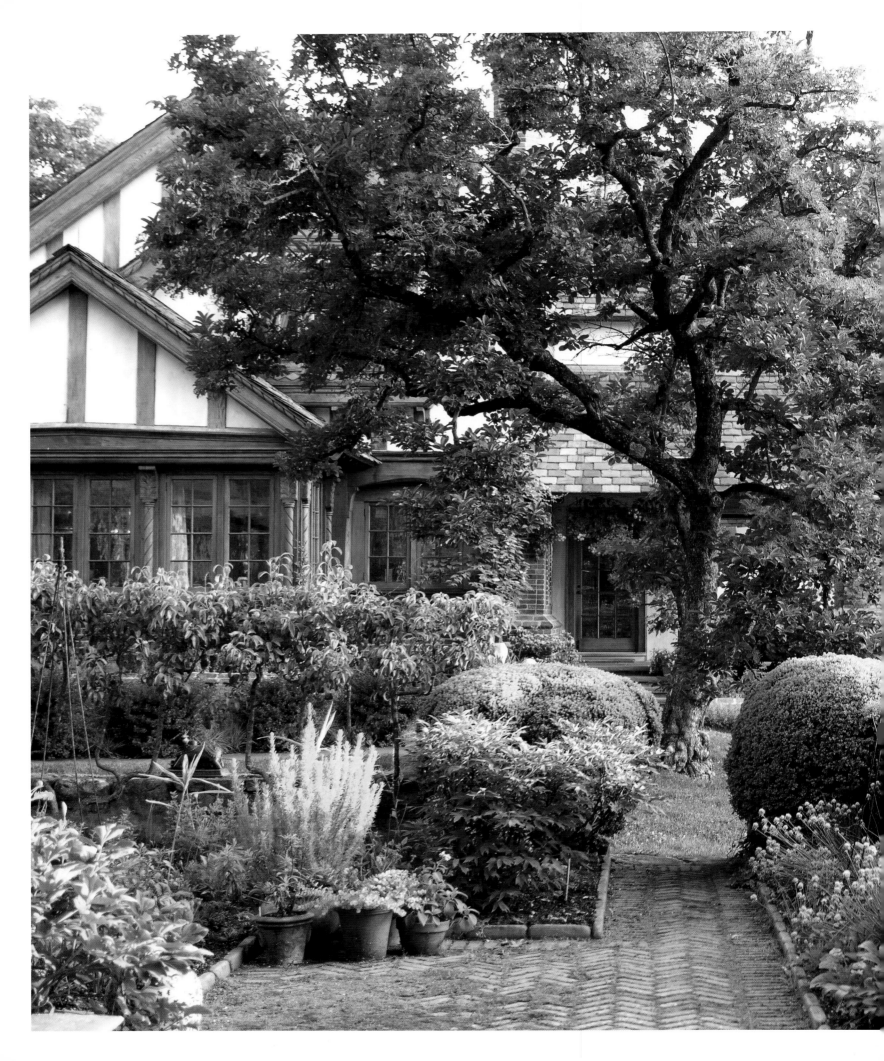

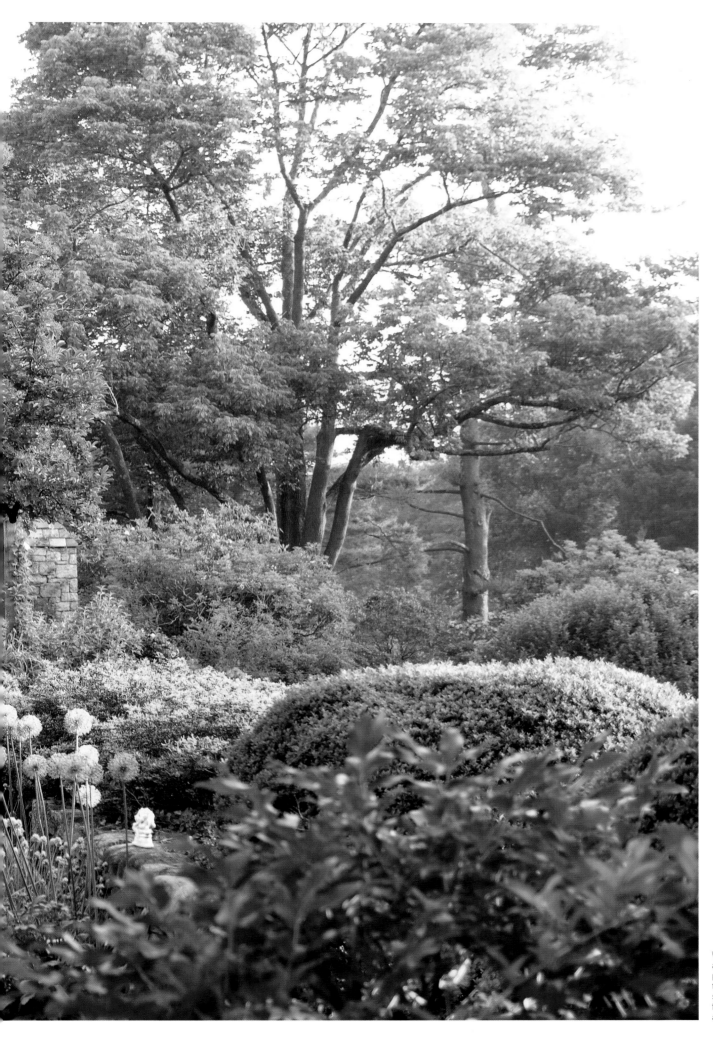

Wadia mixes
annuals,
perennials,
tropicals, and
subtropicals
for color
and texture.



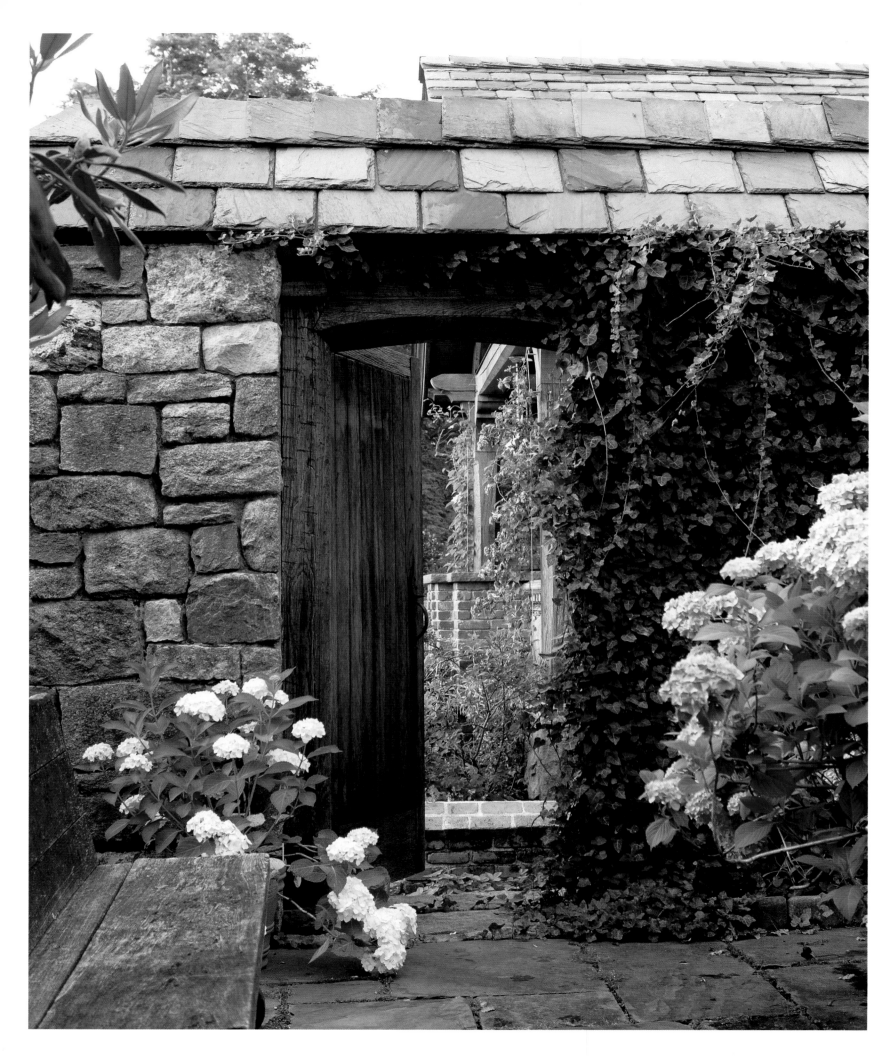

Sea holly.

◄ A stone wall
encloses
an enchanted
space Wadia
calls "Our
Little Garden."

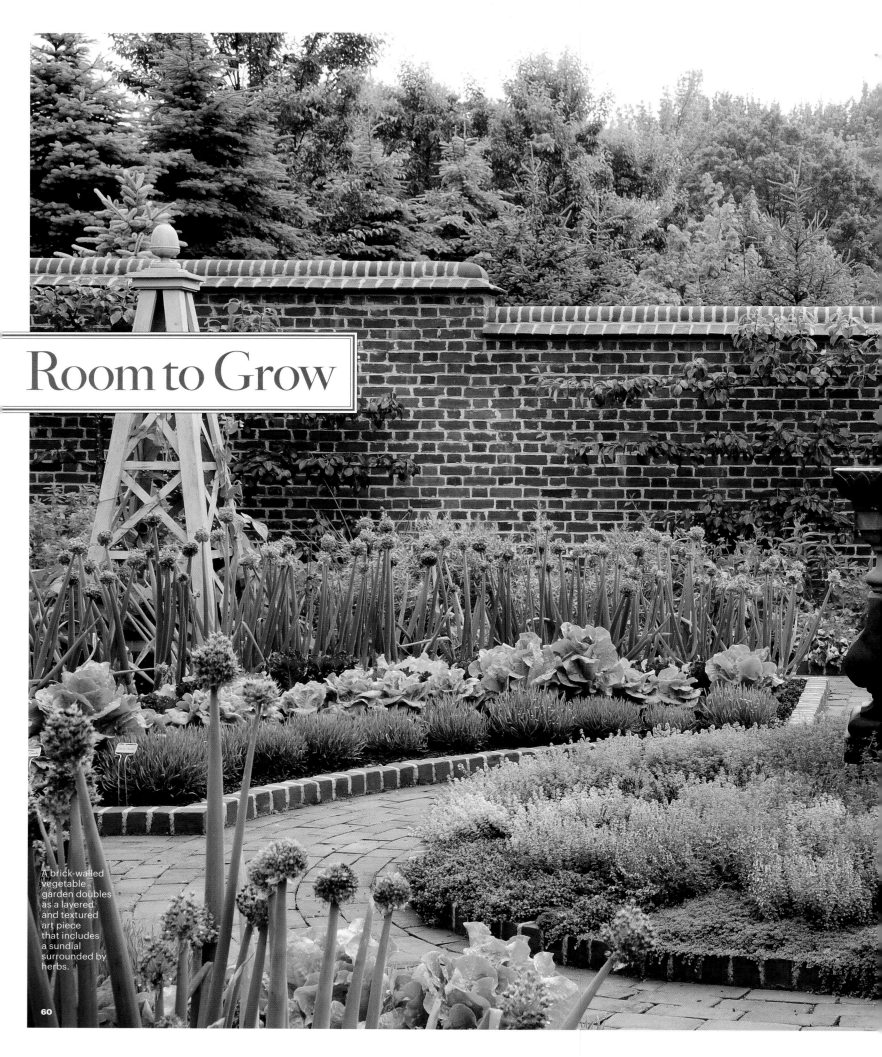

Room to Grow

A brick-walled vegetable garden doubles as a layered and textured art piece that includes a sundial surrounded by herbs.

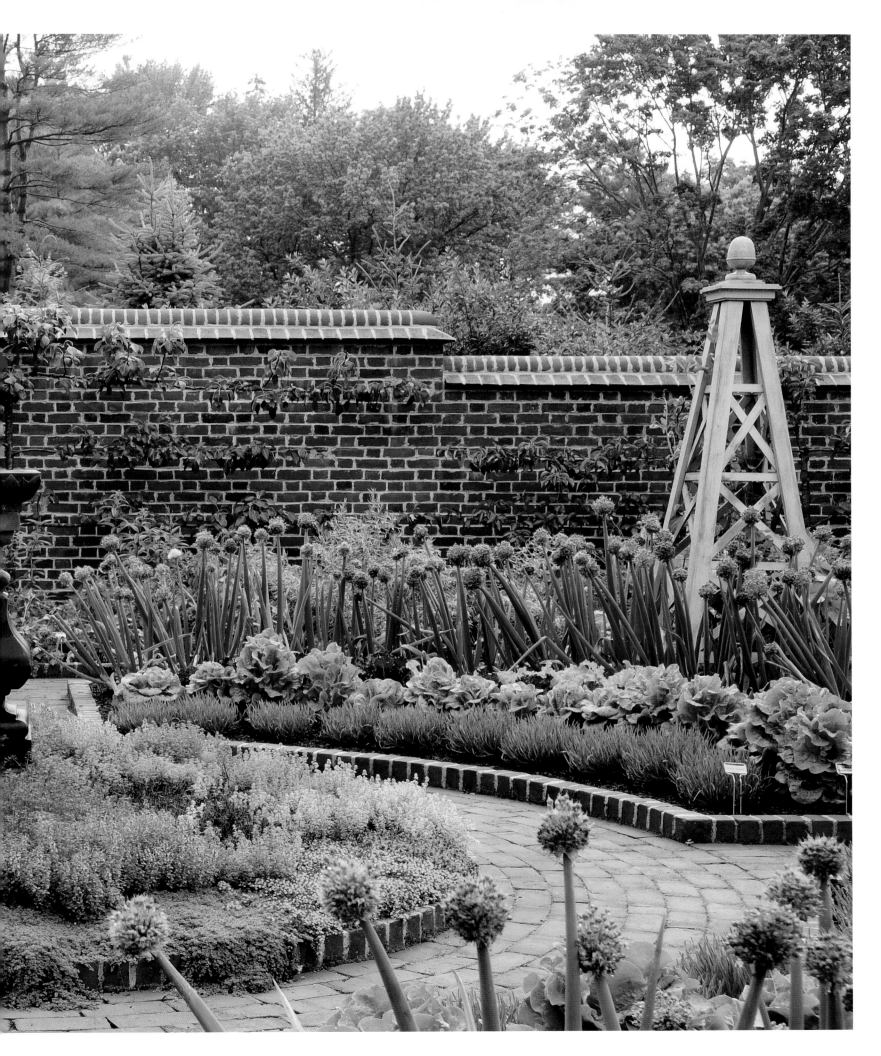

IN 1865, Lucy Glasebrook's Greenwich home sat in the middle of a large working farm. These days it's hard to think that the farmer who once owned the land would not have approved of what she's done to it. Or at least to the seven-plus acres of it she has acquired since 1997. Glasebrook, a collector of European garden ornaments that she likens to her "spare parts department"—a marble fountain decorated with lions; antique faux-bois English strawberry pots; a French faux-bois, cast-concrete gate featuring a hound on the hunt—was determined to enhance the property in a style consistent with its historical pedigree. She dove right in, retaining the services of landscape designer Kate Reid to create colorful counterpoints to the site's wide lawn and tall trees.

Among Reid's embellishments was the addition of a spacious garden of annuals and perennials, each variety chosen to ensure that the garden is in bloom from May to October. The precious contents are tucked into an L-shaped corner behind the house and enclosed in a white picket fence with an arched arbor of new dawn roses. The arbor echoes a Palladian window dressed in ivy, from which Glasebrook can survey her blossoms: puffy clouds of ballerina hybrid musk roses that float above the fence, stalks of red-freckled foxglove like tiny pink bells, Miss Lingard phlox, lady's mantle, nepeta, and French vanilla marigolds, among others. Together the flowers form a frilly border around a pair of magnificently structured boxwood parterres—rounded green doughnuts in square frames with lavender centers.

A few years after moving in, Glasebrook, an avid cook who has more recently immersed herself in modern art, acquired an adjacent parcel of land. Suddenly there was more space to play with. She erected an old barn she'd found in Albany, New York, built a pergola entwined with wisteria, and, with Reid's help, planted a bountiful vegetable garden sure to turn a farmer from any century green with envy. It might also get the nod from a curator or two in Chelsea.

Inside a high brick wall thrive concentric rings of leafy lettuces—buttercrunch, red velvet, Simpson elite—mini mounds of curly chives, and giant bunching onions topped with fuzzy balls. Fluffy sprays of Jersey giant and purple passion asparagus spill over an elevated terrace, and on the perimeter are red-veined Swiss chard, eggplant, bell peppers, pole beans, and a host of heirloom tomatoes including black Russians, Arkansas travelers, and mortgage lifters. The lush growth surrounds a sundial-centered herb garden that doubles as artful ground cover—parsley, sage, rosemary, and thyme. A Georgian potting shed, assembled by a team of Amish workers and guarded by tall stalks of purple kale, completes the picture.

It could be said Glasebrook's grown into the place. Her agrarian predecessor would likely agree. ∎

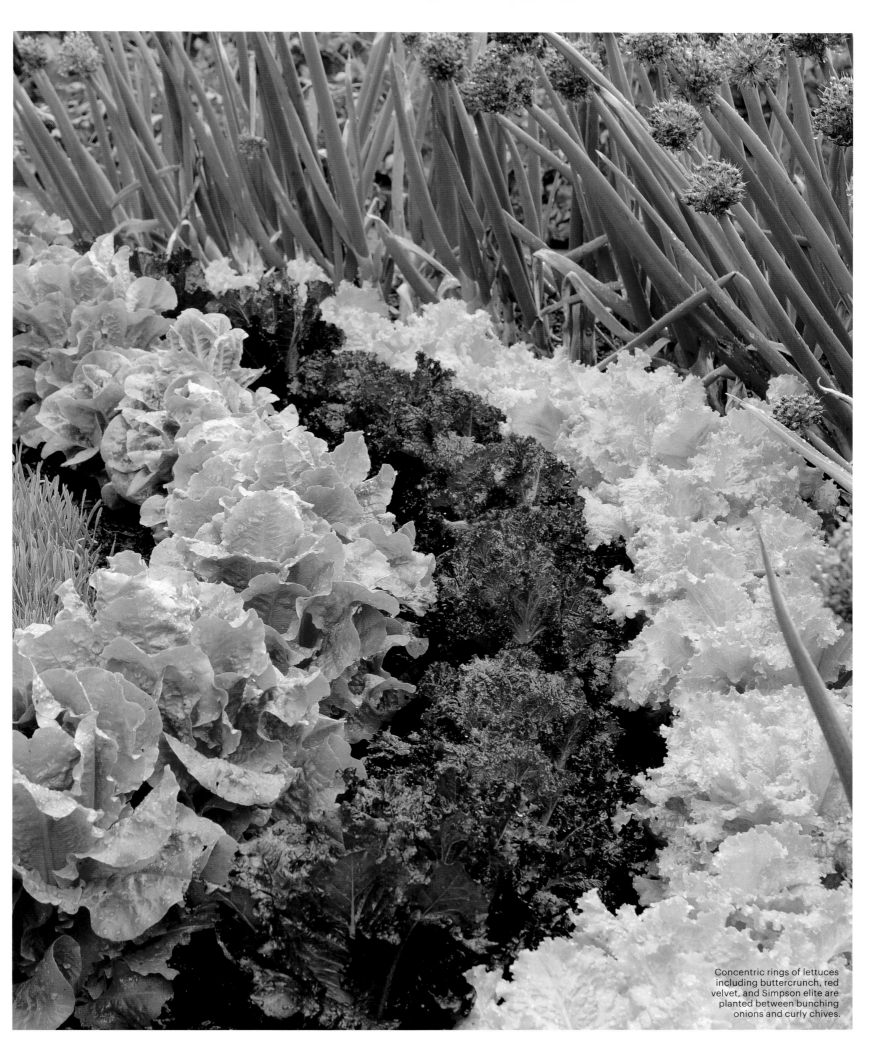

Concentric rings of lettuces including buttercrunch, red velvet, and Simpson elite are planted between bunching onions and curly chives.

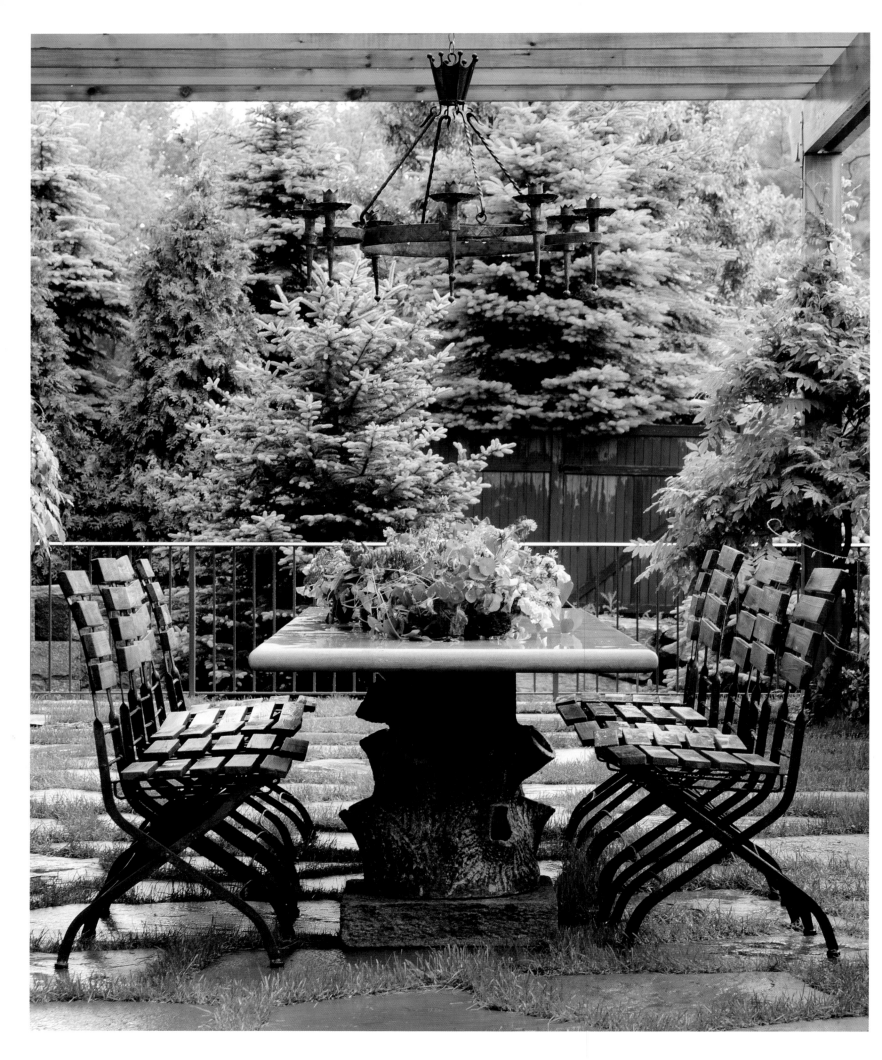

A blossom from
one of Glasebrook's
centerpieces.

◄ Outside the
barn, a pergola
provides cover
for a dining
table mounted
on faux-bois
strawberry pots.

Puffy clouds of ballerina hybrid musk roses rest on a picket fence.

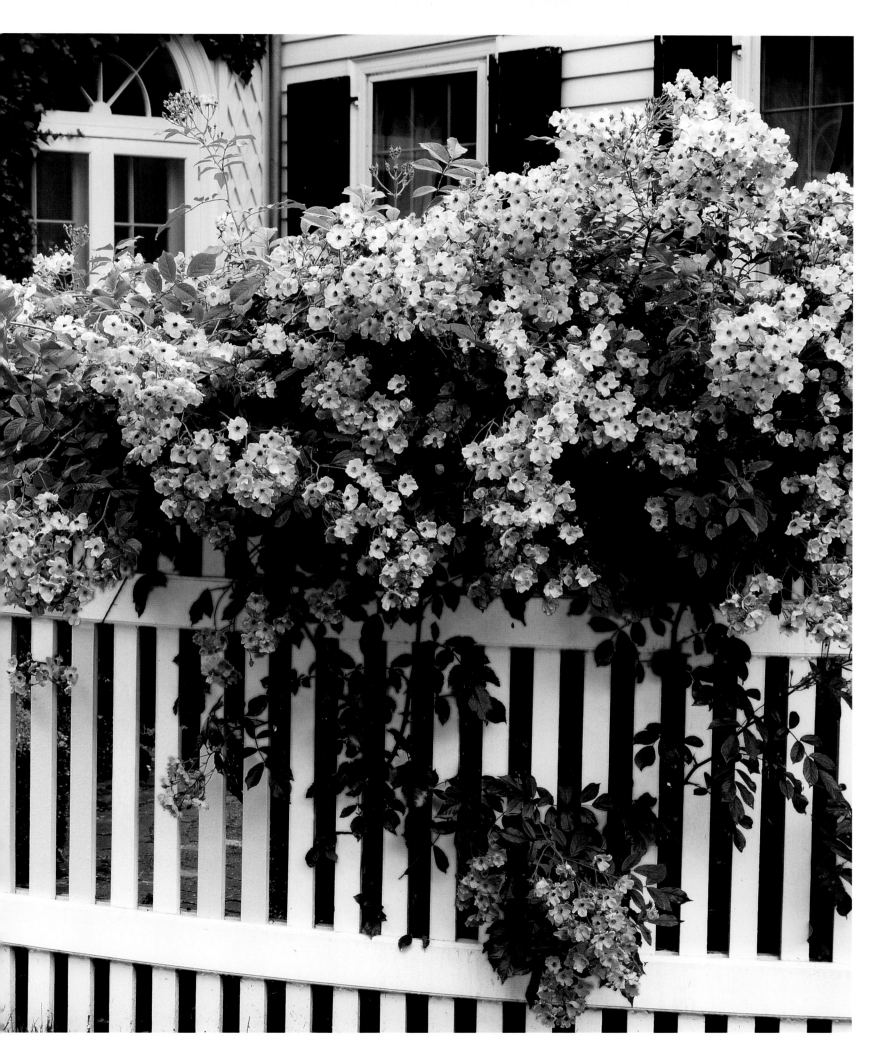

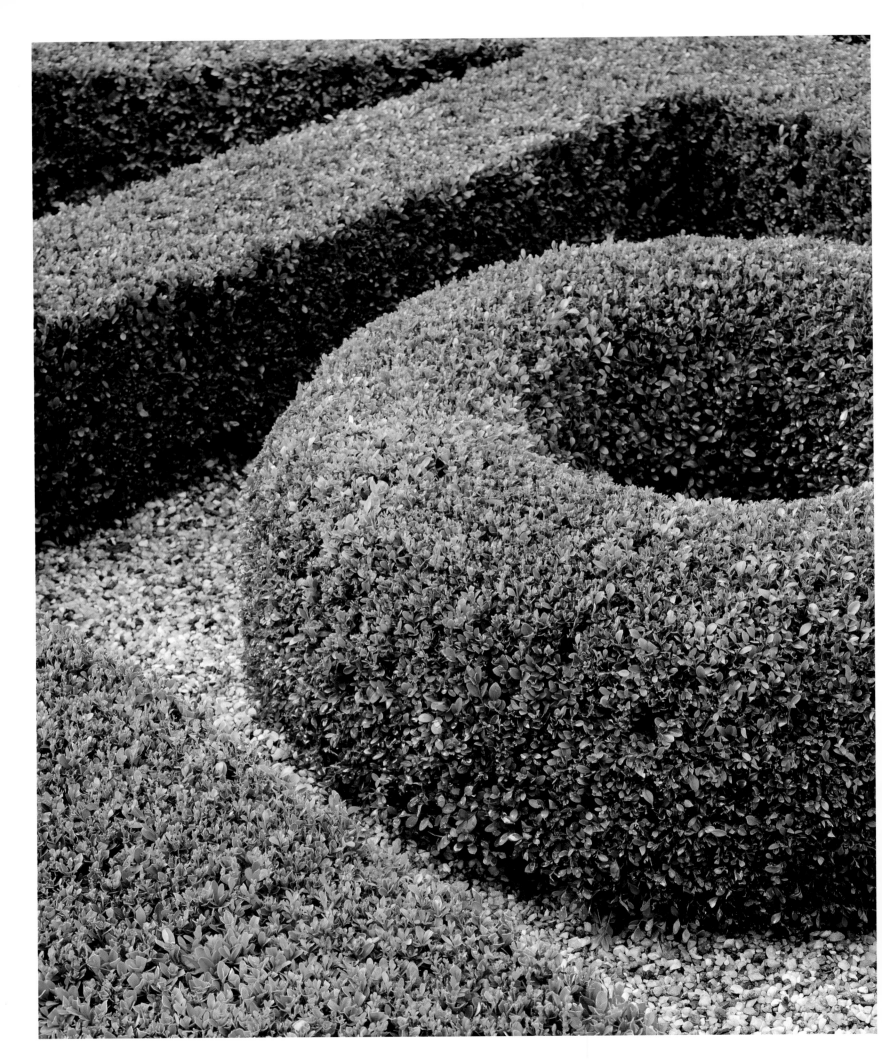

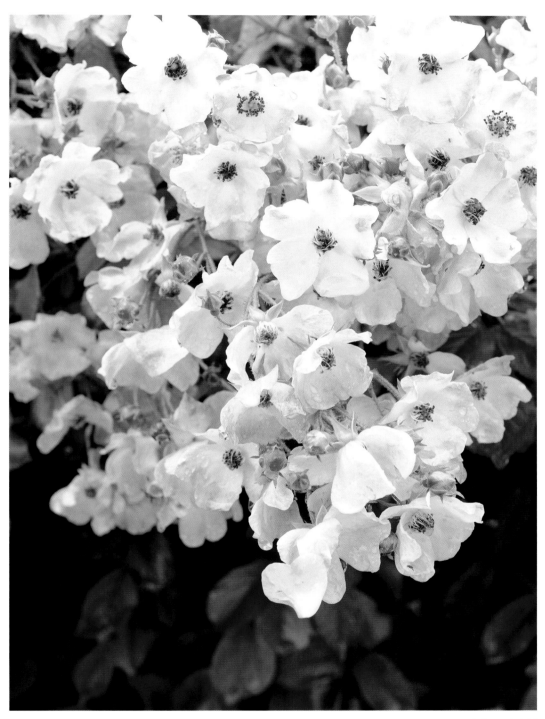

Ballerina hybrid
musk roses.

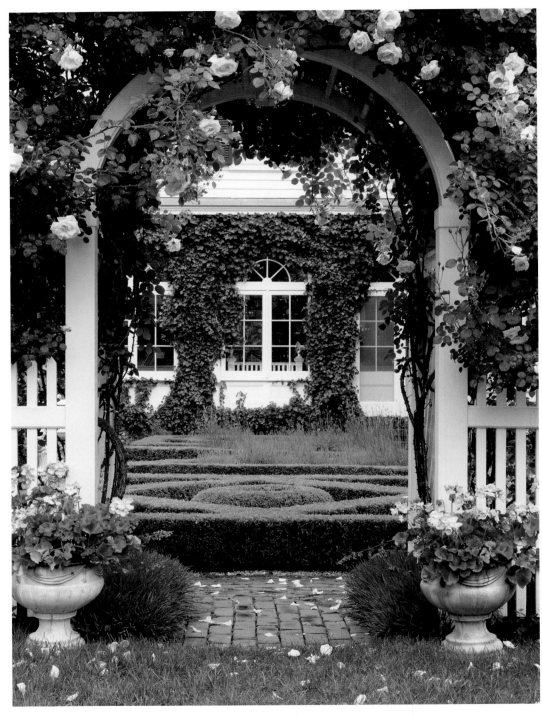

An arbor of new
dawn roses.

Red-speckled ▶
foxglove like tiny
pink bells.

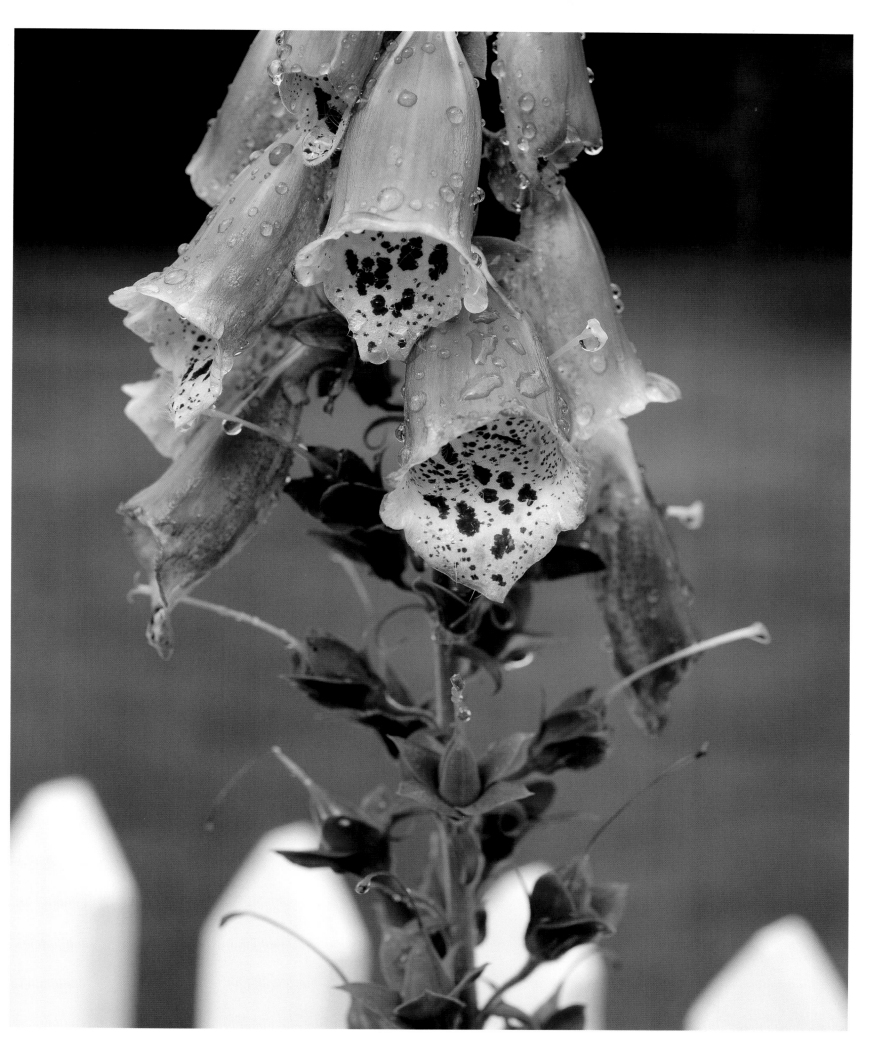

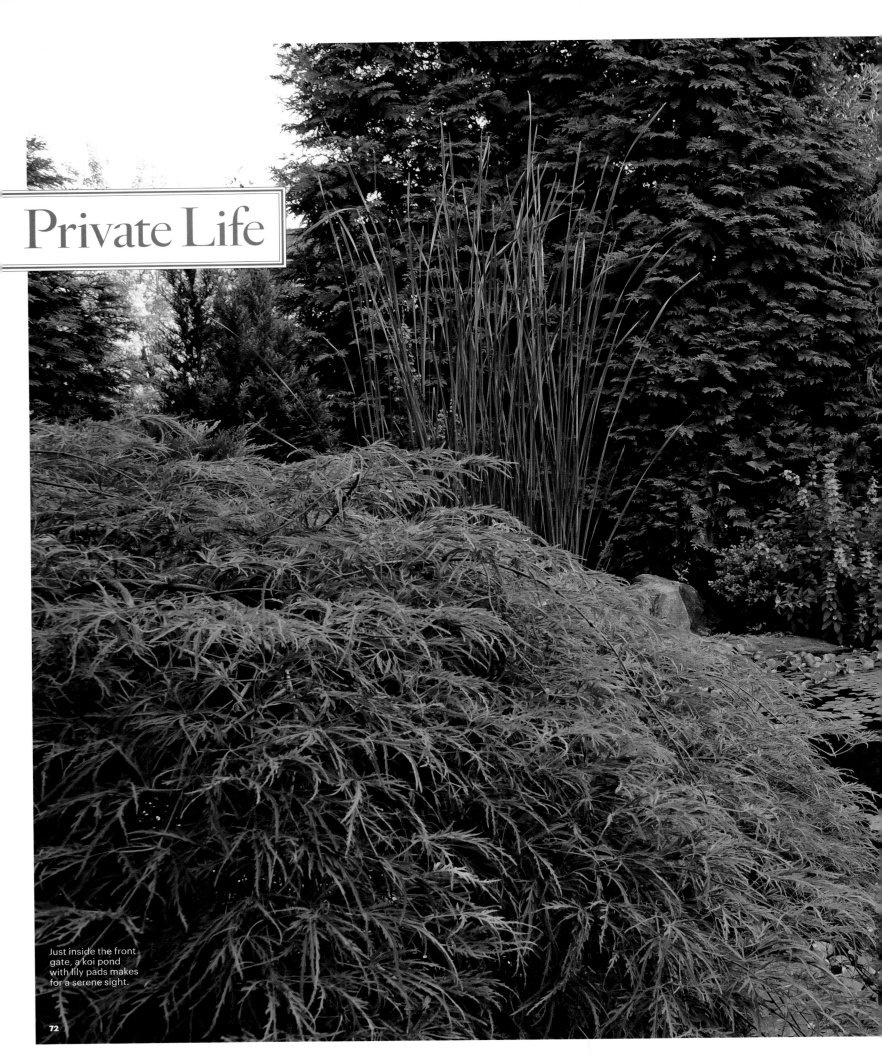

Private Life

Just inside the front gate, a koi pond with lily pads makes for a serene sight.

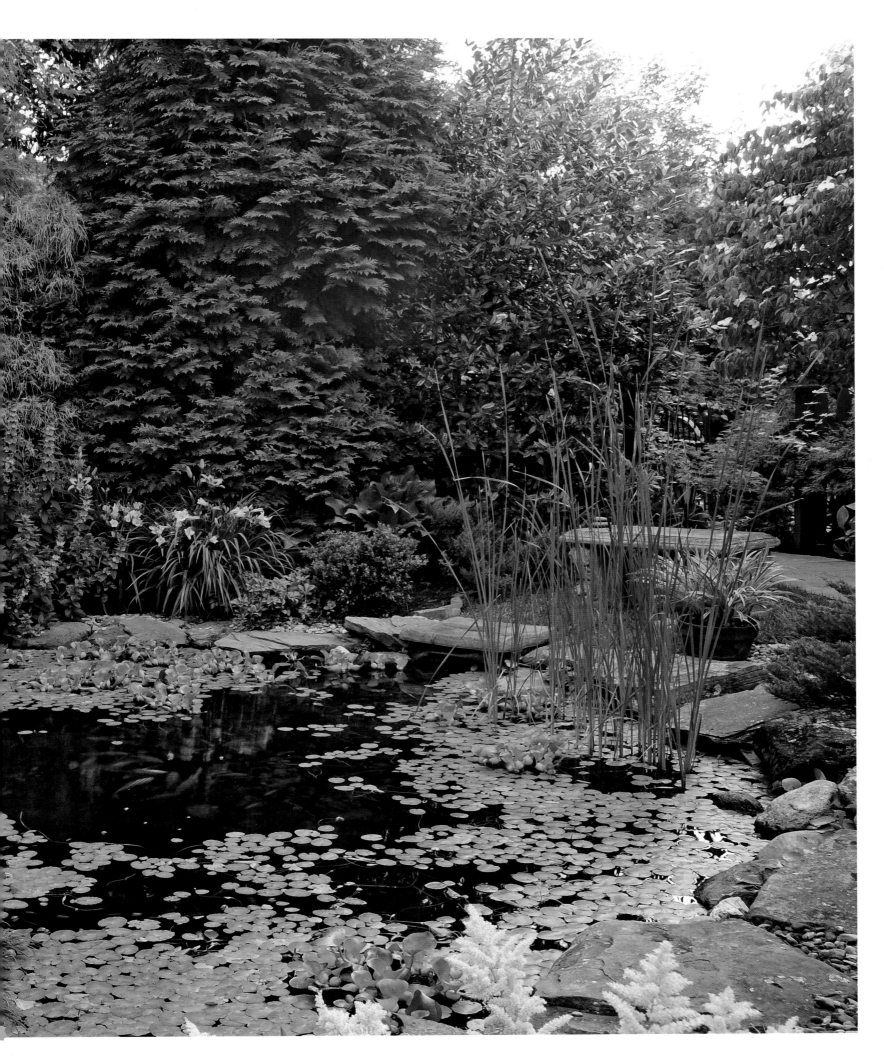

IF ANYTHING motivated Jane Valenstein as she began building her garden in 2002, it was a desire for privacy. Situated on a narrow (and breathtaking) strip of land between Long Island Sound and Greenwich Cove in Old Greenwich, her home is in a cluster of houses that made it difficult to enjoy an unspoiled view. So Valenstein turned her gaze inward and discovered that she could create her own bella vista. By dividing her land into a series of enchanting little "rooms," connected by narrow footpaths and alternating between shaded and sunsplashed, she delights the eye and makes it hard to believe her property is only half an acre.

An interior decorator and former art teacher whose mother was a landscape architect, Valenstein says she learned on the job, having long ago absorbed by osmosis such concepts as tracking the sun, watching the canopy, and using trees as screens. Her work proves that no matter how small a space, it's possible to create an abundance that unfolds in surprising ways.

Among the unexpected gems on the bird-friendly property is a koi pond with 75 fish that is so well hidden in a grove of trees just inside her front gate that you wouldn't know it was there. Fed by a burbling waterfall, the lily pad pond is bordered by flat stones and ensconced in a textured combination of reedy grasses including knife-like cat-o'-nine-tails, six-foot-tall King Tut, and a show-stealing Japanese cutleaved maple that drapes gracefully toward the water's surface.

Out back, on the far side of a rectangular pool, she designed a lush set for an antique birdbath using Annabelle hydrangeas and framed it—a little girl holding a large scallop shell—with fragrant French lilacs, meticulously pruned to resemble a pair of umbrellas that stand like sentinels at a castle gate.

Valenstein leans toward a subtle formality and seems to like things slightly askew. In a side garden gated by arbors, she went to town with pink knockout roses, white peonies, and purple nepeta, as well as an assortment of daylilies, foxglove, lupine, astilbe, and geraniums—and a velvety rose called Cinco de Mayo whose pinky red color mimics that of a soft poppy. Quietly observing the splendor is a diminutive statue of St. Francis, sculpted by Jose de Creeft and protected, thanks to Valenstein's deft touch, in a collar of boxwood that recalls the folds of a monk's robe.

To enclose her little slice of paradise, Valenstein constructed a thick screen of new and existing arborvitae, blue spruce, American holly, dwarf Alberta spruce, blue holly, privet, and a crab apple that she says is the "star of the property" because every year it carpets the lawn in pinky white petals.

A starlet worthy of a private screening. ∎

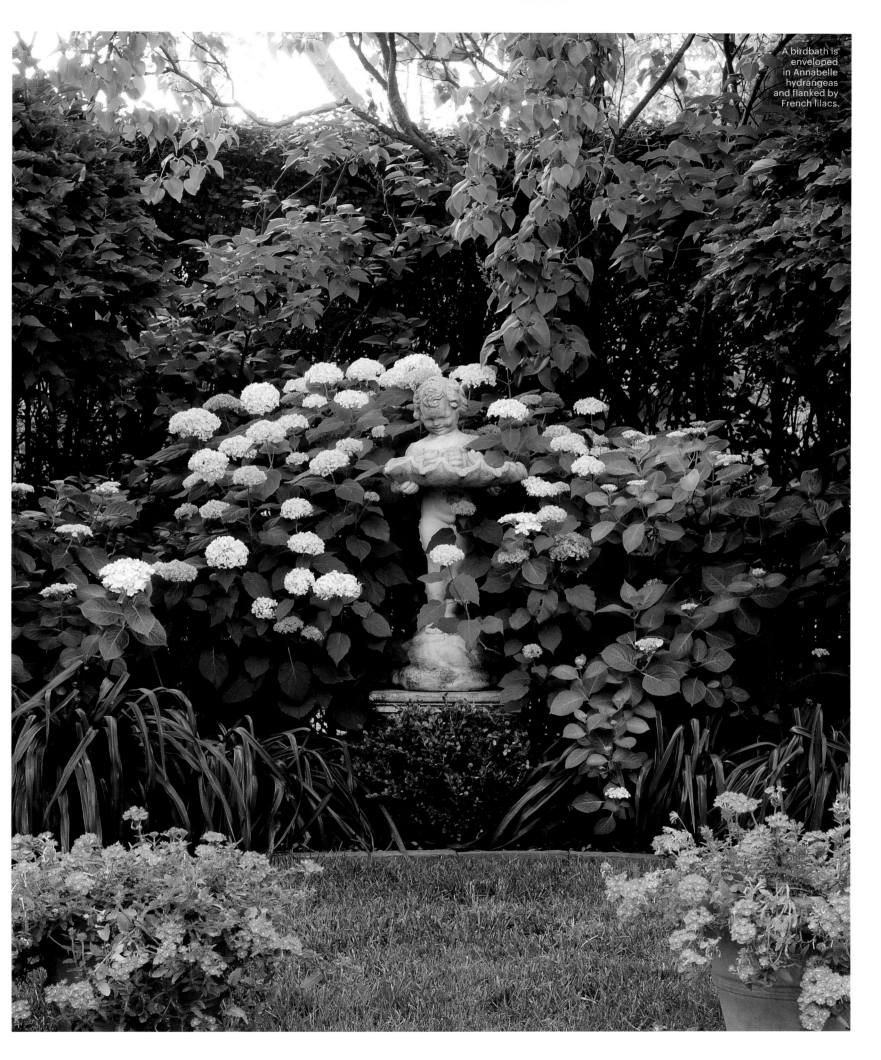

A birdbath is enveloped in Annabelle hydrangeas and flanked by French lilacs.

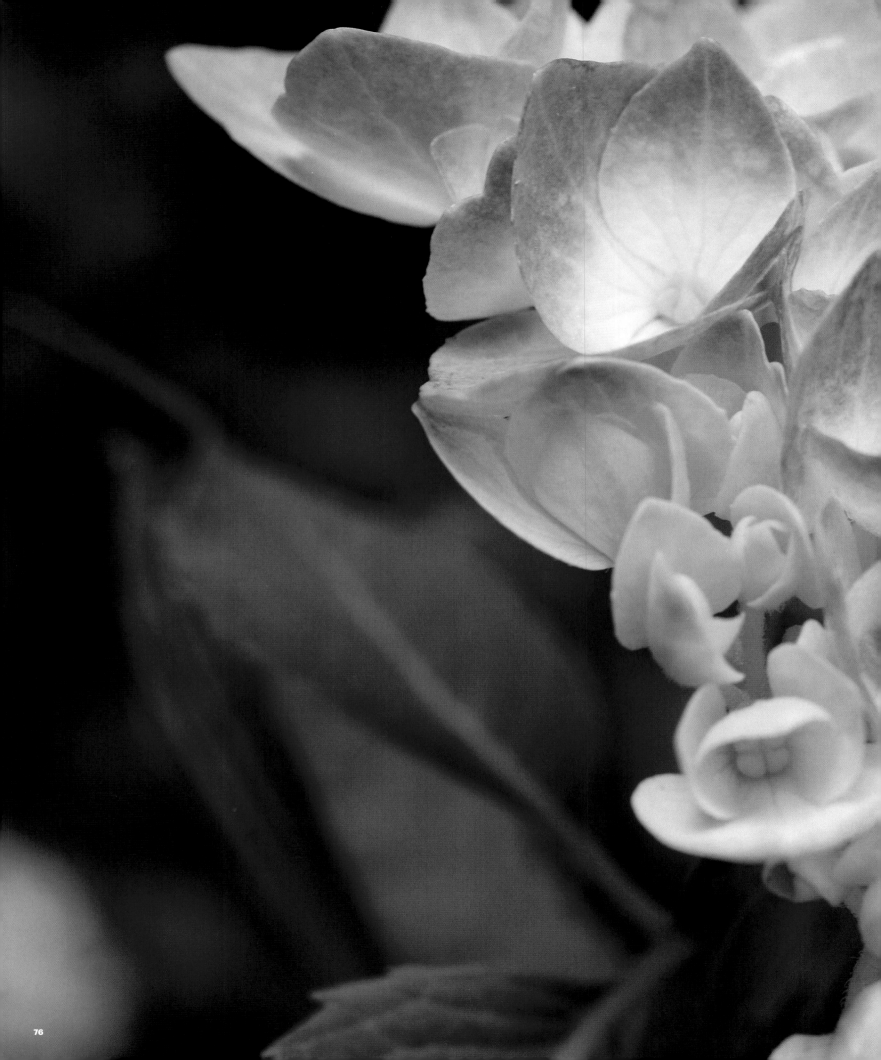

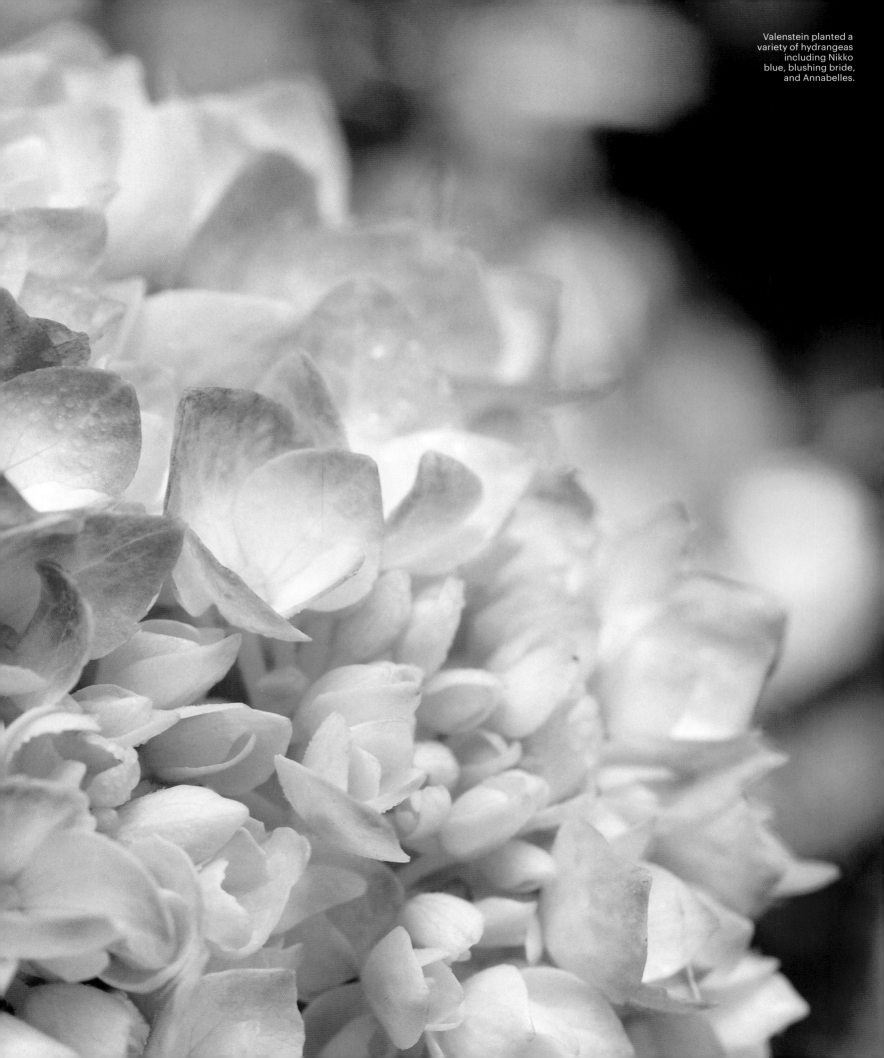

Valenstein planted a variety of hydrangeas including Nikko blue, blushing bride, and Annabelles.

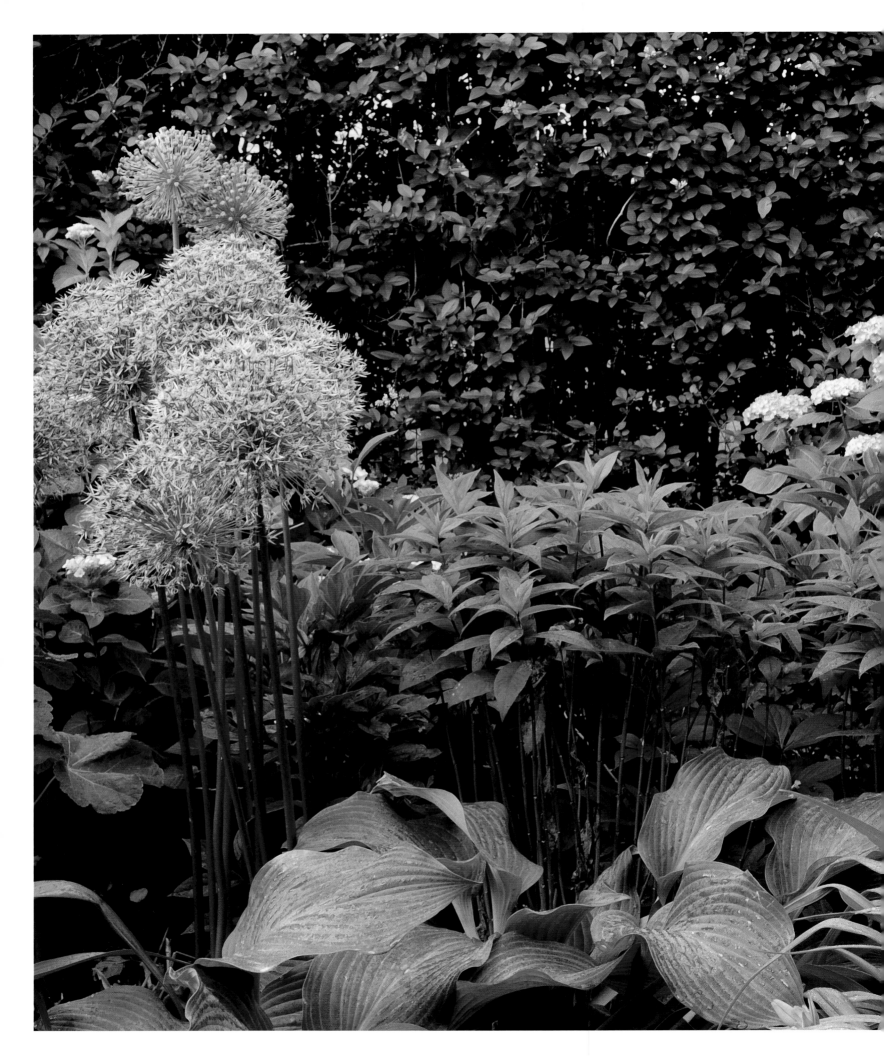

A perennial garden features allium, peonies, and Nikko blue and blushing bride hydrangeas, among many other flowers.

Daylilies and
loosestrife add
color to the
lily pad pond.

A daylily close up. ▶

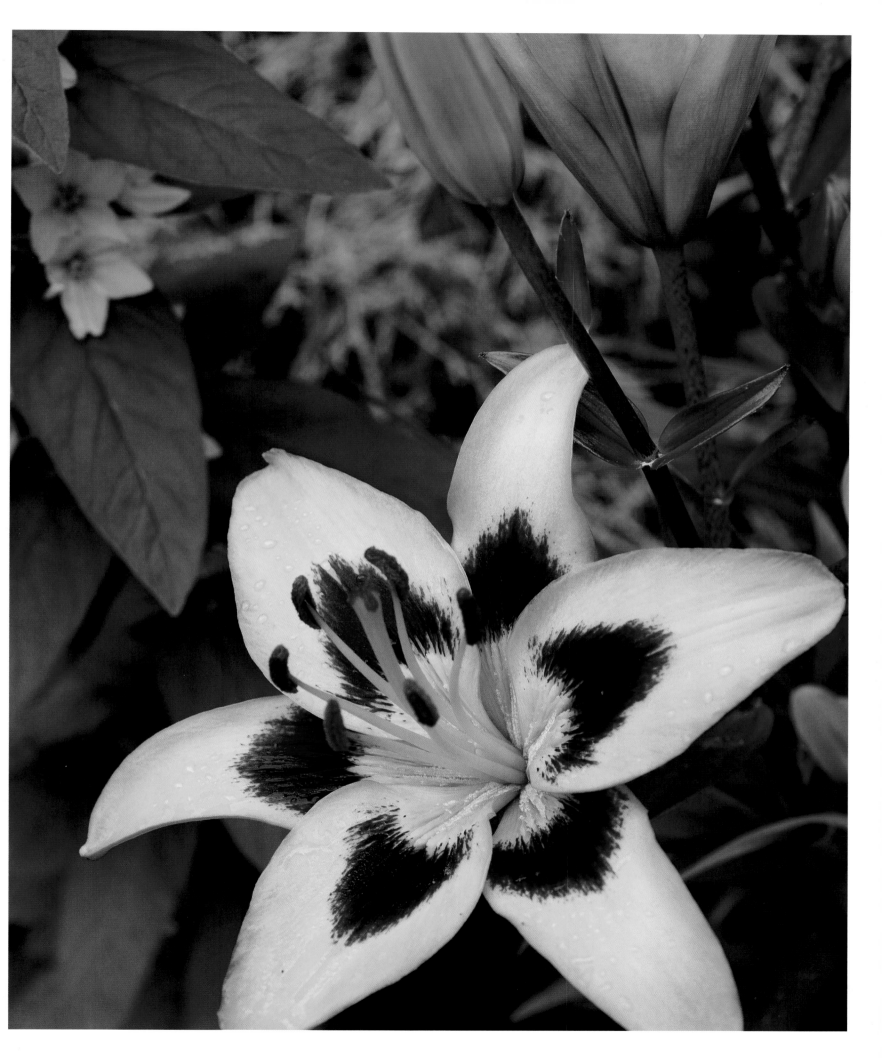

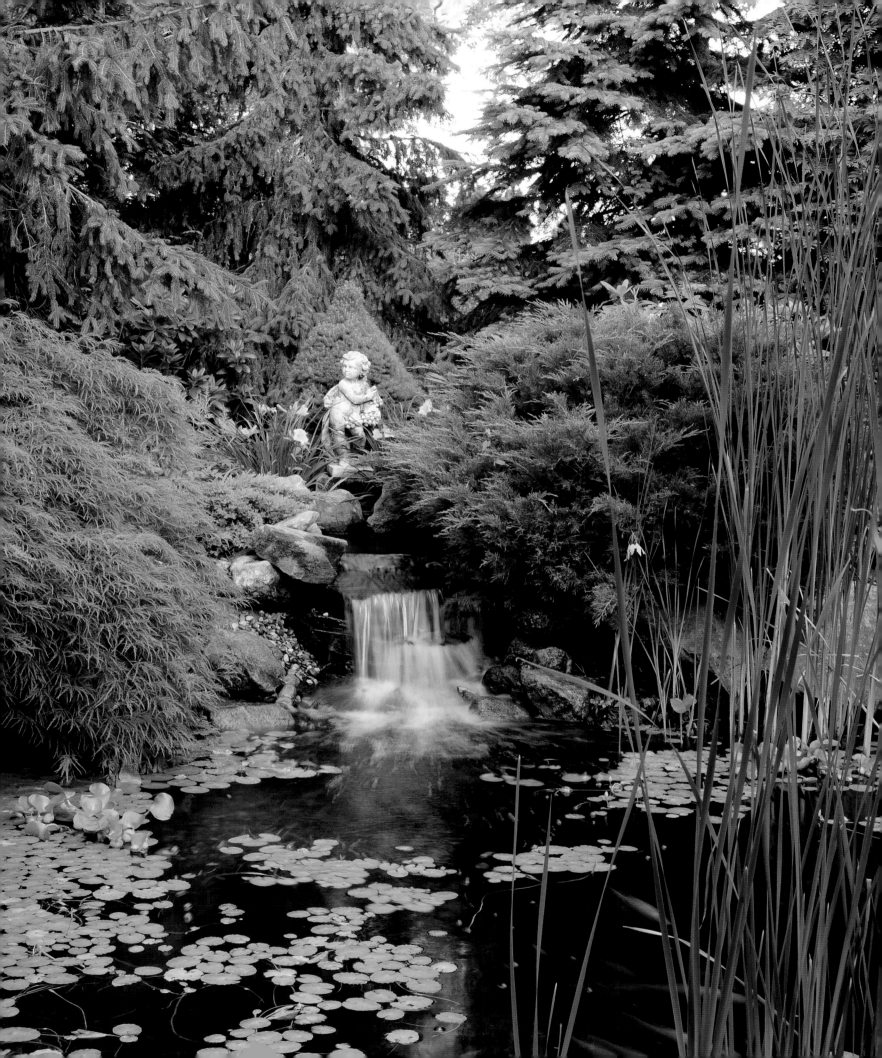

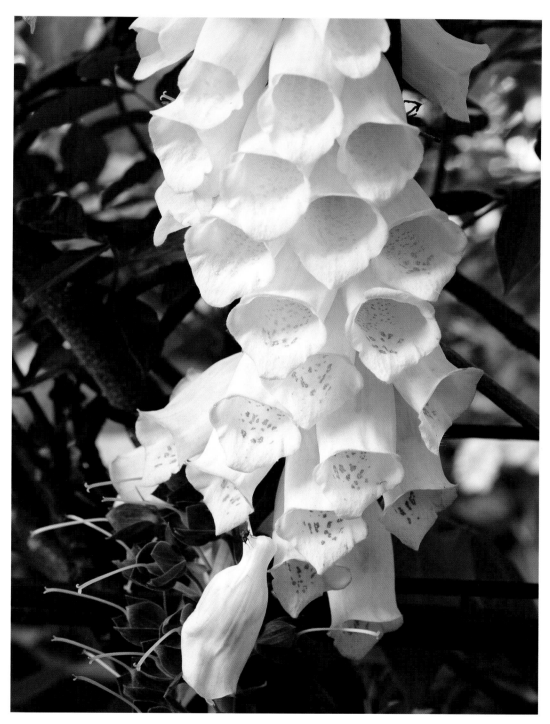

Foxglove.

◄ A babbling
fountain spills
into a koi
pond stocked
with 75 fish.

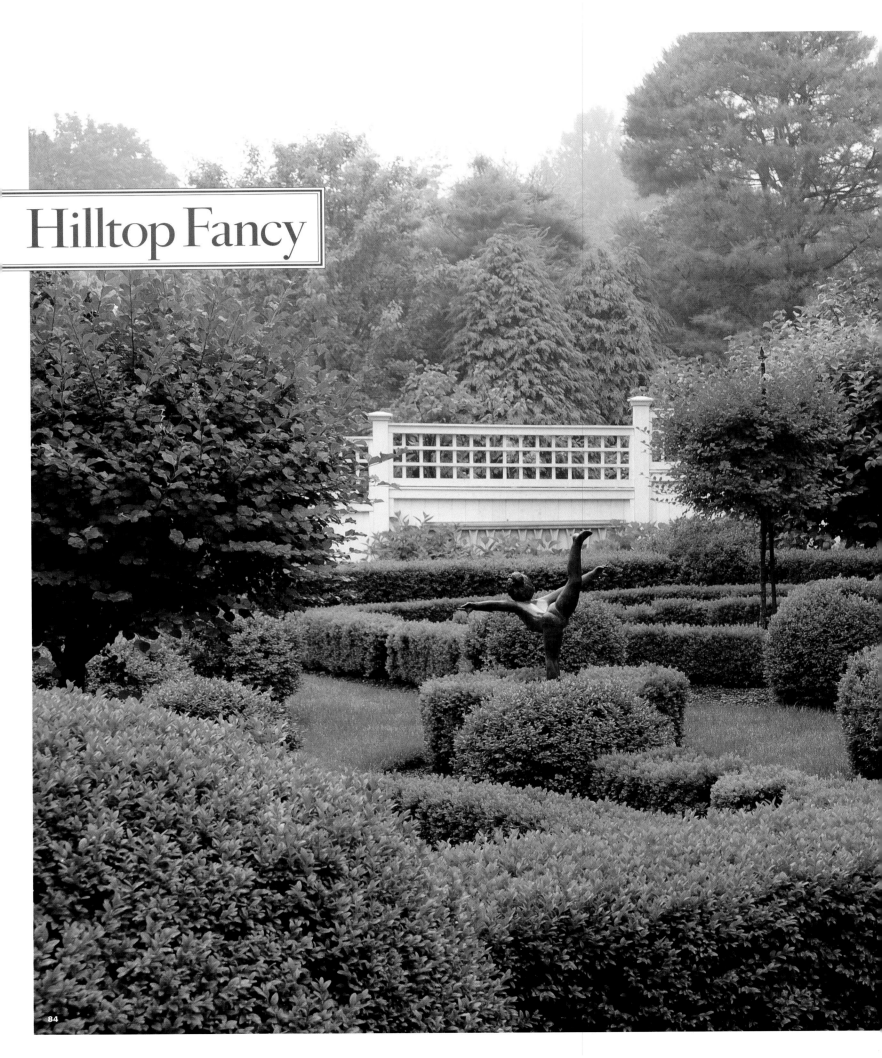

Hilltop Fancy

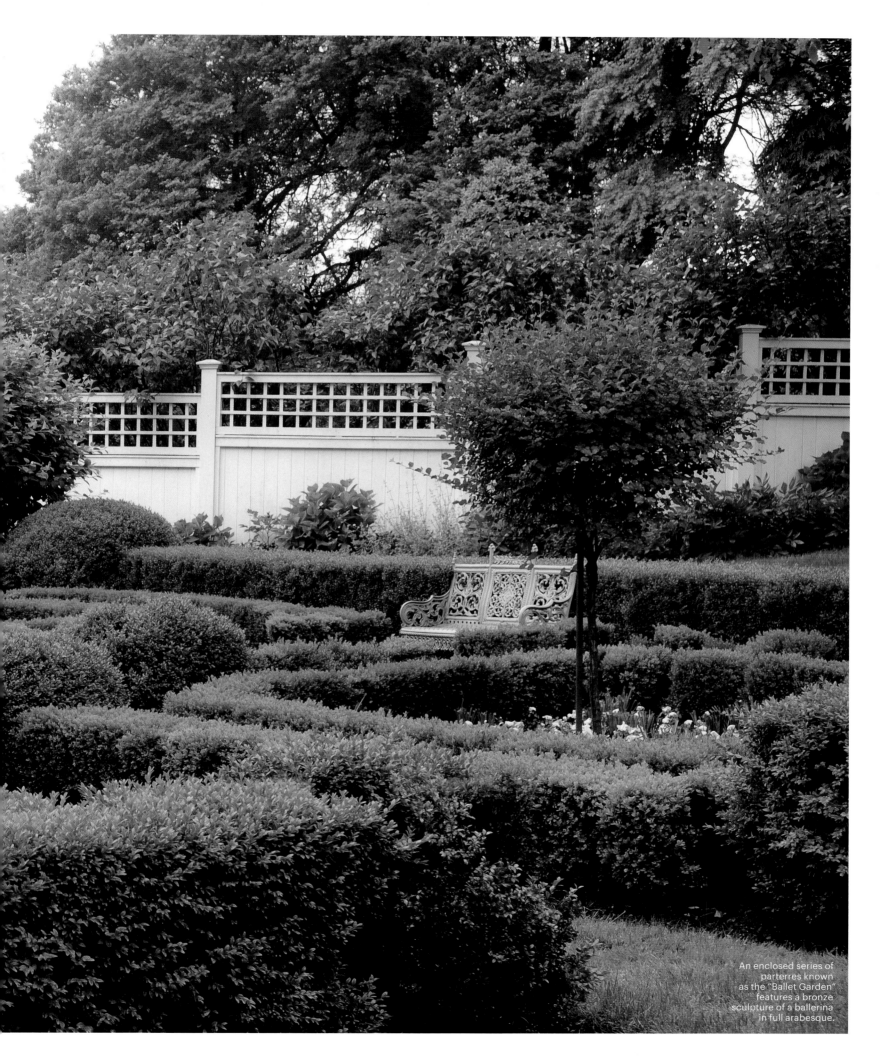

An enclosed series of parterres known as the "Ballet Garden" features a bronze sculpture of a ballerina in full arabesque.

YOU KNOW you've stumbled upon a little slice of heaven when an unobstructed view of Long Island Sound fails to distract you from the splendor right at your feet. Such is the case on the rolling six acres that surround Candy and Bill Raveis's home on the highest point of Fairfield's Greenfield Hill. Everywhere you look there's another cover shot that's better than the last—wispy clouds in a blue sky that seems bigger than before you got here, grass that seems greener, roses that are more fragrant.

Candy, a devoted grandmother, interior decorator, and studious collector of antique birdcages, fine French furniture, and bouncy Yorkshire terriers, says that in designing her gardens she found herself influenced predominantly by the French and English ones she visited in her travels. She also saw an opportunity to indulge her playful side. And indulge it she did. Scattered around the property are whimsical topiaries she shaped with her own hedge clippers—an elephant, a teddy bear tea party, a canopied bed of roses fit for a rabbit—as well as sculptures and ornaments that hint at their owner's winking sense of fun and folly. Chauncey, the eight-foot cast-bronze rabbit that resides in "Mr. McGregor's Garden," would be one.

Her inner gardens, the ones closest to the house, possess a formality that derives from their grounding in bluestone, some of it crisscrossed with seams of grass, and from elaborate parterres of English dwarf boxwood. There's the tranquil space she calls the "Yoga Room," which features a sitting Buddha in a courtyard lined in lavender; "Lily's Terrace," which was named for the Yorkie she lost; and the space known as the "Ballet Garden," which centers on a bronze sculpture of a dancer in full arabesque.

Other delights include a French gazebo smothered in white and pink roses, a slim-lined wrought-iron pergola topped with a tangle of wisteria, an antique birdhouse cast in concrete and made in Norway, and iron benches patiently awaiting a contemplative soul.

Formality dissipates as one moves down the hill away from the house and encounters one of the property's more breathtaking focal points: from a gateway of stone steps covered in grass, one takes in the full beauty of the space, a cascading lawn dotted with the knotty trees of an old apple orchard, 60 in all.

The fact that all this magic is hidden away behind a long private drive makes it that much more magnificent: a stunning surprise for the visitor who perseveres and follows the map.

Just as Candy would have planned it. ■

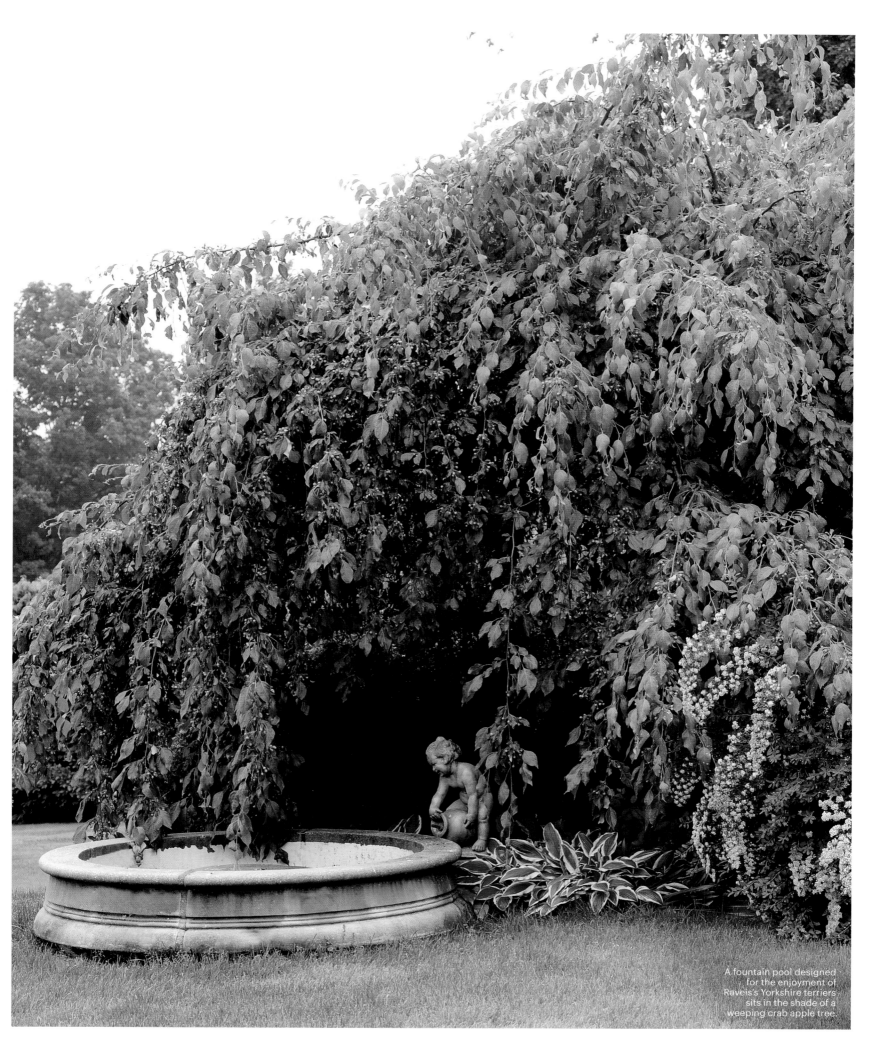

A fountain pool designed for the enjoyment of Raveis's Yorkshire terriers sits in the shade of a weeping crab apple tree.

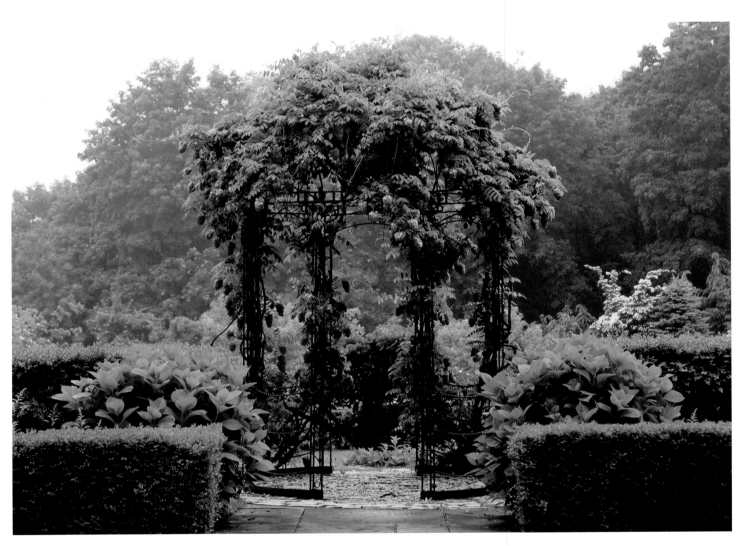

A wrought-iron
gazebo topped with
a tangle of wisteria.

Wisteria.　▶

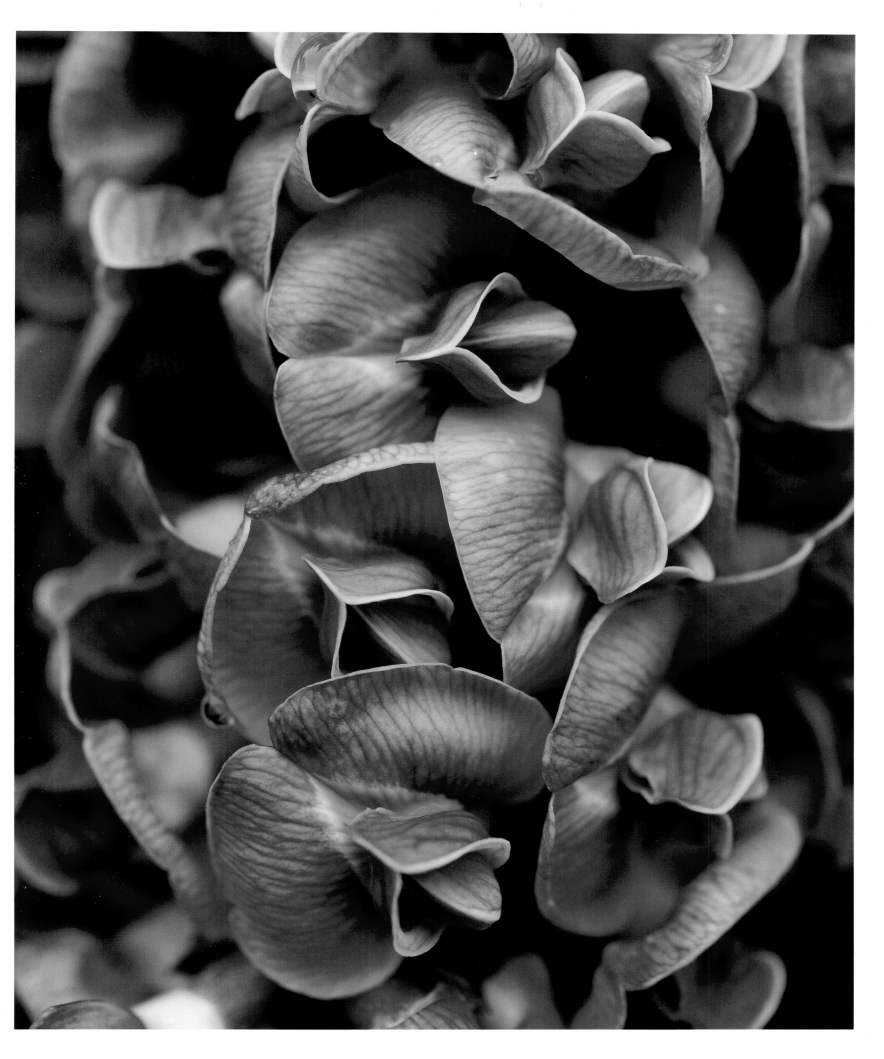

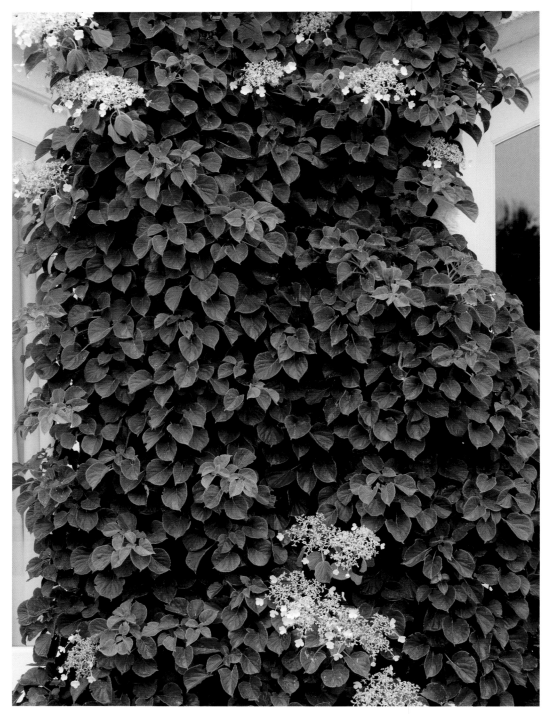

A hydrangea vine.

A sitting Buddha ▶
presides over
the "Yoga
Room," ringed
in lavender.

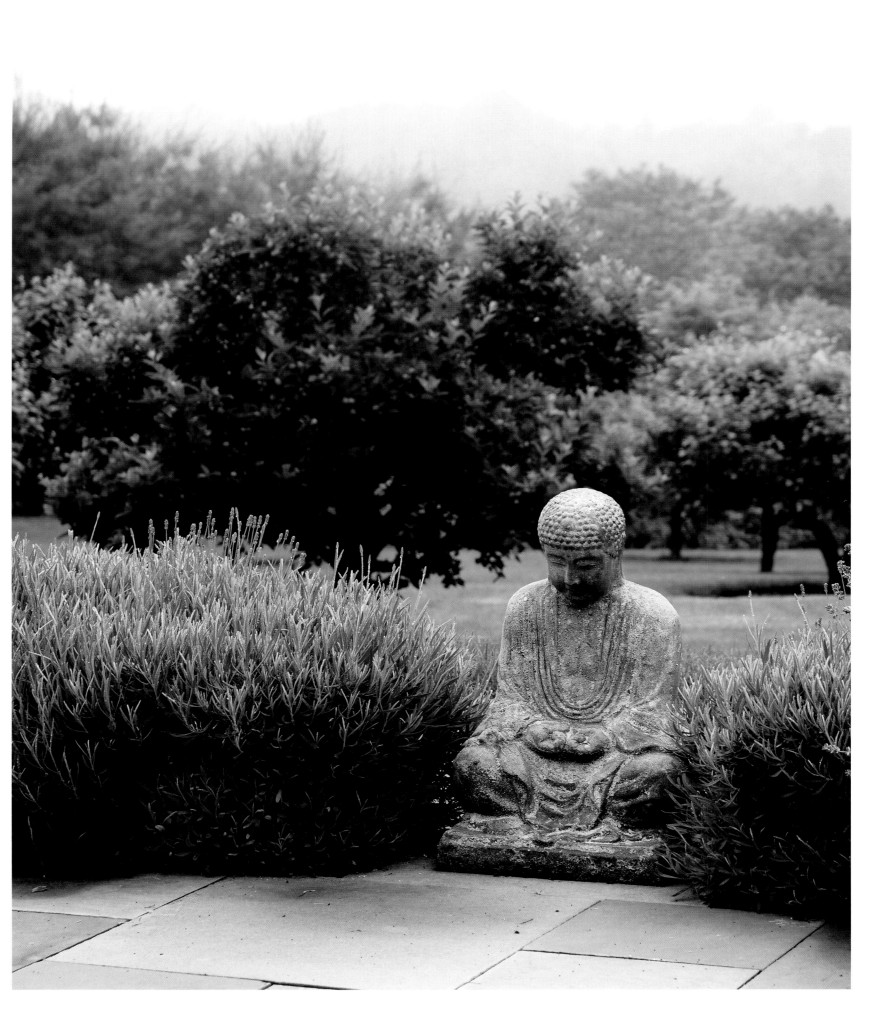

Japanese maple.

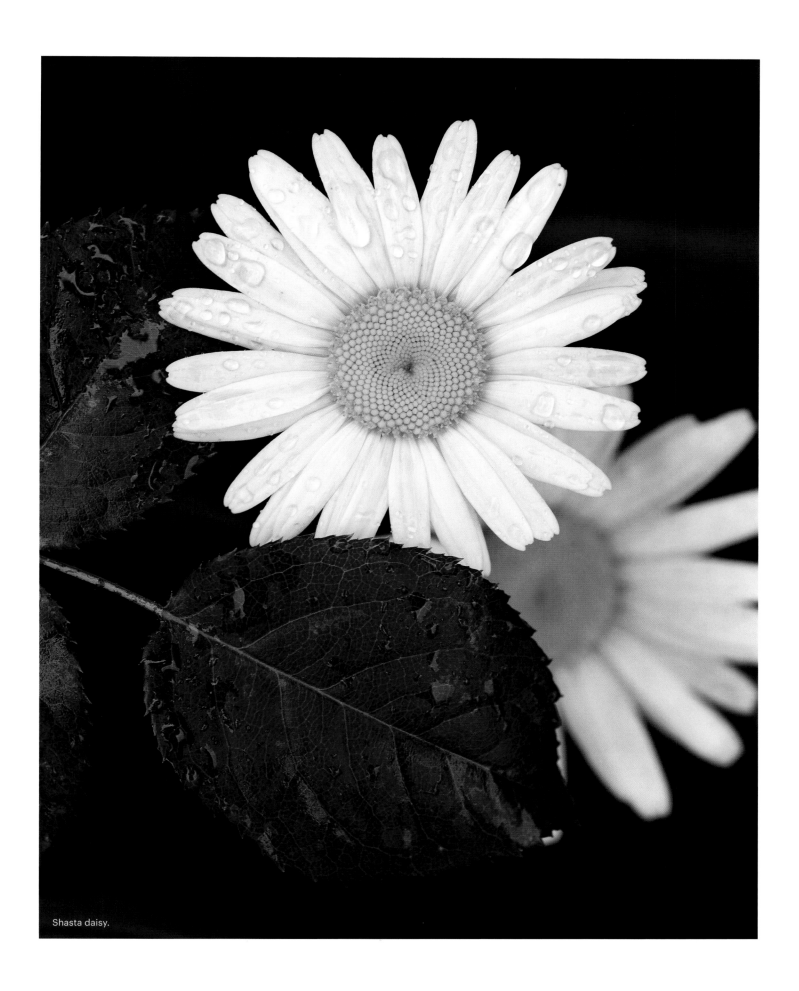

Shasta daisy.

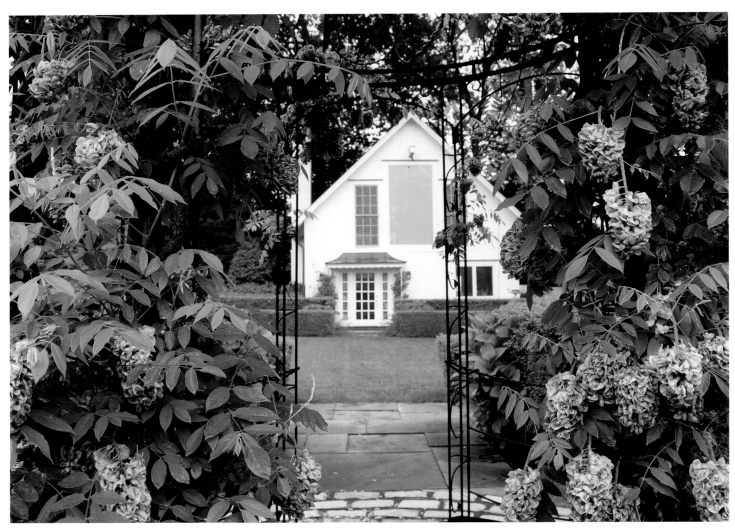

A gazebo frames
the view.

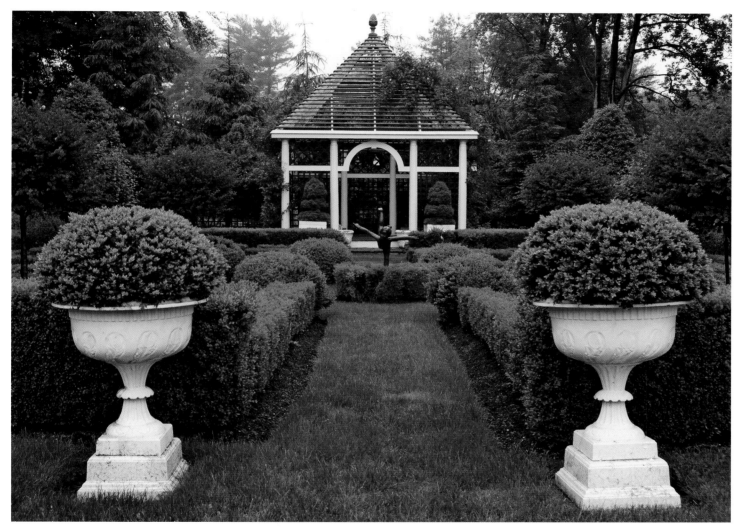

A pair of planters
marks a path
between parterres.

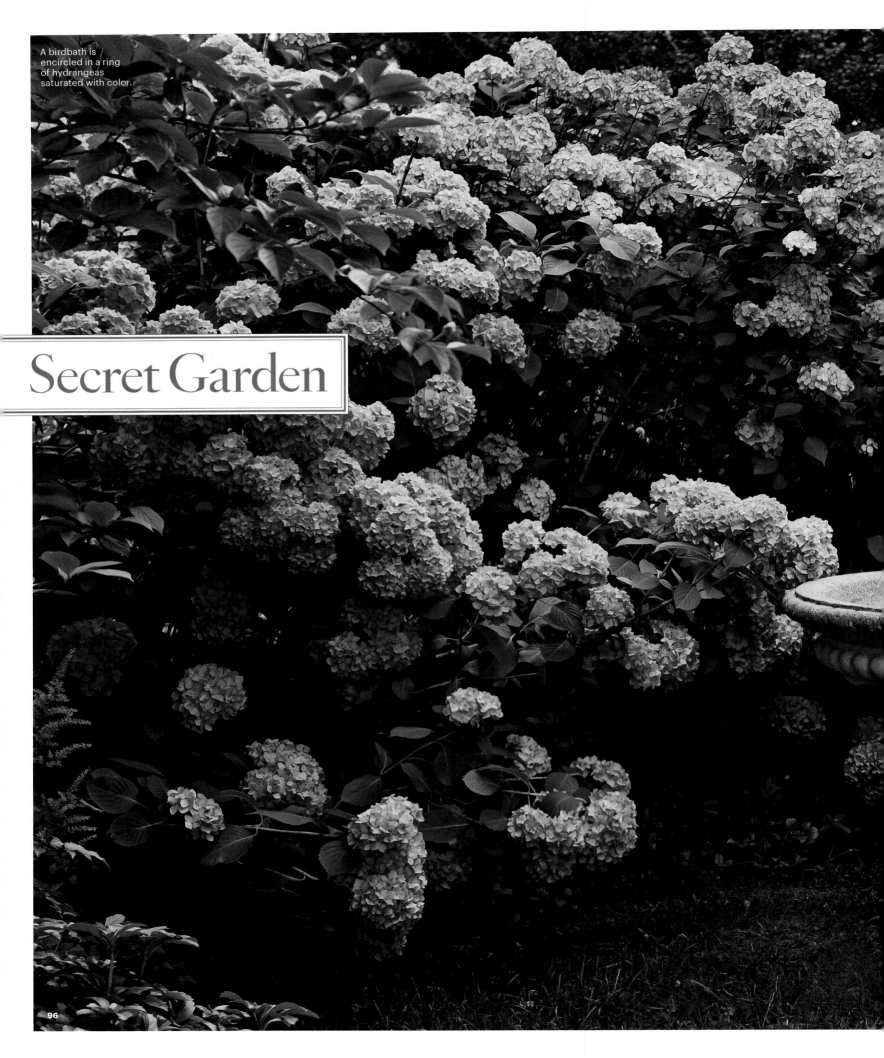

A birdbath is encircled in a ring of hydrangeas saturated with color.

Secret Garden

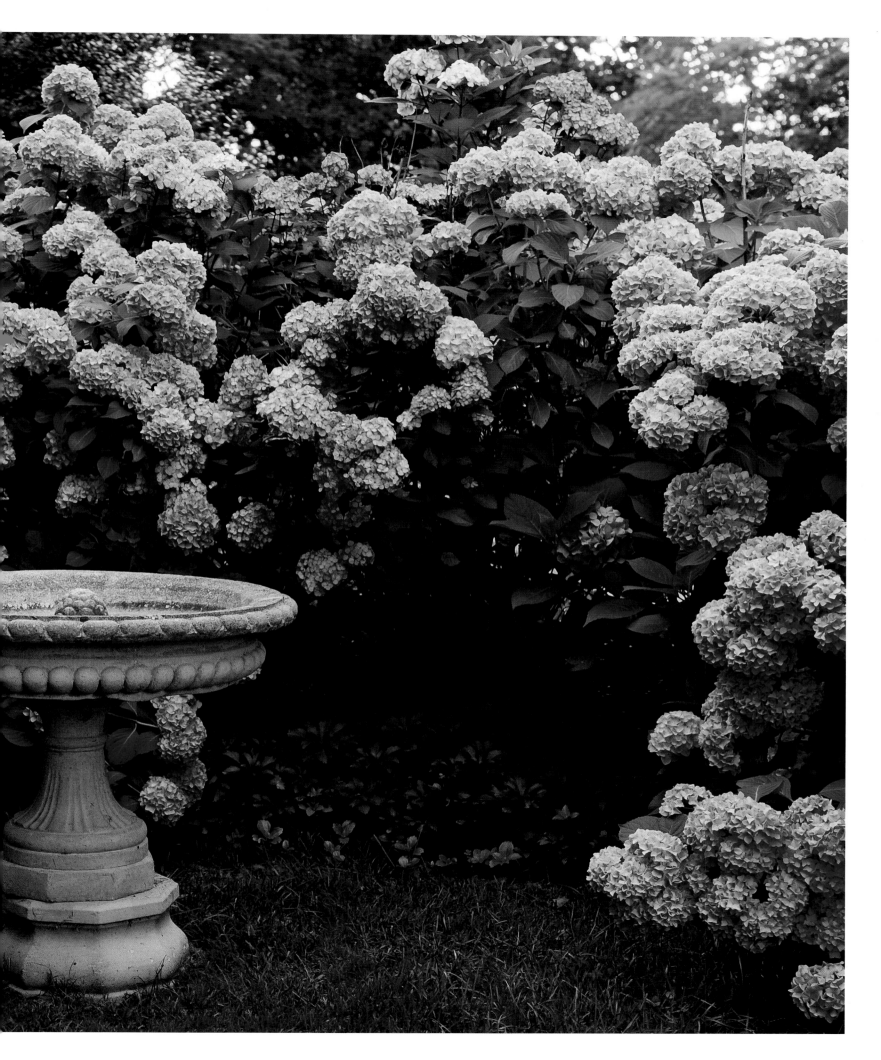

FROM OUT FRONT you wouldn't know what verdant pleasures lie behind the Greenfield Hill home Dawn Kreitler once owned. Across the street from a Revolutionary War–era cemetery with headstones softened by time, the expanded 19th-century farmhouse gives no hint of anything other than an ordinary lawn and an ancient tree or two. But when you wander around back, a hidden garden is yours to savor.

The property wasn't always this way. When Kreitler moved in, it was in disarray, overgrown with untended boxwoods, leggy rhododendrons, and hemlocks gone awry. But Kreitler, a skilled editor with a vision for how her land could look, embarked on a dramatic transformation, clearing brush, pruning healthy trees and removing dead ones, and making some of her home's existing amenities more accessible.

Among her improvements was the rock-edged bluestone deck, with steps and a stone wall, she added to one of the property's best-kept secrets: a keyhole-shaped pool sunk into the ground and enclosed in a towering hedge of arborvitae and hemlock.

Moved perhaps by an innate longing for alignment, Kreitler marked the drama of the vista with an elliptical stone terrace, its pavers stitched together by grass, which lines up with the pool but appears to float above it. The terrace is centered on a stone fountain that glistens in the sun and is bordered by boxwood topiaries and thick beds of pachysandra. The entire composition is accessible through matching white arbors entwined in new dawn roses that serve as gateways to this precious idyll.

Kreitler's artful hand is apparent in subtle juxtapositions of natural elements and man-made forms. A gleaming granite orb tops a column rooted in a cluster of Annabelle hydrangeas and flanked by a pair of mounded ilex; a rustic wooden birdhouse stands beside a flowering butterfly bush; a birdbath is ringed in a skirt of hydrangeas saturated with color.

Kreitler planted her perennial border with variety—coreopsis moonbeam, autumn sedum, buckets of pink peonies, fall-blooming anemone, nepeta—and fixed an espaliered apple tree to the side of her barn.

As you follow the footpath away from the house, past the fenced-in vegetable garden where she corralled her kids for safekeeping while she picked her tomatoes, peppers, string beans, and basil, and past the root cellar buried in the mound, the big lawn recedes into the wild, shaded by a canopy of sugar maples nearly as old as the soldiers across the street. ∎

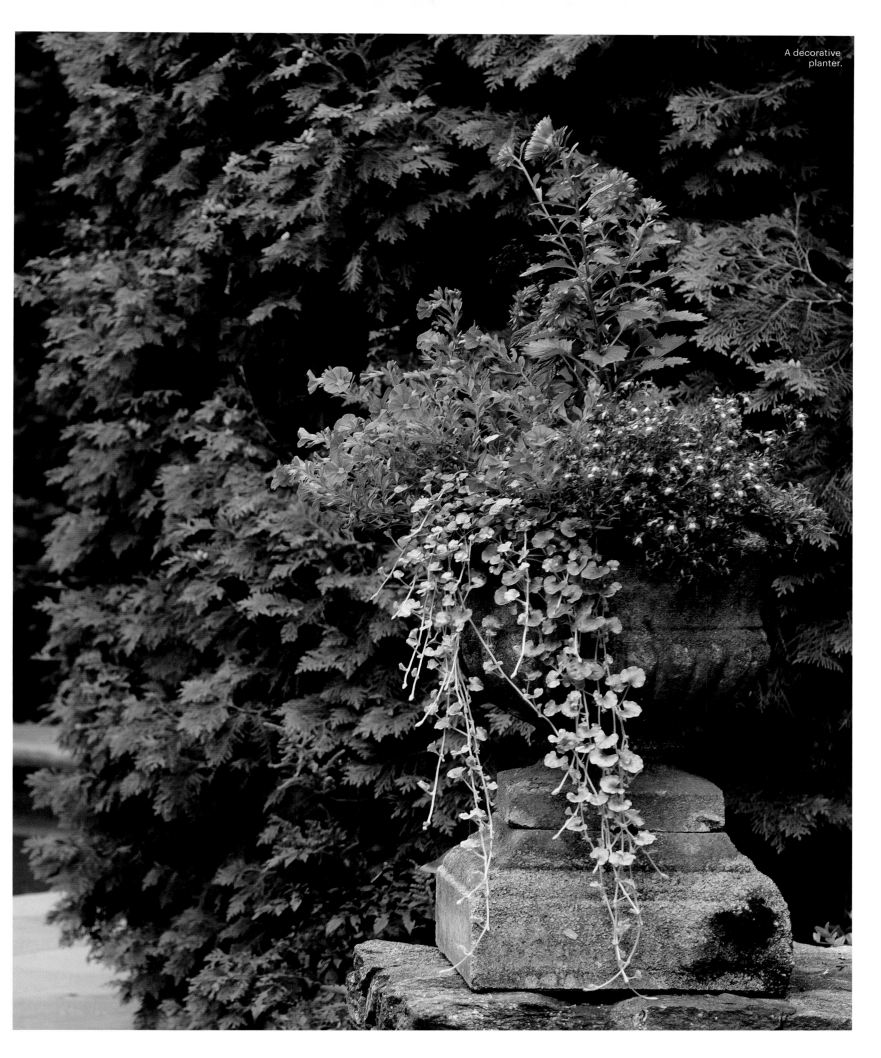

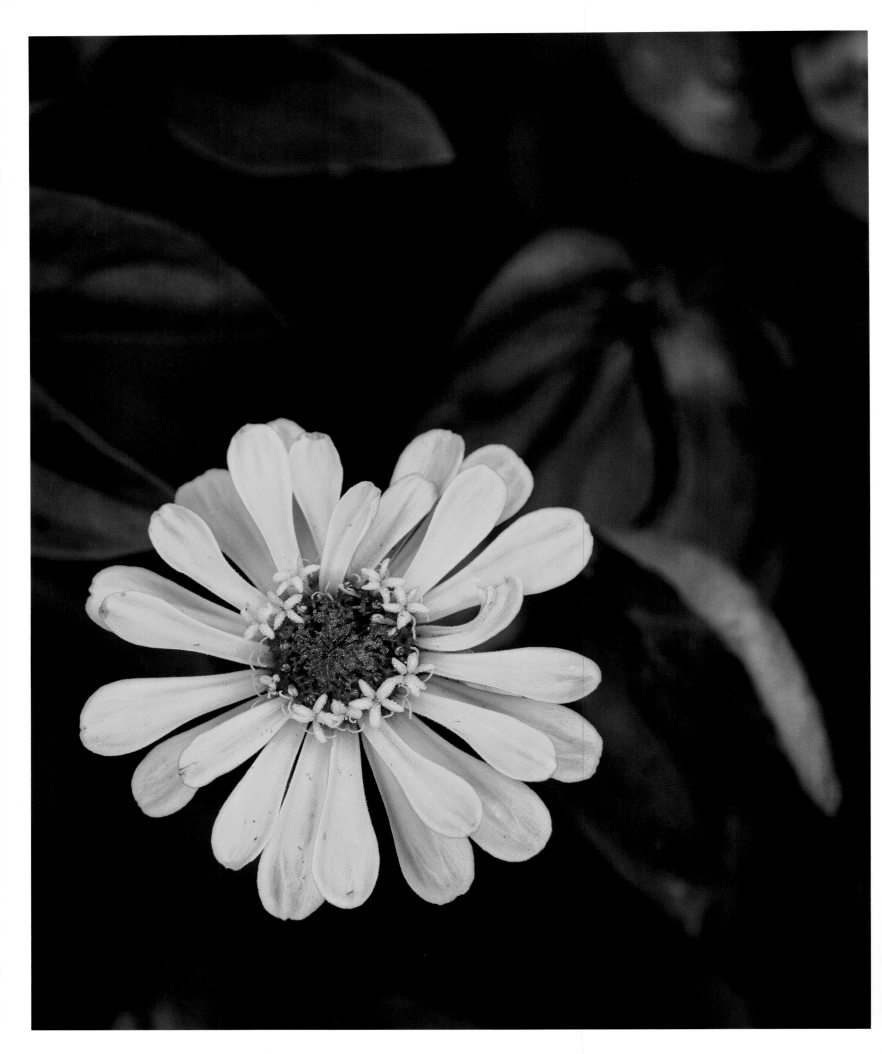

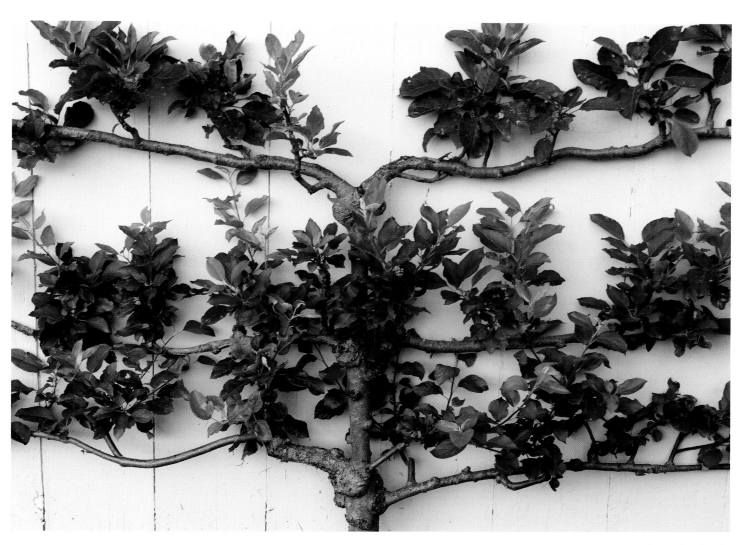

An espaliered apple
tree features two
varieties of apples.

◄ A zinnia.

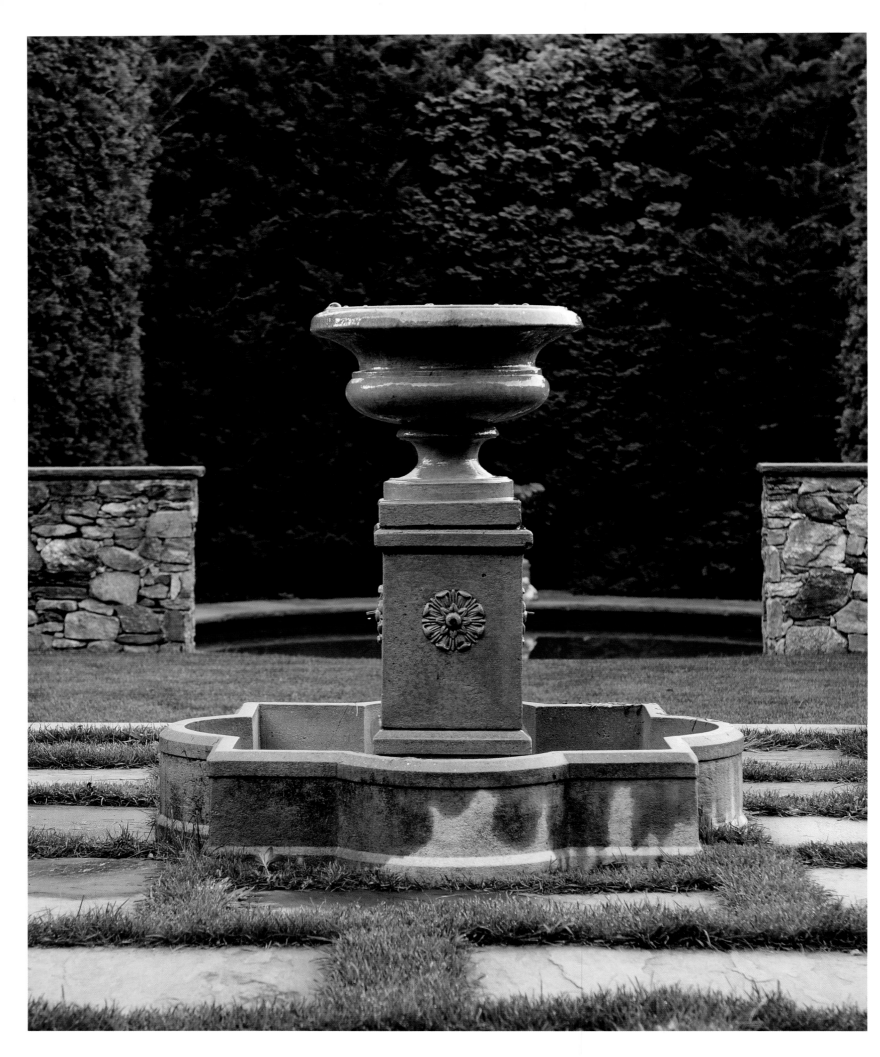

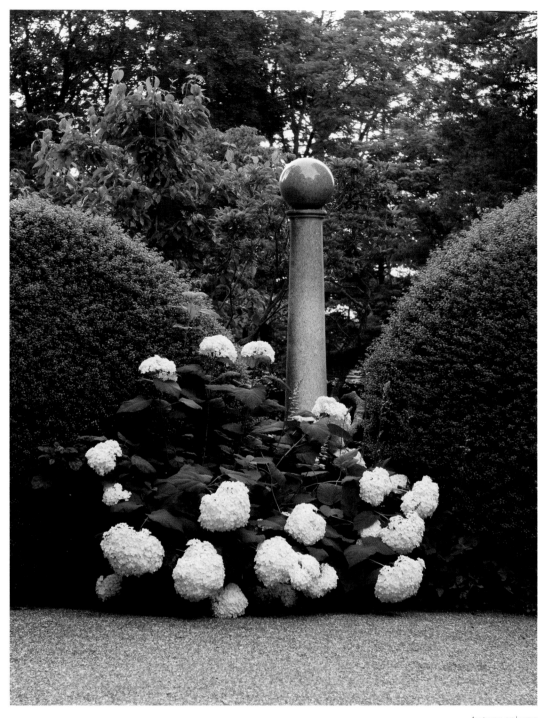

A stone column topped by an orb echoes the rounded forms of two shrubs.

◄ A stone fountain sits in an elliptical courtyard. The pavers are stitched together with grass.

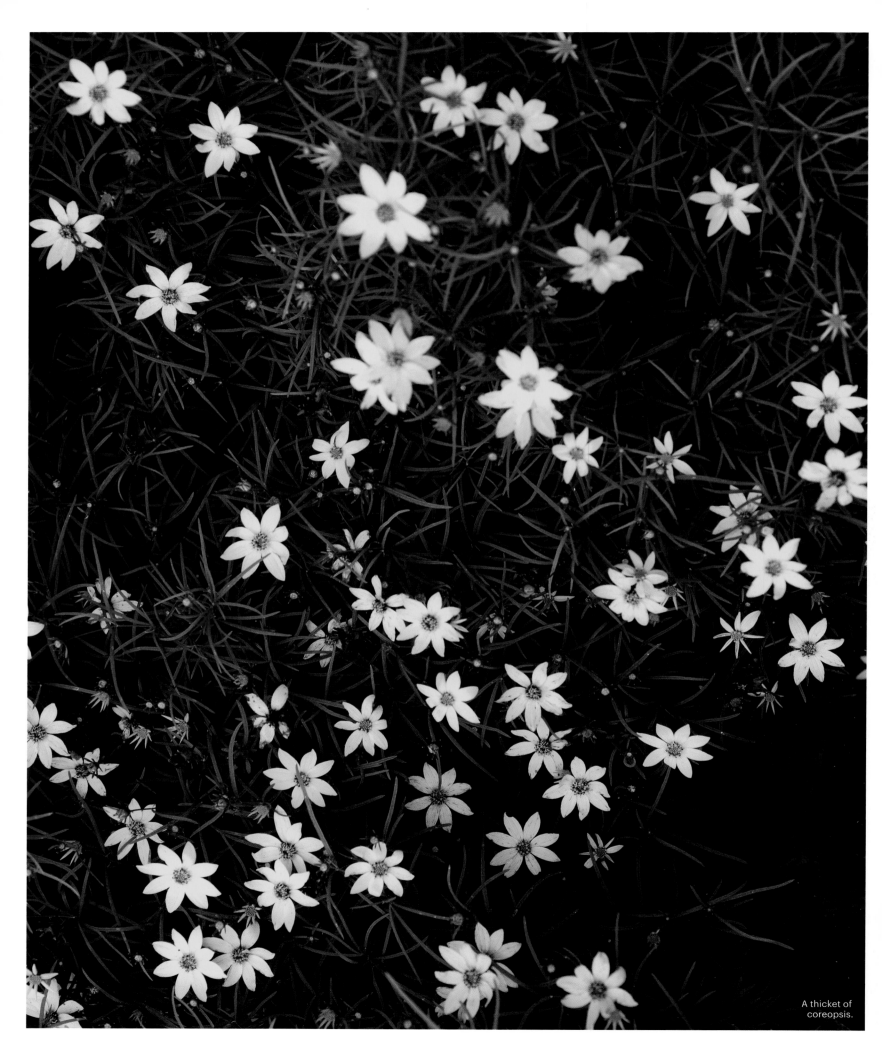

A thicket of
coreopsis.

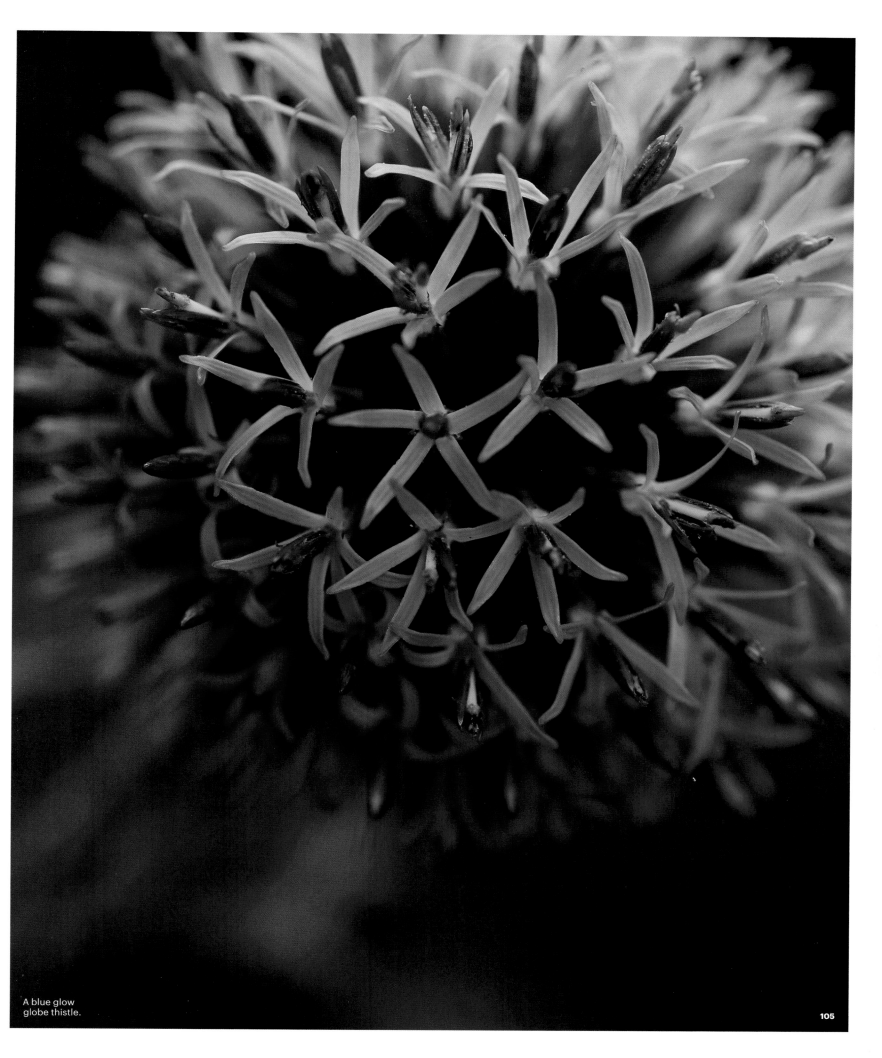

A blue glow globe thistle.

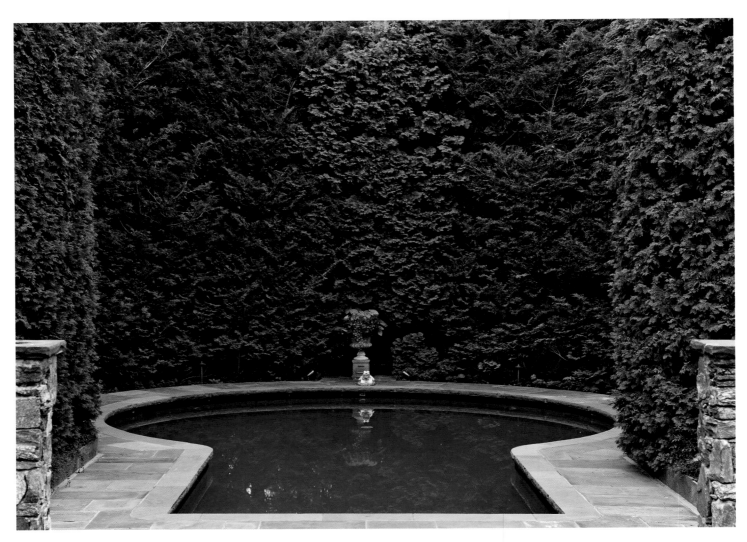

A secret keyhole-
shaped pool is enclosed
in a towering hedge of
arborvitae and hemlock.

Hens and chickens. ▸

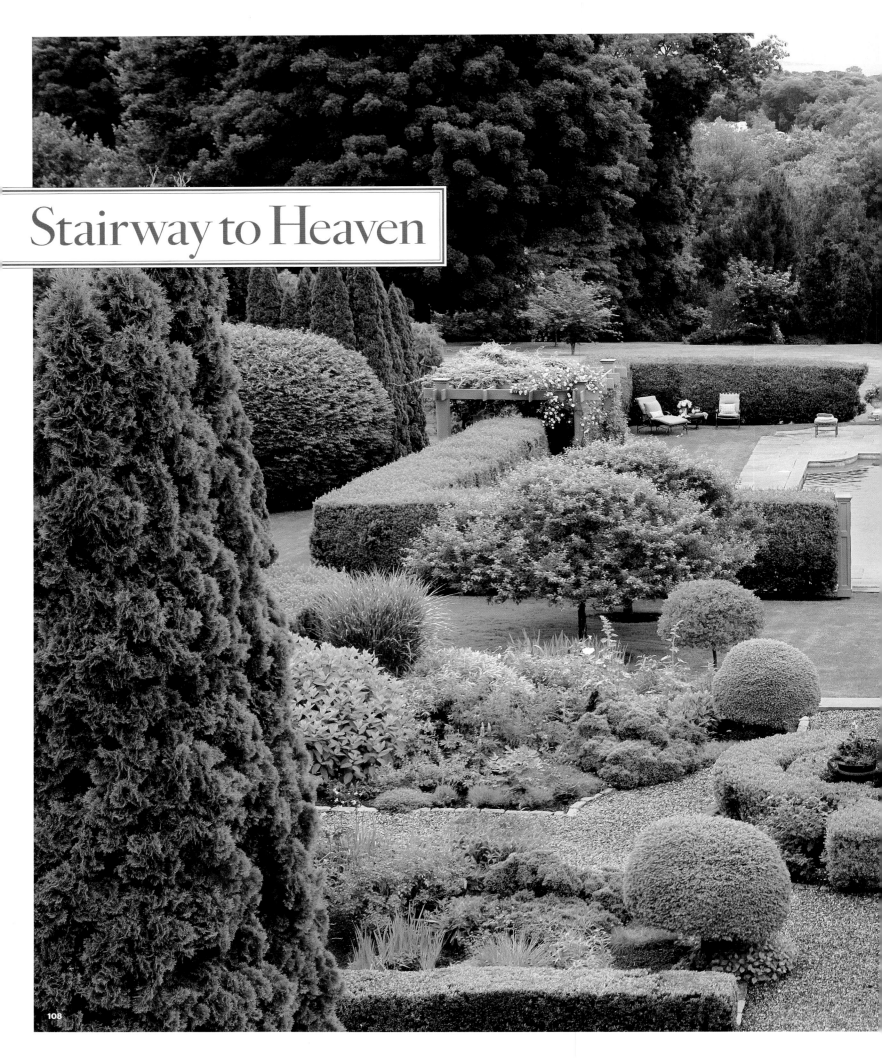

Stairway to Heaven

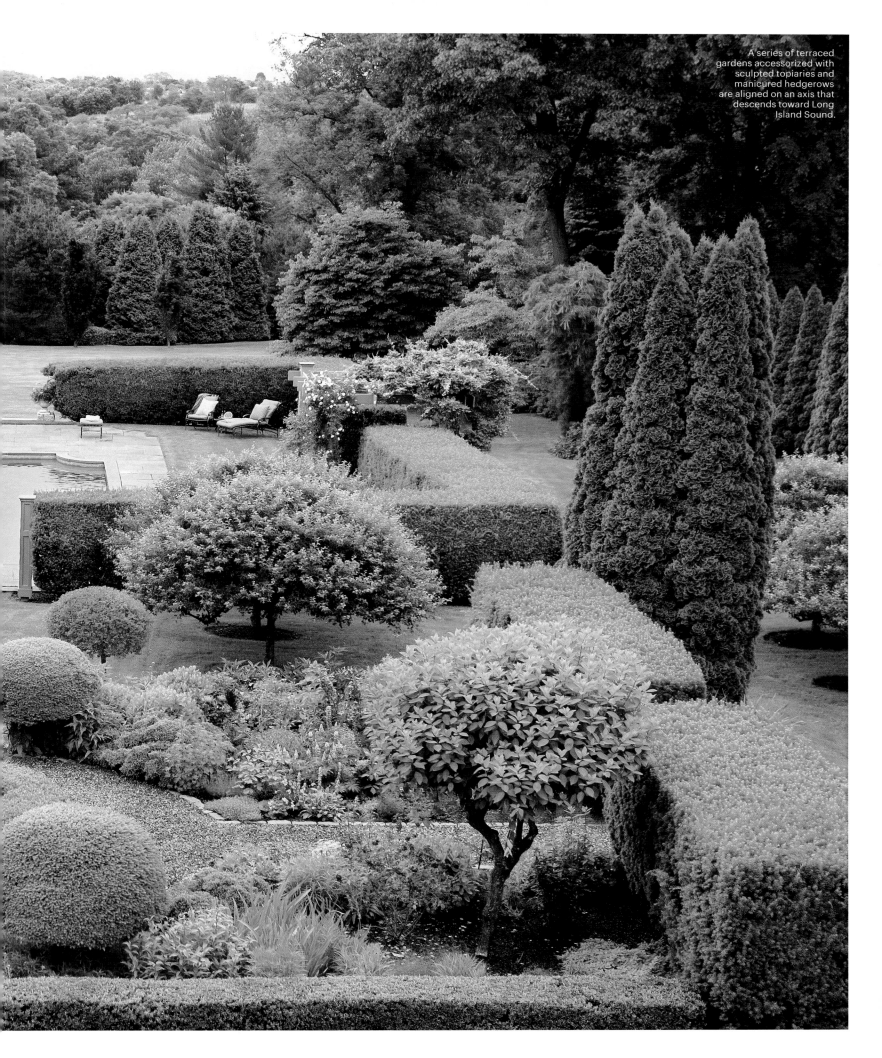

A series of terraced gardens accessorized with sculpted topiaries and manicured hedgerows are aligned on an axis that descends toward Long Island Sound.

THERE ARE GARDENS and then there are gardens. Open-air theaters that promise to transport you to another place. Susan Sosin owns one of those gardens. Hidden on Southport's Sasco Hill behind a house that denies it's even there, it is a lofty procession of grand terraces that gradually descend toward Long Island Sound; a five-acre study in symmetry that blurs the boundary between earthly pleasures and celestial bliss.

Constructed over the course of two decades by the couple from whom Sosin bought the property in 2005, and devoutly tended to for years by arborist-gardener Russ Janisch, each garden level possesses its own aesthetic, relying on a horticultural magician's bag of tricks—specimen trees, shapely topiaries, and manicured hedgerows—to tease the eye, all the while demonstrating that with enough patience and a good pair of pruning shears, man truly can conquer nature.

On the terrace nearest the house is a jewel of a space: four quadrants of perennials—peonies, lupines, PeeGee hydrangeas, sedum, echinacea, dahlias, astilbe—each punctuated with its own dwarf lilac topiary trimmed to evoke a mushroom cap. The quadrants center on an interlocked spiral of boxwood anchored by an urn planted with knockout roses, sweet potato vine, and annuals that swap out every year. Just below is a lawn decorated with eight slender-trunked Sargentina crab apple trees that serves as a transition—one needs to pause in a place like this—to yet another level where a seven-foot precision-cut hedgerow of Hatfield yews frames a rectangular pool. There, pergolas draped in lavender wisteria and climbing pink roses provide a splash of color.

Flanking the central garden axis are allees formed by emerald green arborvitae hedgerows planted in a serpentine manner—more than 150 trees in all—that at 20 feet high truly soar toward the sky. Inspired by those at Thomas Jefferson's Monticello, these exquisite spaces are carpeted in a lawn that stifles all sound as it wanders down to an open meadow planted, on its edges, with weeping white pines, red twig dogwoods, spirea, and forsythia. Elsewhere on the property are English oaks, ilex hoogendorn, and specimen trees, including a tricolor beech whose purple leaves feature green and pink markings, and a golden rain tree whose seed pods resemble illuminated Chinese lanterns.

Sosin, who built a balcony in order to savor the view, says she considers herself a deeply appreciative caretaker who marvels at the forms rendered in foliage rather than in stone. Gatekeeper to another world is more like it. ∎

Delphinium.

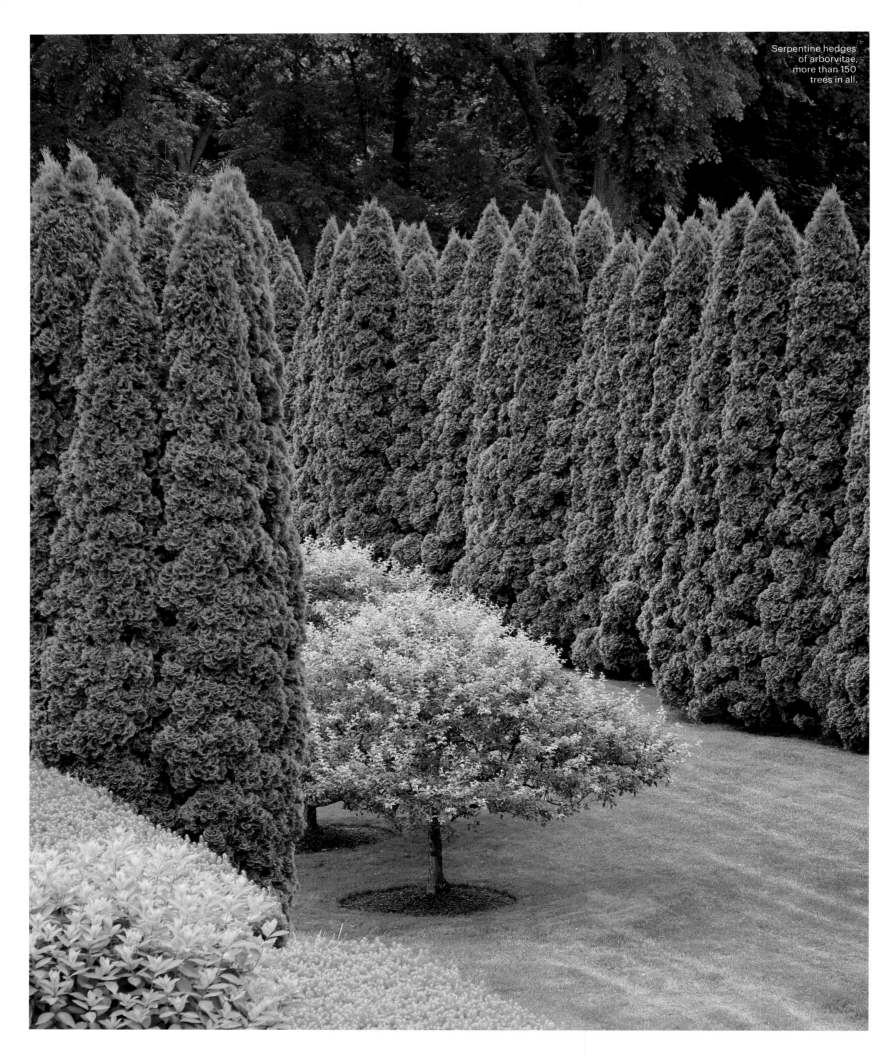

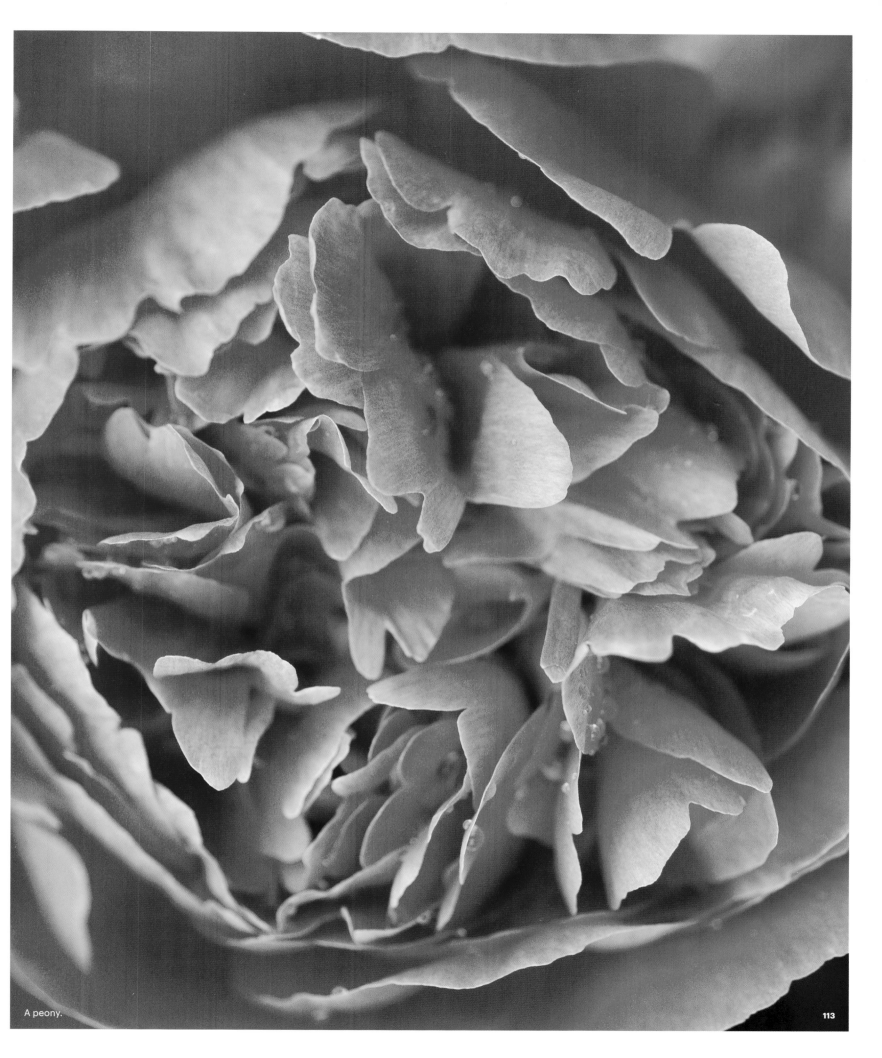

A peony.

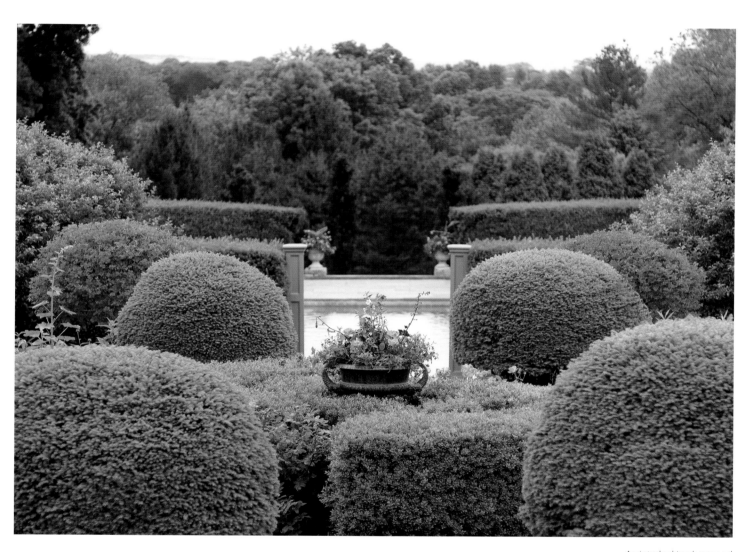

An interlocking boxwood
parterre is framed
by dwarf lilac topiaries.

◄ Lantana.

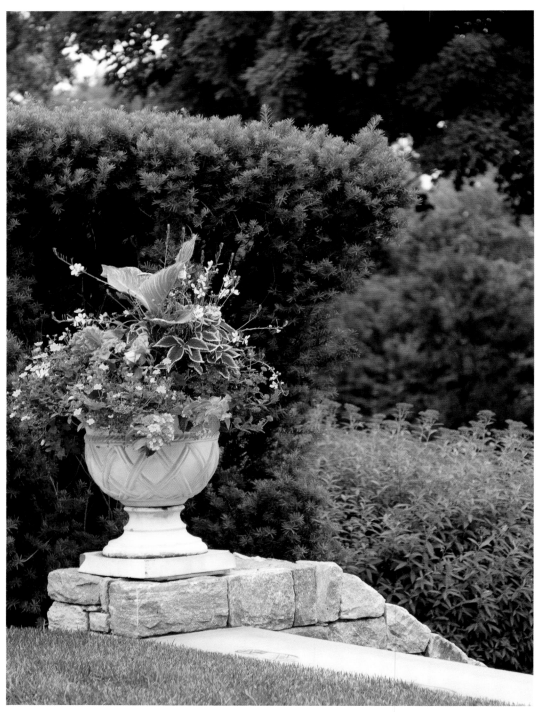

A planter marks
the descent to the
lower meadow.

Dahlia. ▶

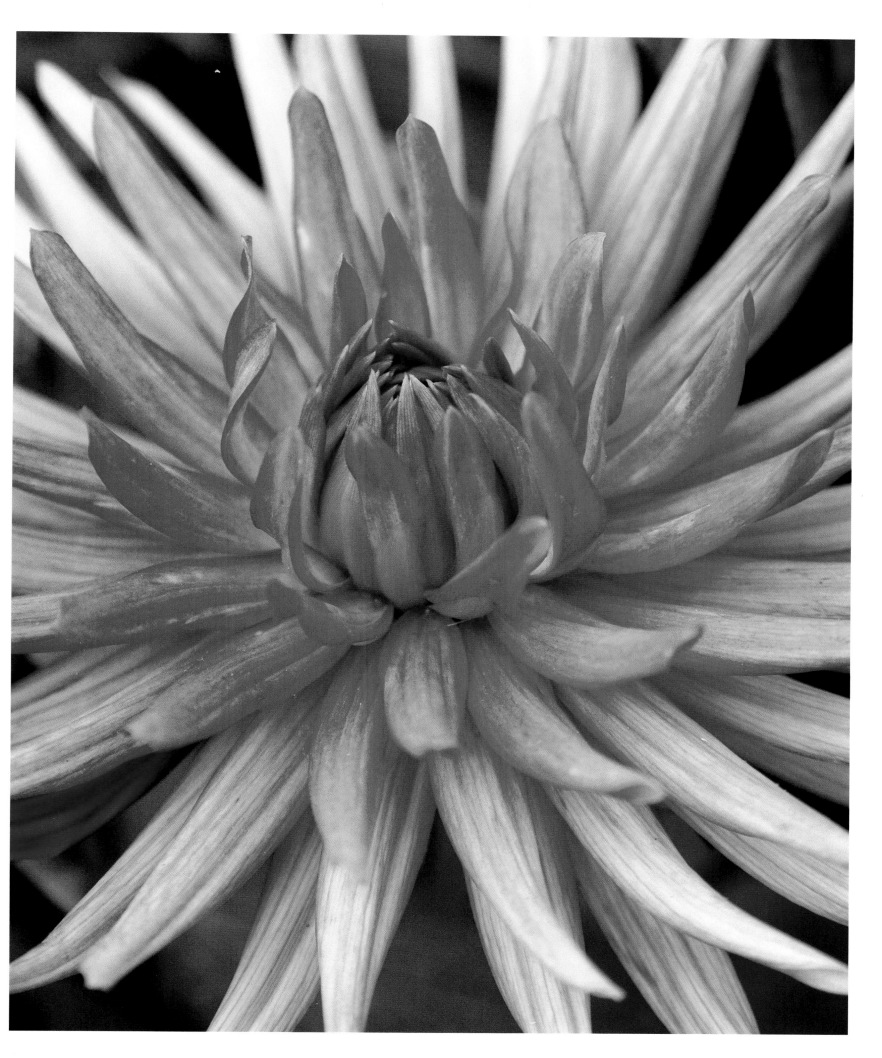

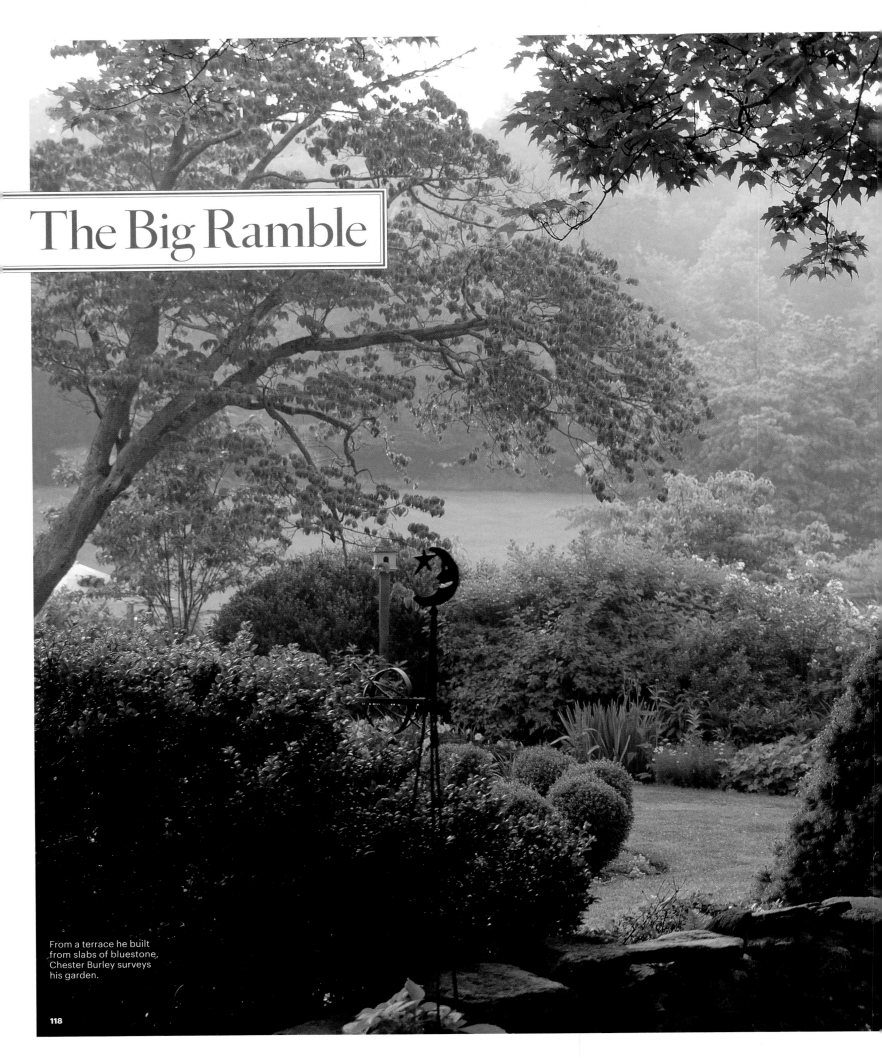

The Big Ramble

From a terrace he built from slabs of bluestone, Chester Burley surveys his garden.

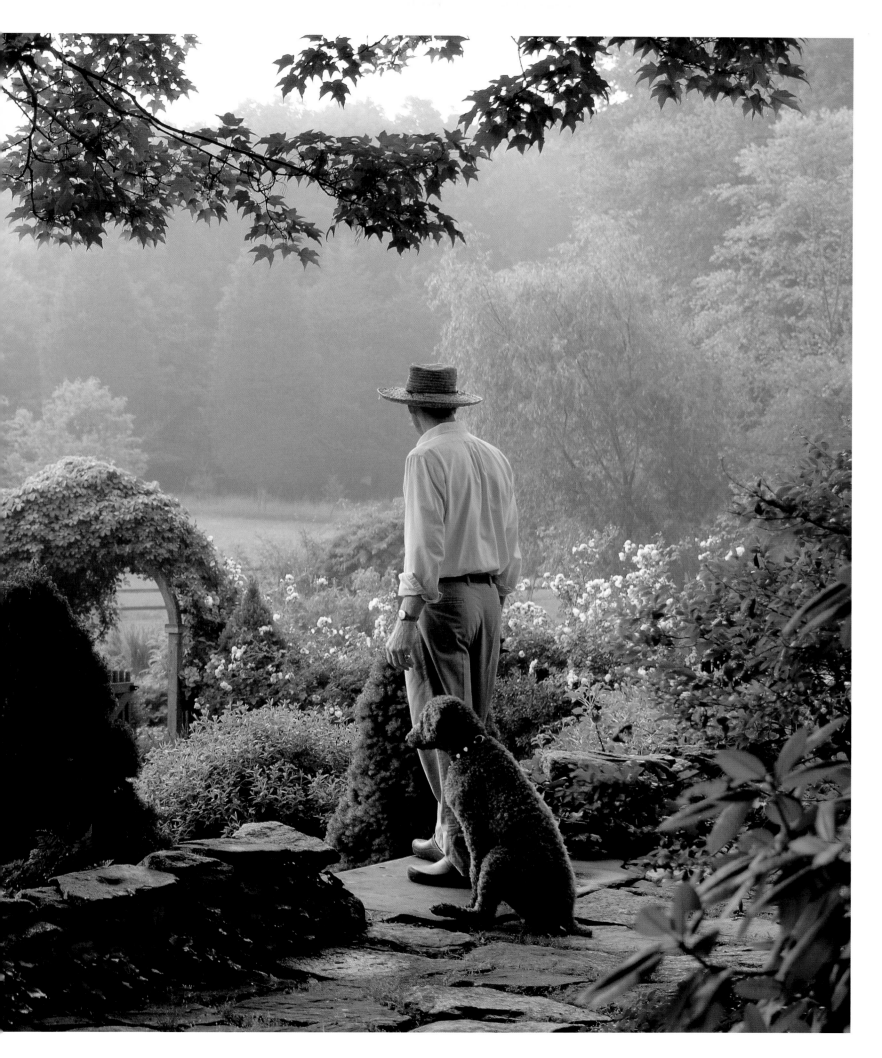

O N A WET and wooded stretch in Greenfield Hill, Chester Burley has made peace with nature, evoking the rambling romance of a classical English garden, equal parts wild and formal. Like an architect designing a home with distinctly public and private spaces, Burley, who insists he had no plan, constructed a series of outer and inner "rooms" that, from the property's distant perimeter on an adjacent preserve, grow increasingly defined and structured without losing the essential quality of a thorny thicket.

The loosely sculpted three-acre property—which the gardener describes as his "hobby"—was a labor of love that endured for 13 years and strictly eschewed chemical pesticides and fertilizers. The project withstood at least one flood and one drought, and involved hauling trees with cars and ropes, transplanting shrubs, hosting weeding parties for friends fueled by copious quantities of wine, and, summoning his inner Inca, using steel bars and rollers to heave slabs of bluestone seven inches thick to build a terrace for viewing his masterpiece.

From that terrace, the eye travels from the woods in the distance over alternating bands of foliage and grasses that include a high meadow that Burley mowed only twice a year, outgrowths of cattails, and an expansive, slightly more manicured lawn. Integrated into the panorama are naturalistic vignettes such as a narrow stream, its banks studded by river birches, a lone weeping willow, a majestic 40-year-old dogwood, a shade garden with delicate ferns, and a structured inner garden gated by an arbor of akebia and featuring soft shoulders of rhododendron and azalea and clipped forms like boxwood balls and conical Alberta spruce.

In his scheme, he incorporated a vegetable garden and a cutting garden, and stuck for the most part to a color palette that moves from pinks and purples in May to blues and yellows at the height of summer. He relied on interwoven leaf sizes, colors, and shapes—boxwood, rhododrendron, inkberry—to give the garden texture, while weathered fences, old stone walls, a dammed brook with its own island, a wooden footbridge, and a tree house he built himself emerge as subtle points of interest that, whether preexisting or added later, appear to have been part of this land for a very long time.

Looking back, Burley, who at his new home is now designing his fourth garden, says this one helped him "overcome the pain of learning." That pain was assuaged, he says, by the "tonic" of a creative pursuit—being able to look at what he'd done and appreciate the work that went into it. Time well spent. ∎

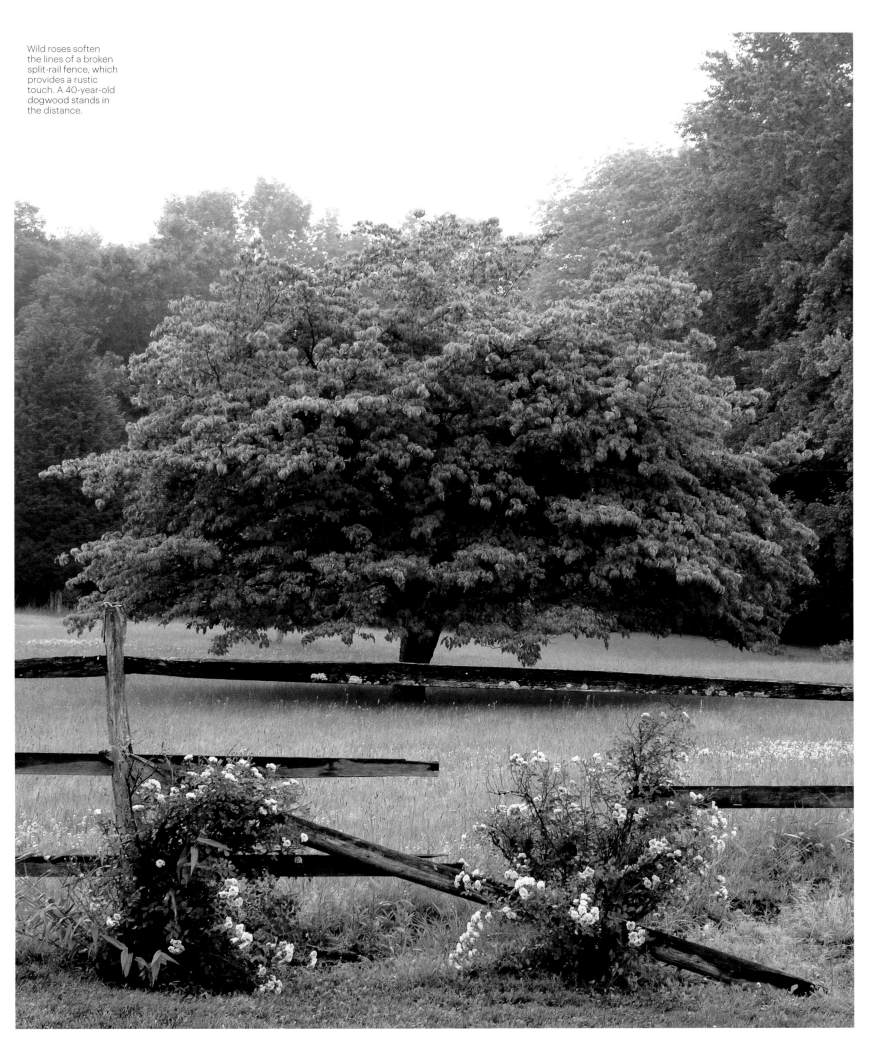

Wild roses soften the lines of a broken split-rail fence, which provides a rustic touch. A 40-year-old dogwood stands in the distance.

An arbor of
climbing akebia
provides exit
and entry to
Burley's inner
garden room.

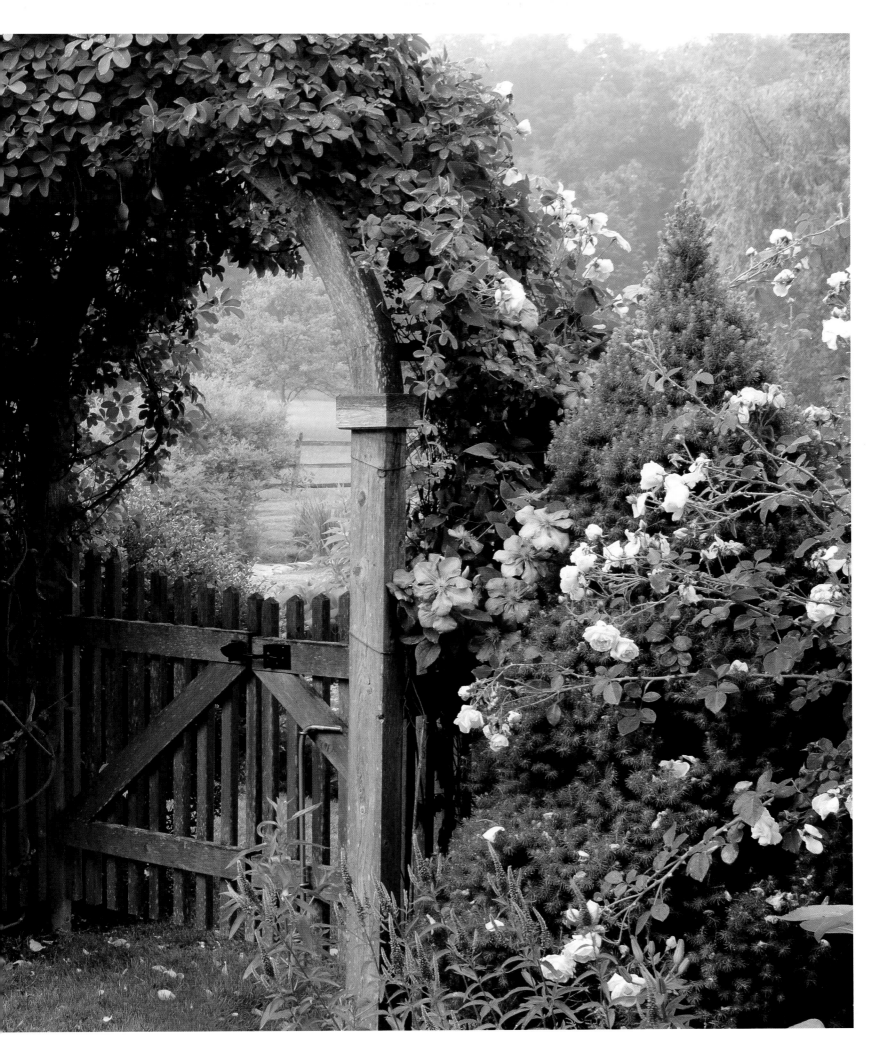

A spray of coreopsis.

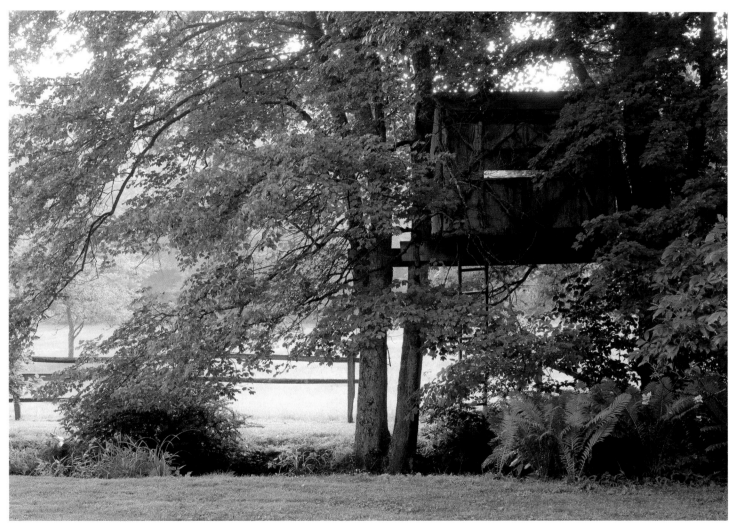

Burley built a tree
house above a stream
whose banks are
studded with river
birches. The tree
house serves as one
of the property's many
points of interest.

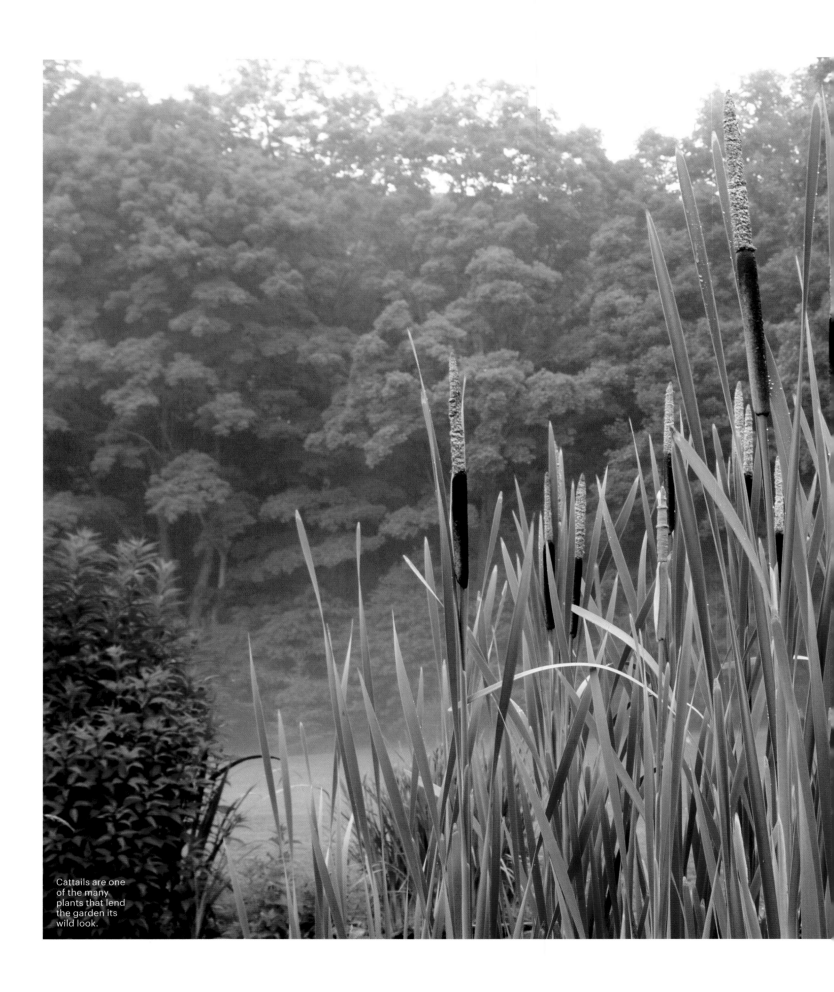

Cattails are one of the many plants that lend the garden its wild look.

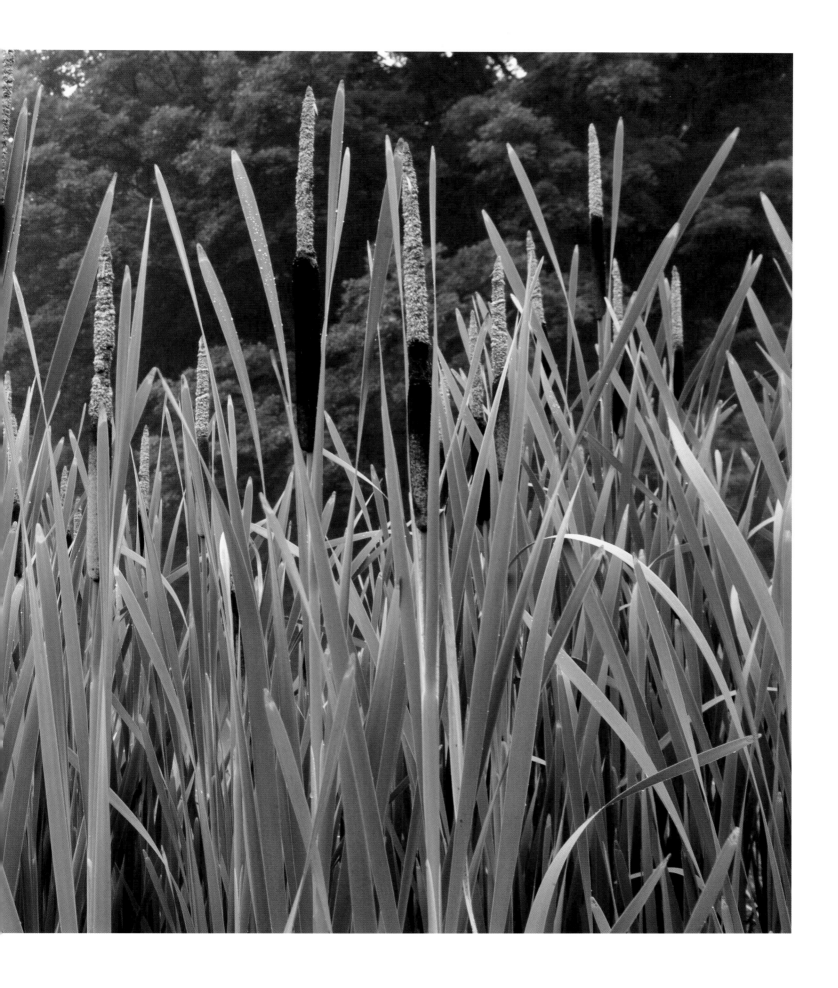

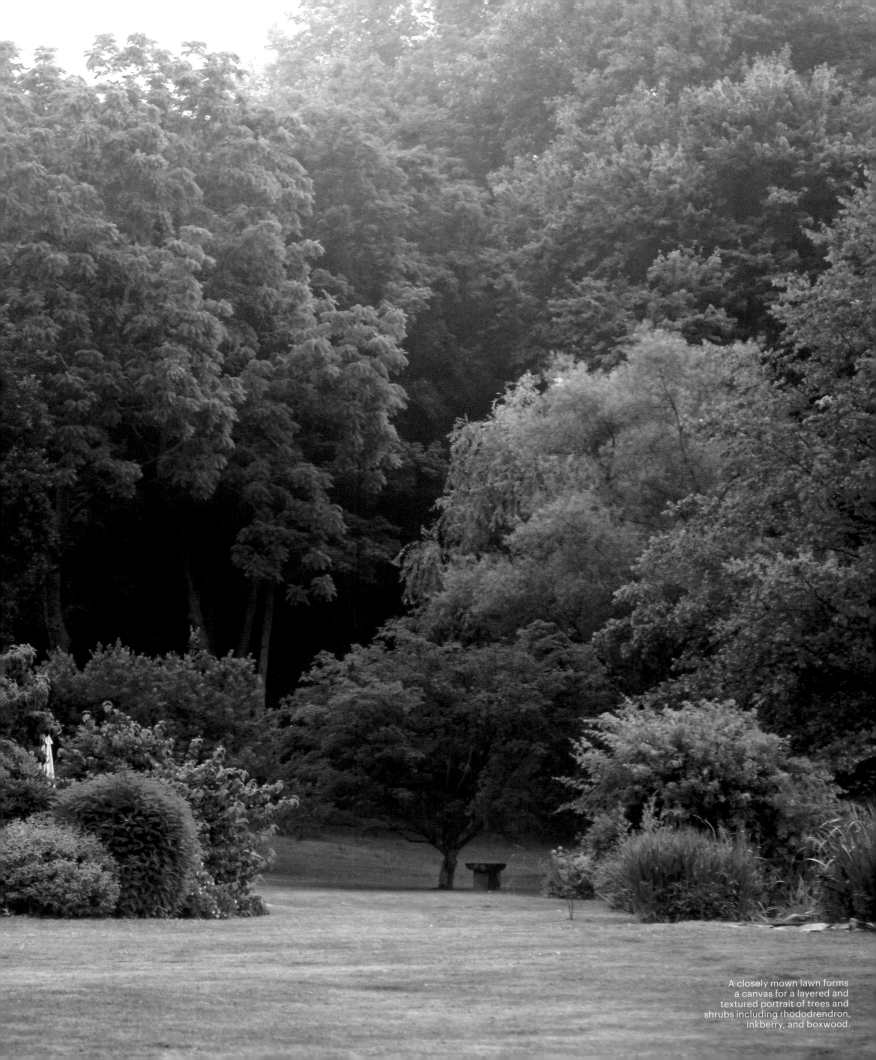

A closely mown lawn forms
a canvas for a layered and
textured portrait of trees and
shrubs including rhododrendron,
inkberry, and boxwood.

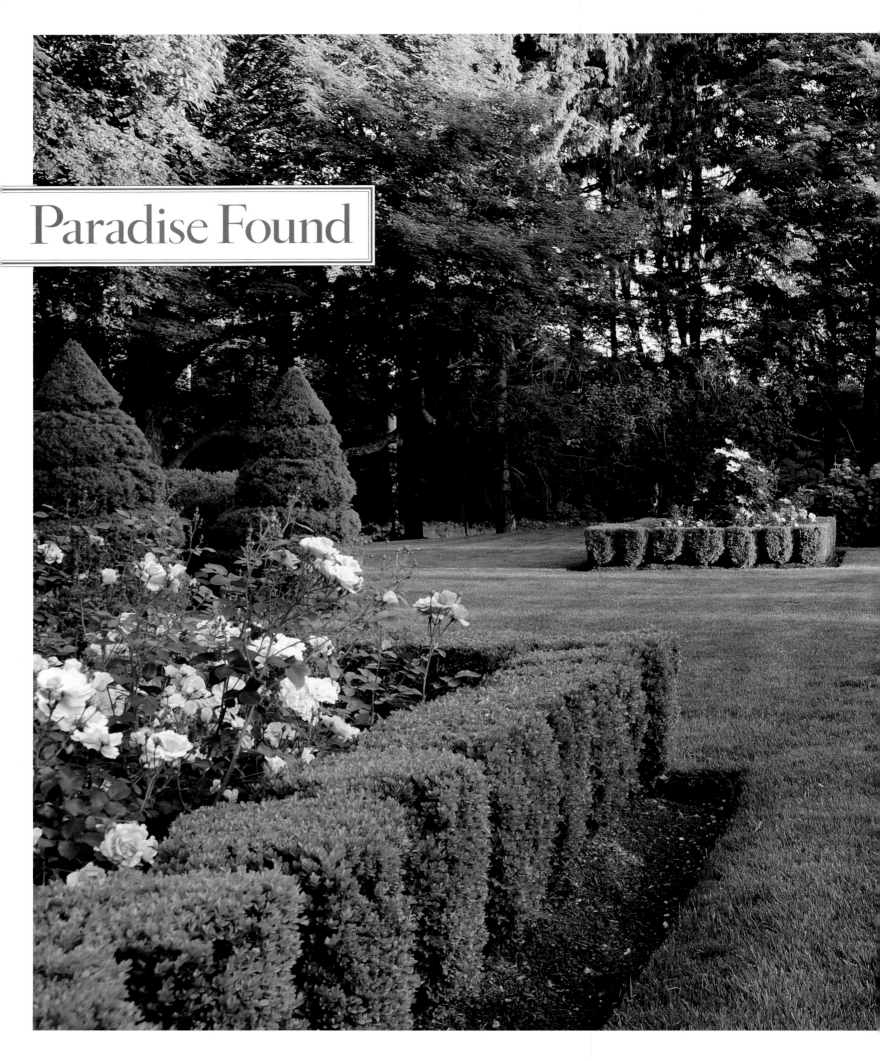

Paradise Found

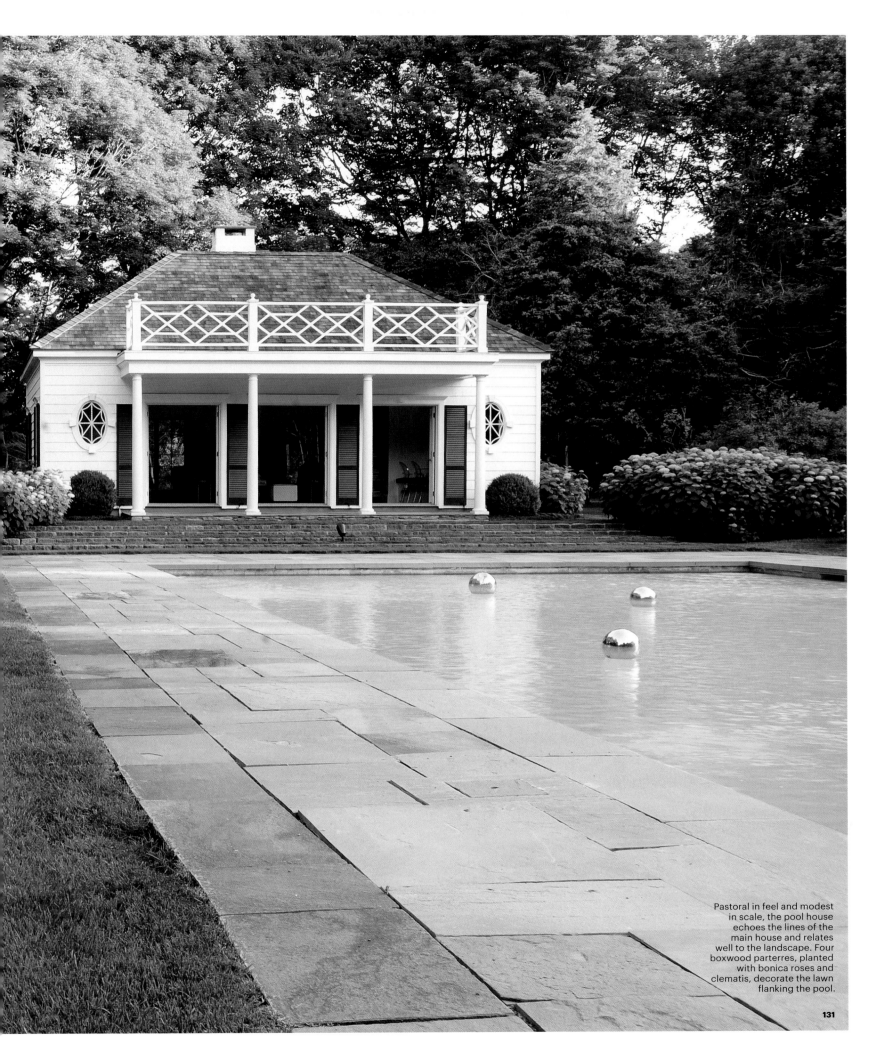

Pastoral in feel and modest in scale, the pool house echoes the lines of the main house and relates well to the landscape. Four boxwood parterres, planted with bonica roses and clematis, decorate the lawn flanking the pool.

OR 20 YEARS, Donna Craft pined away for this property from her home seven miles across town. A native of Canada, she saw in it the quintessential New England charmer: a gentrified federal-style house with white shingles and green shutters designed by architect Walter John Skinner in 1958, a vast lawn dotted with stately sugar maples skirted in pachysandra, and a 30-by-55-foot pool surrounded in bluestone.

Then one day in 2006 or 2007, she heard a whisper in the real estate wind: the property, known as Maple Hill Farm, might be for sale. Encouraged, she wrote a note to the owner and left it in the mailbox. The owner called the next day and invited her to come see it. Craft made it only as far as the kitchen window, where she took in the view of the pool, the dwarf English boxwood parterres, and the meandering stone walls, before she decided to take it. She hadn't yet spied the tiny room, paneled in reclaimed 18th-century cherrywood and featuring a lead sink and decorative details that the previous owner had transported from France and installed specifically for cutting and arranging flowers from the gardens.

A fixture on the local philanthropic circuit, Craft also surmised that the site, consisting of seven acres that straddle the Easton-Fairfield line, would be exceedingly suitable for entertaining and fund-raising on behalf of the causes about which she is passionate.

An avid gardener who can often be found trundling around the property in her John Deere Gator, Craft wasted no time in getting to work. At the far end of the pool, 310 feet from the main house, she commissioned an architect to design a pool house that would echo the architectural lines and details of the main house. Pastoral in feel and modest in scale, it relates well to the landscape and sits on an axis that essentially bisects the property, lending the composition a symmetrical harmony.

With the organizing principle in place, the rest was easy. Craft rejuvenated the four parterres, which are inlaid into the lawn on either side of the pool like shallow rectangular planters, and filled their centers with pale pink bonica roses. She gave these living planters height with trellised clematis and shaped six common boxwoods into orbs that rest on the lawn. She pruned Alberta spruce trees to mimic tiered Christmas trees, and planted eight varieties of peonies and hundreds of tulips and daffodils. Then, out front, near a rustic little barn that dates to the 1930s, she trained a hedge of burning bush into an arbor that turns flame-red in summer.

Sometimes dreams do come true. ■

A bonica rose.

A rustic 1930s barn
is hidden behind a
hedge of burning
bush that Craft
trained into an arbor.

Trellised ▸
clematis
lends height
to the
parterres.

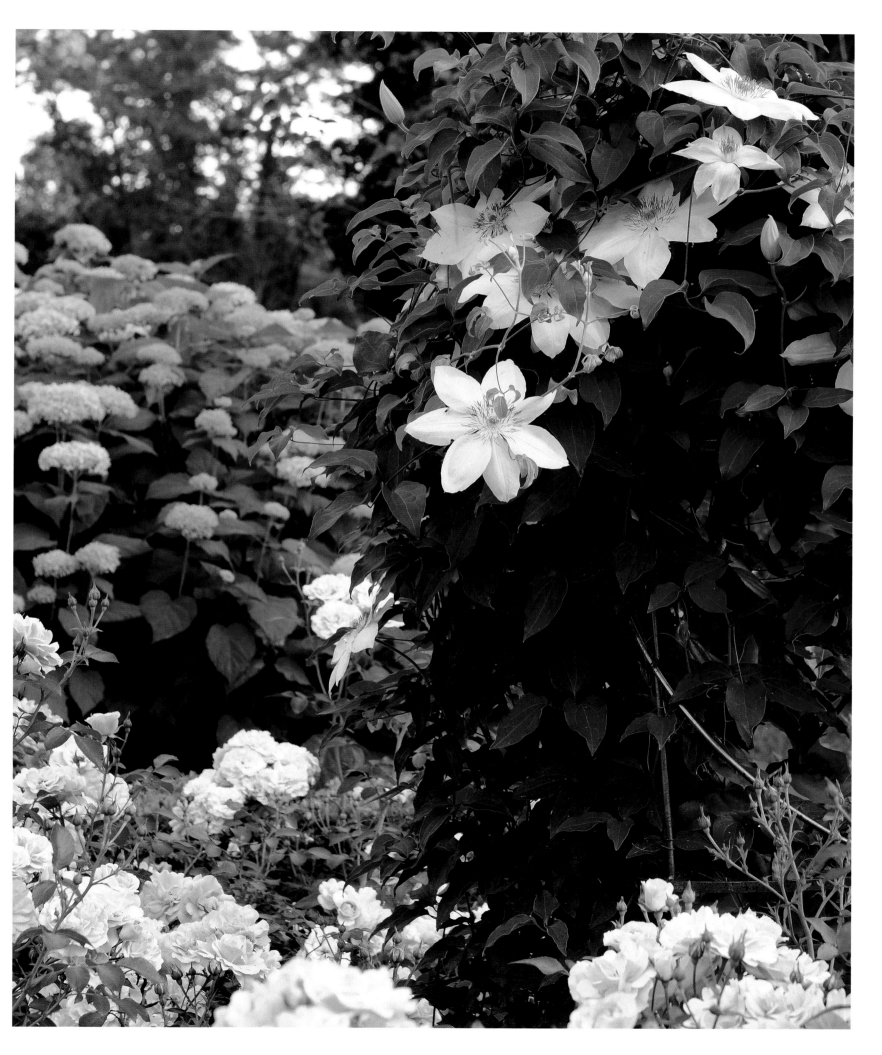

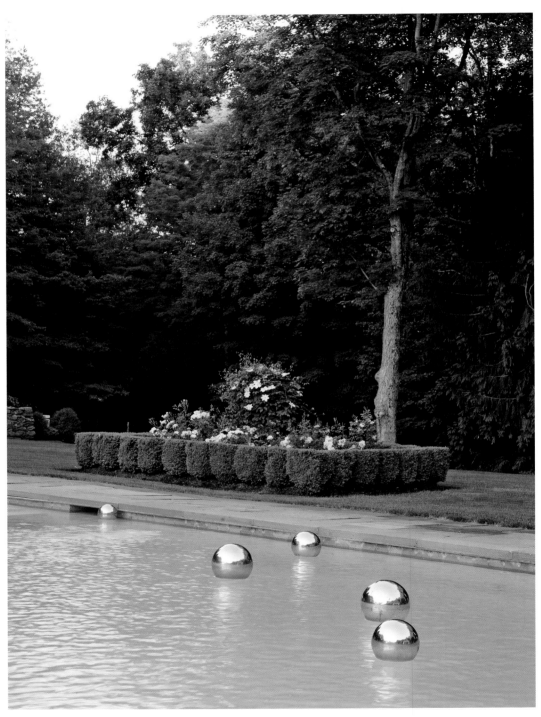

Silver balls do double duty, providing a decorative touch while keeping birds away.

Clematis. ▸

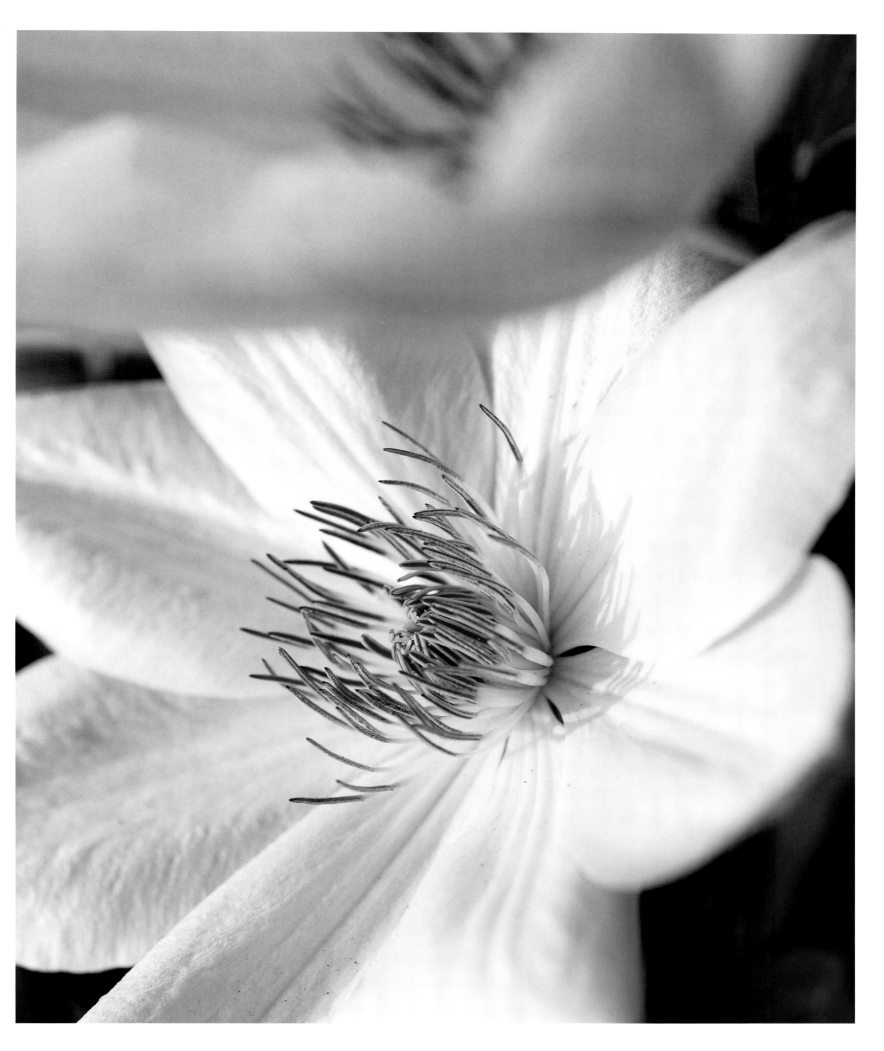

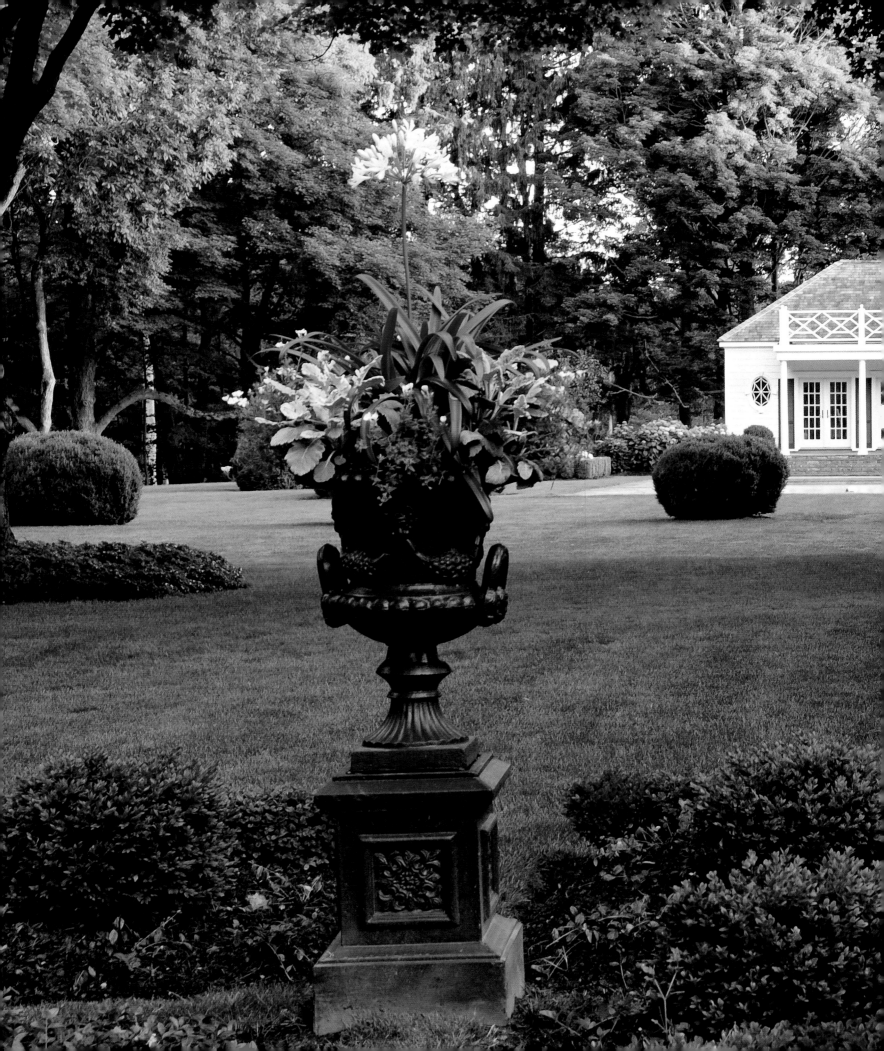

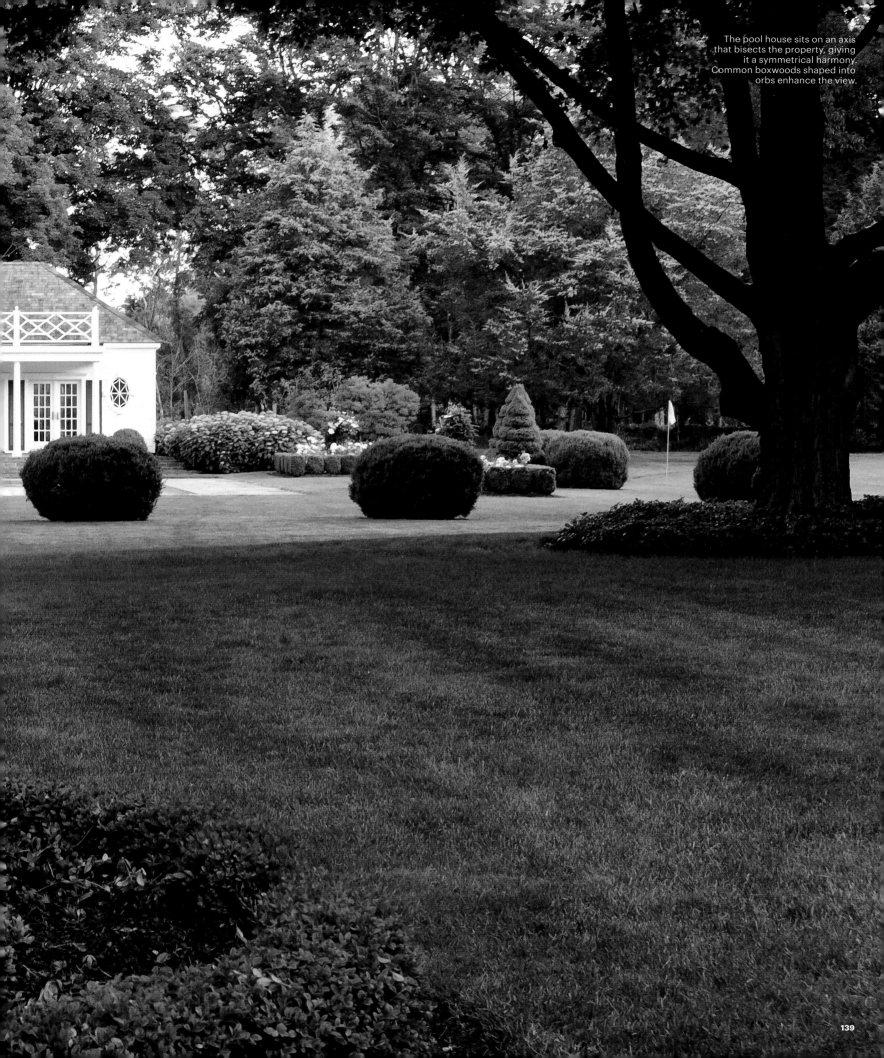

The pool house sits on an axis that bisects the property, giving it a symmetrical harmony. Common boxwoods shaped into orbs enhance the view.

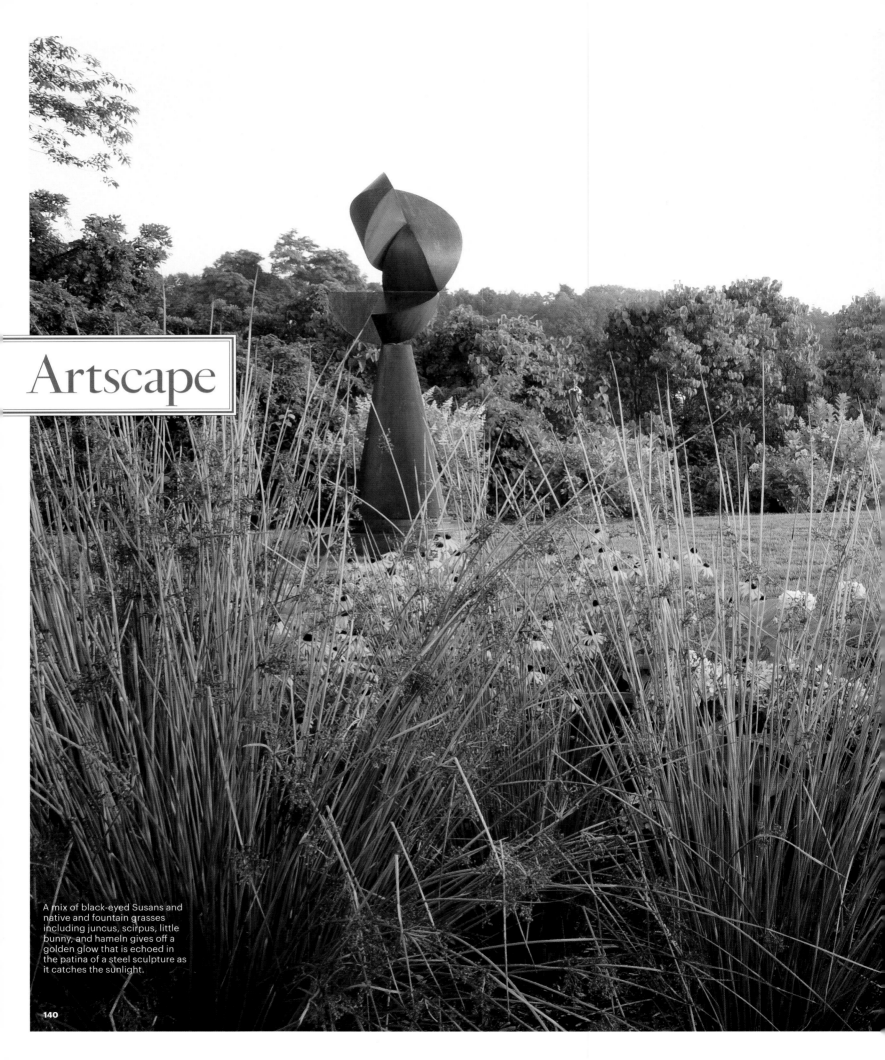

Artscape

A mix of black-eyed Susans and native and fountain grasses including juncus, scirpus, little bunny, and hameln gives off a golden glow that is echoed in the patina of a steel sculpture as it catches the sunlight.

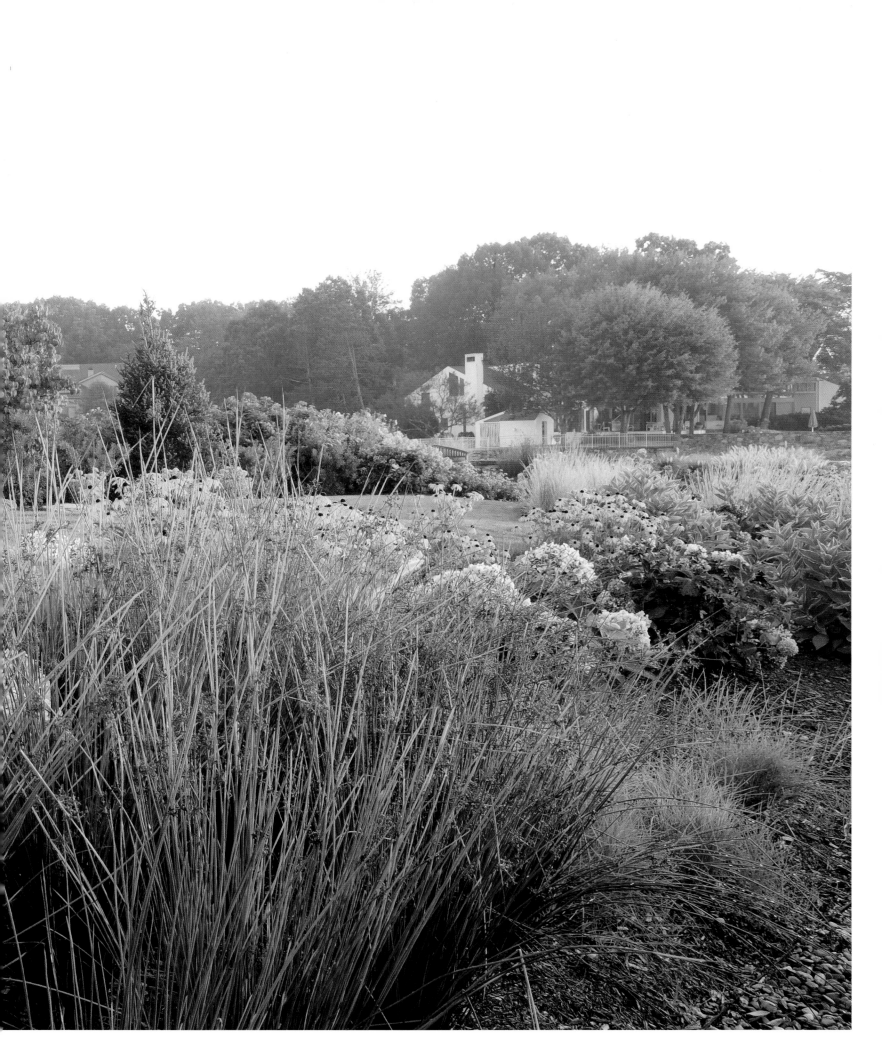

WHEN ANN AND SID Weiner began building their home on a Westport peninsula where the Saugatuck River meets Long Island Sound, the terrain consisted of a flat patch of dirt on a stunning horizon. The site was desperately in need of some softening—and some points of interest that wouldn't detract from the view. Most important, according to Ann, was that the landscape mimic the movement of the shoreline by following its contours.

The points of interest were easy. Collectors of sculpture, the Weiners own several large limited-edition steel and bronze pieces that became the centerpieces of magnificent and whimsical vignettes that magically draw the eye to what Ann, with considerable deference, calls the "vistas." It helps that she, an artist whose eclectic work includes two- and three-dimensional pieces in a variety of media, has a talent for such composition.

In a freshwater pool, the Weiners installed a fountain by French artist Jean-Michel Folon in the form of a man wearing a hat and holding what looks like the shaft of an umbrella. When the water is flowing, it emerges from the slender pipe in a surprising parasol that splashes into the puddle at the man's feet. Out on the edge of the property, just above a large flat rock that disappears at high tide and once served as a landing point for Indian traders, is a large cast-bronze wheel mounted on its rim. The sculpture, by Thomas Ostenberg, looks as though it's rolling in off a wave, propelled by the motion of a dance (or a tussle) between a man and a bull.

To address the living aspects of the landscape, Ann, who says her creativity flows more freely as a result of so inspirational a place, put together a pair of experts—landscape contractor Andy Stewart and landscape architect Alice Eckerson—to collaborate with her in bringing her outdoor scheme to life. The result is a series of garden beds of varying heights, colors, and textures that consist largely of plants you might see on Nantucket and elsewhere in New England. They're hardy enough to withstand hurricane winds and Nor'easter surges, but also delicate and airy enough not to occlude the view.

Up against the seawall is a beachy tableau of Montauk daisies; black-eyed Susans; roses including Lady Elsie May, blanc de coulbert, and iceberg, and willowy grasses including little bunny, scirpus, and juncus. On a gentle berm near the pool, evergreens including dwarf Japanese black pines, limber pines, and Hinoki cypresses mingle with quickfire, endless summer, and tardiva hydrangeas. Between the two is an undulating lawn that leads to a little enclave of rose of Sharon that provides cover from the neighbors. There, on a secret bench, Ann sips her morning coffee while taking in the takeoffs and landings of egrets, cormorants, seagulls, and swans. In this place where art imitates nature, nature is art. ∎

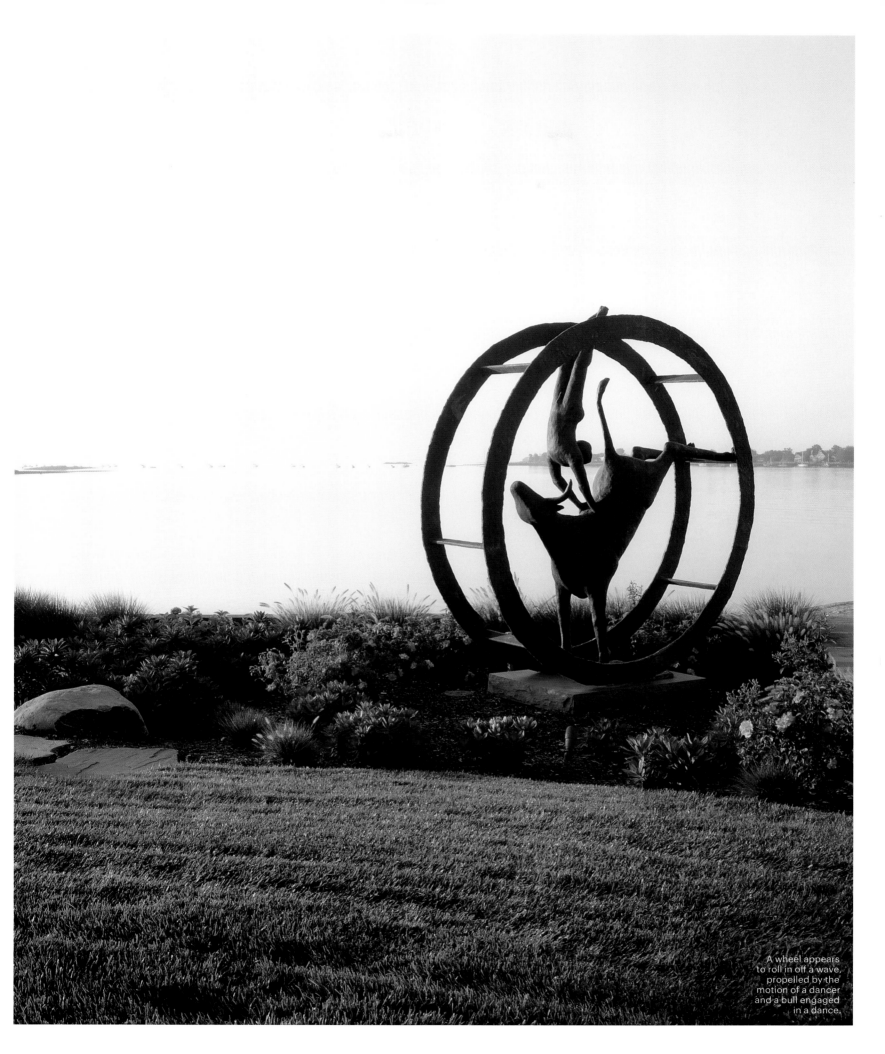

A wheel appears
to roll in off a wave,
propelled by the
motion of a dancer
and a bull engaged
in a dance.

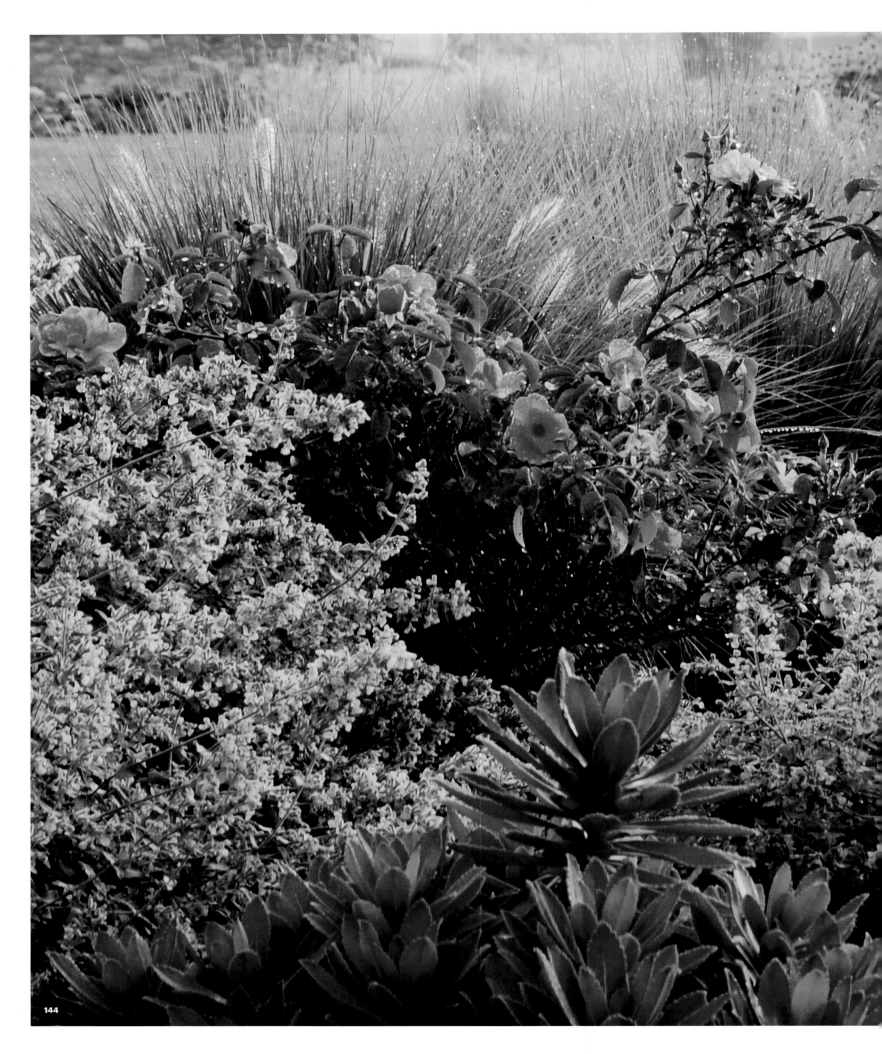

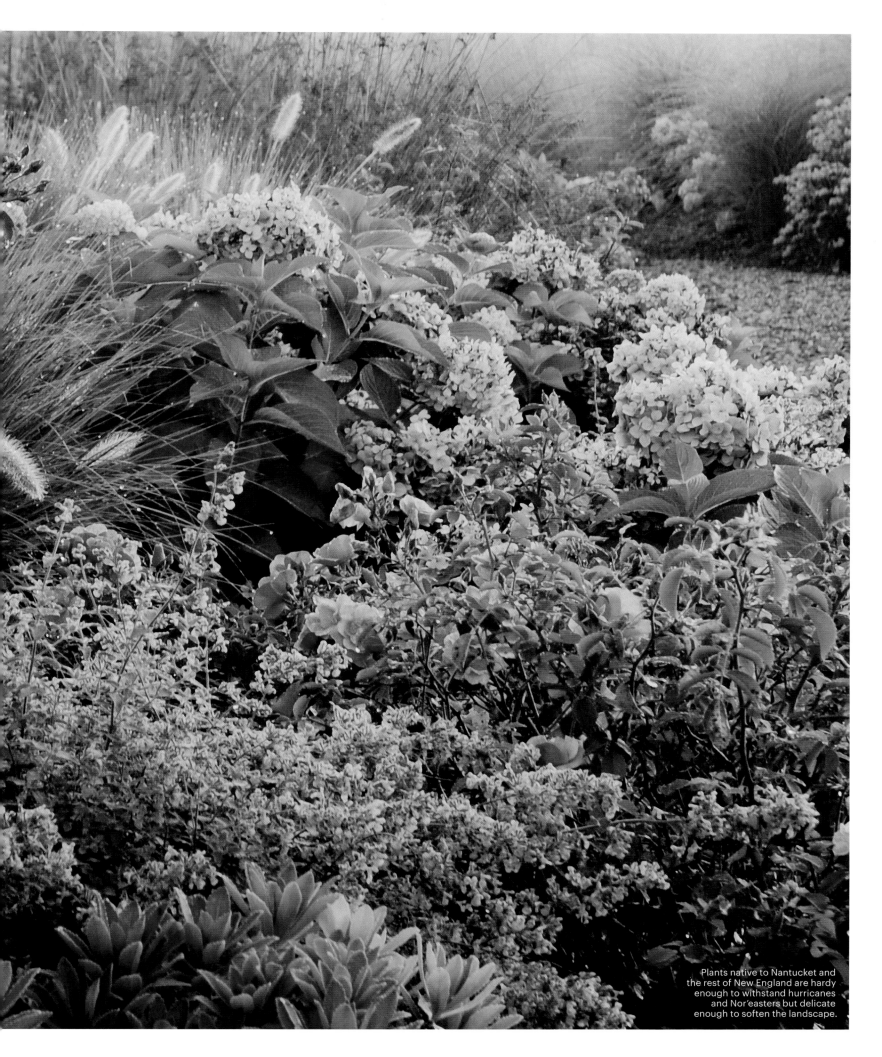

Plants native to Nantucket and the rest of New England are hardy enough to withstand hurricanes and Nor'easters but delicate enough to soften the landscape.

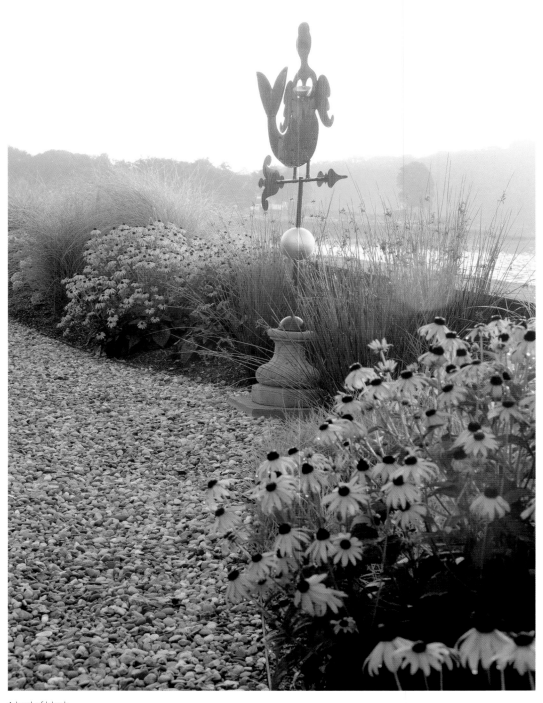

A bed of black-
eyed Susans
frames a
weathervane.

A black-eyed Susan in ▶
the morning dew.

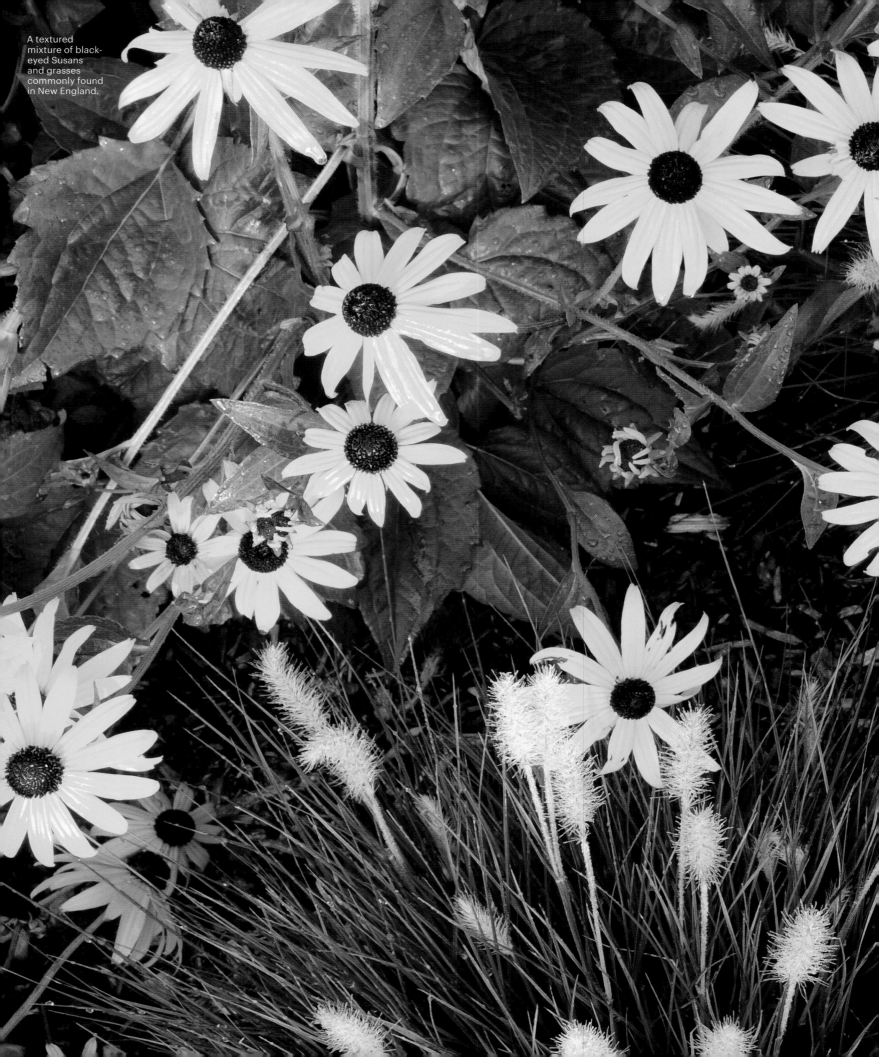

A textured mixture of black-eyed Susans and grasses commonly found in New England.

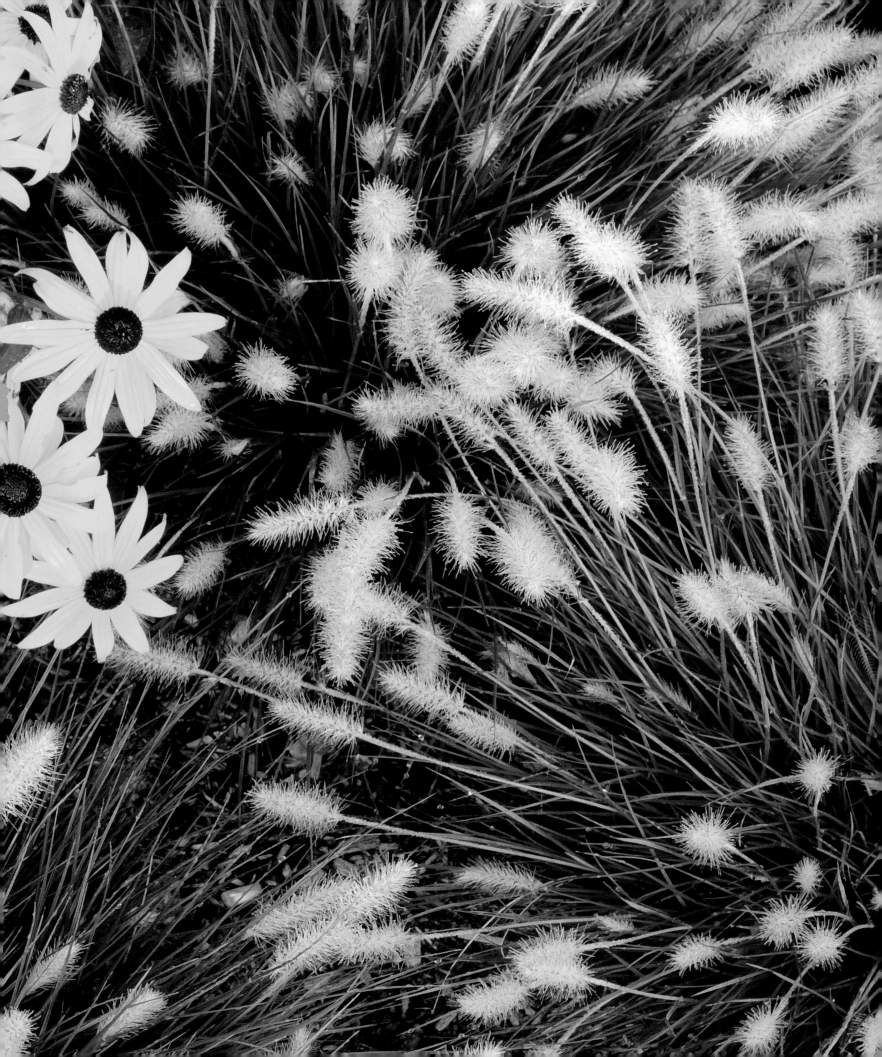

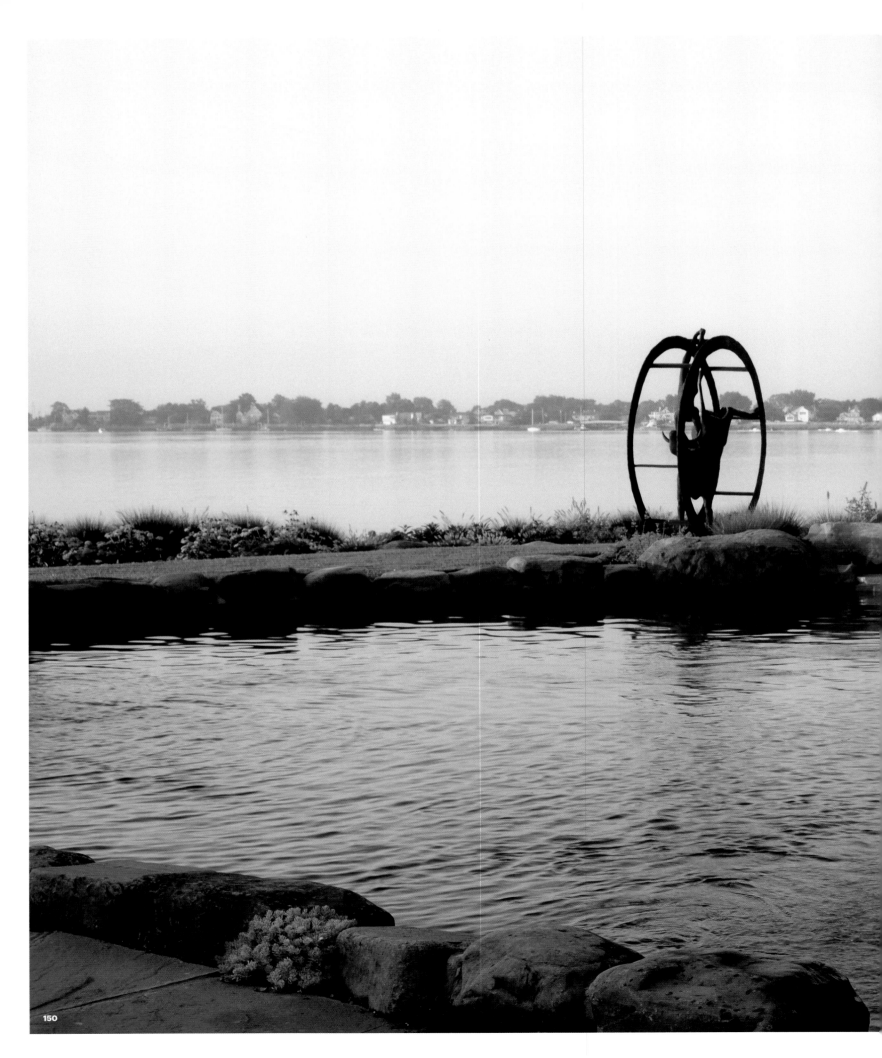

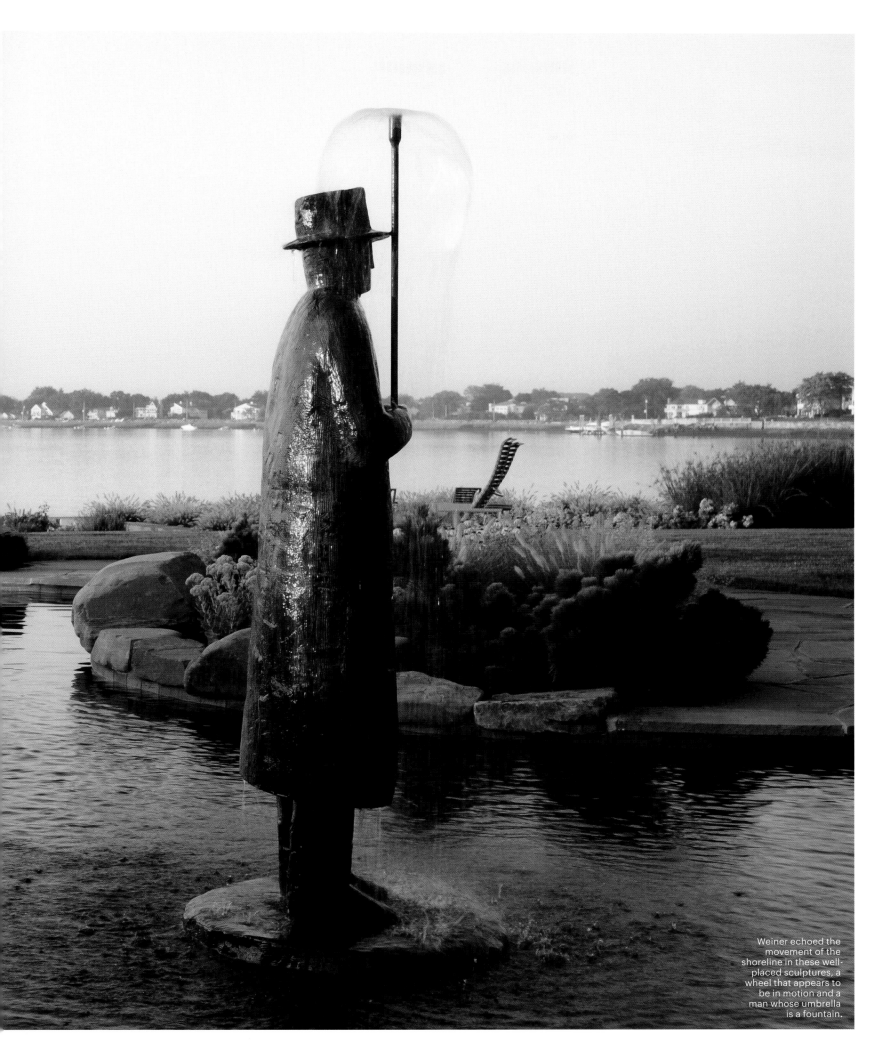

Weiner echoed the movement of the shoreline in these well-placed sculptures, a wheel that appears to be in motion and a man whose umbrella is a fountain.

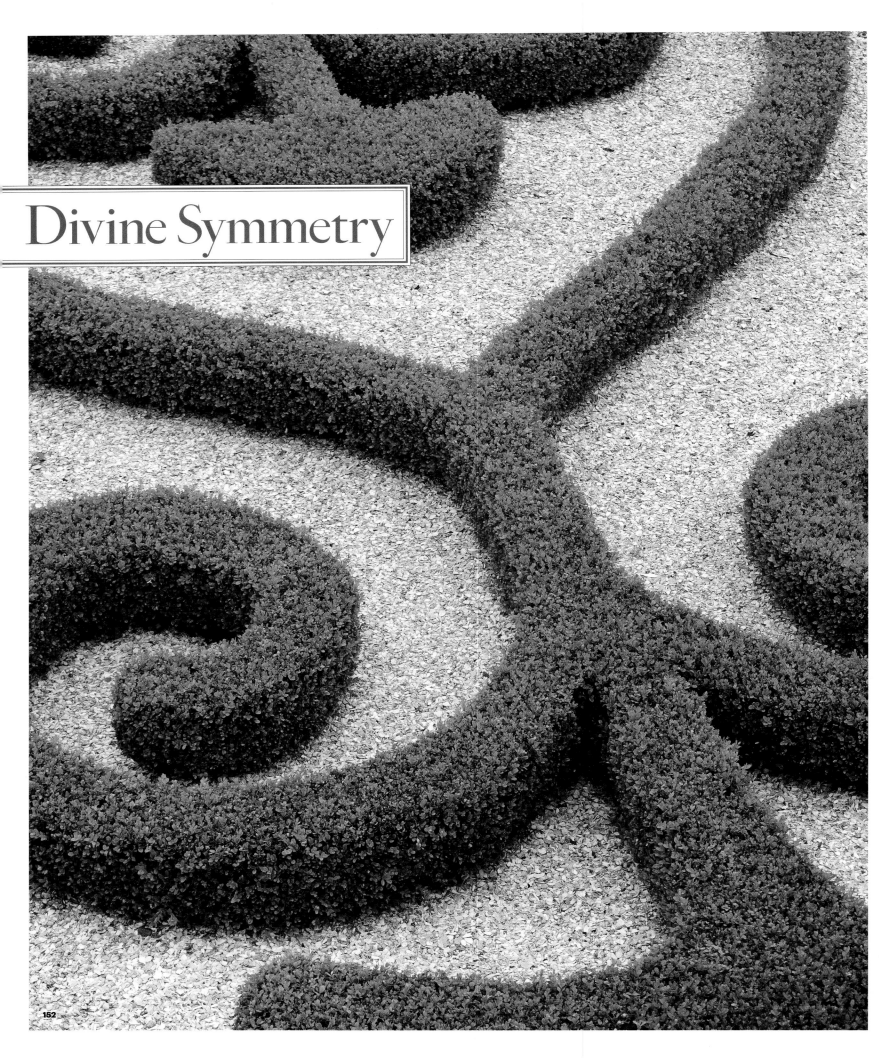

Divine Symmetry

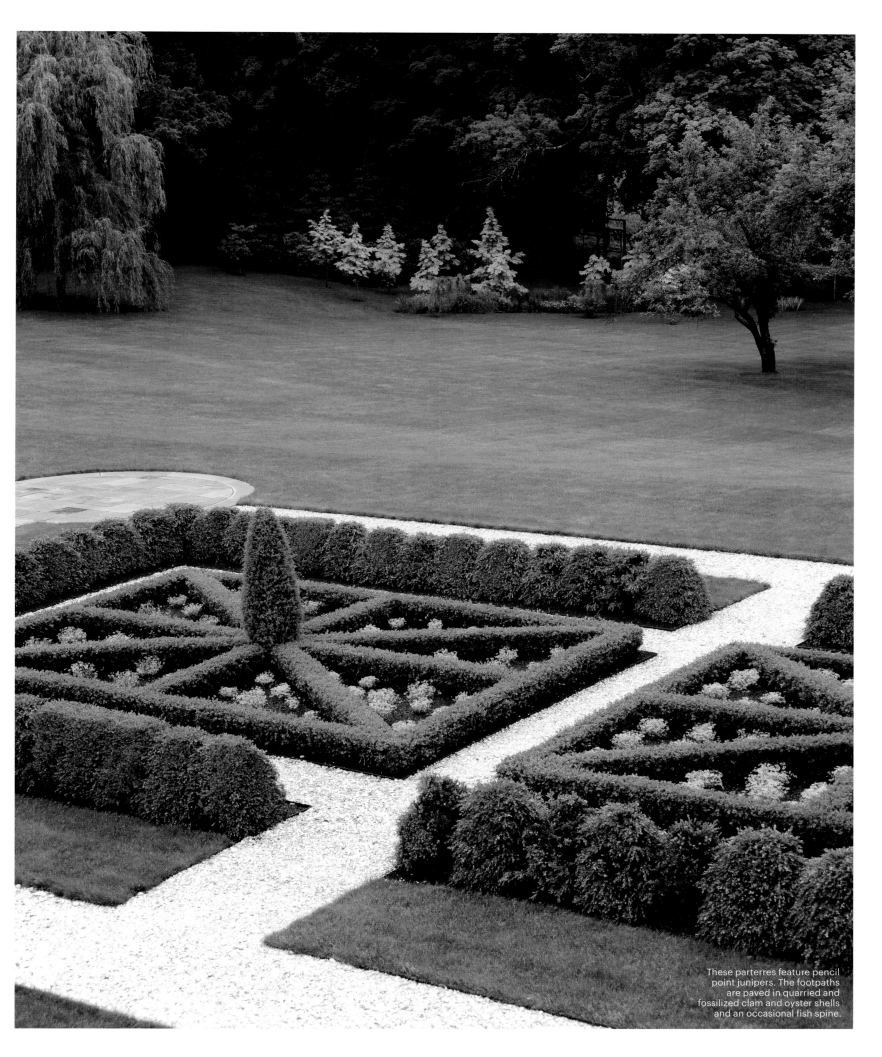

These parterres feature pencil point junipers. The footpaths are paved in quarried and fossilized clam and oyster shells and an occasional fish spine.

IN A FORMER LIFE, Phillip Watson must have been a nobleman in the court of Louis XIV, tasked with designing gardens that would titillate the king. That's the thought that strikes you, at least, when you enter the gates of this eight-acre estate in Greenwich and advance down a drive lined with linden trees.

Watson, a horticulturalist and garden designer who studied under Rosemary Verey, the grande dame of English garden design, knew when he saw the property that it possessed a scale conducive to parterres like those at Versailles, designed by landscape architect Andre Le Notre for the aesthetically oriented sovereign in the late 17th century.

A combiner of discipline and whimsy, Watson intuited that the property's innate symmetry demanded balance. So in the center of the drive, where a fountain had been, he designed a central parterre consisting of an elaborate configuration of scrolled anchors, a nod to his clients who enjoy much of the year in Palm Beach, where they keep their boat. Constructed of winter gem boxwood trimmed to a shin-rubbing height, the anchors are joined end to end and laced with winding footpaths carpeted in quarried and fossilized oyster and clamshells, and an occasional fish spine.

Aligned with the front entry of the house, the large anchors are flanked by rectangular parterres each with interior diagonals that radiate from a nexus marked by a pencil point juniper. Taller green mountain boxwoods, on their way to being molded into flat-topped pyramids, enclose each parterre.

Out back, where the cupola-topped pool house is separated from the main house by a 44-square-foot pool Watson designed, pergolas are adorned in pink, blue, and white wisteria, and the patio's perimeter is densely planted with creeping verbena and parlor maple.

Everywhere you look there are layers of delight: towering deciduous trees under-planted with woody shrubs, Norway spruce, sprays of peonies that line the stairs on either end of the house, and the haphazard remains of the old apple orchard that Watson left intact.

At the edge of the property, where it drops away into the woods, Watson planted a tiered perennial garden—gaillardia, joe-pye weed, solidago fireworks, and Siberian irises. It's buttressed by a hidden retaining wall that makes it appear to be floating, blurring the property's boundary rather than defining it, and as a result making the property seem much larger than it is.

Just as King Louis would have liked it. ∎

Even the tiniest flower
is rich with detail.

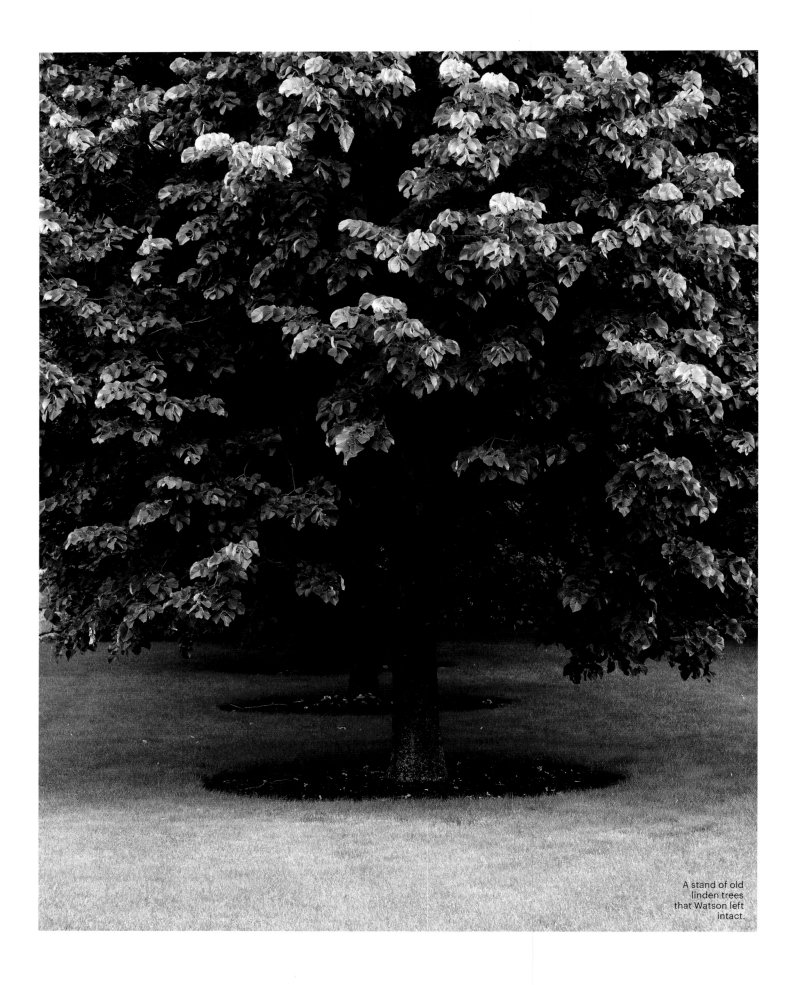

A stand of old linden trees that Watson left intact.

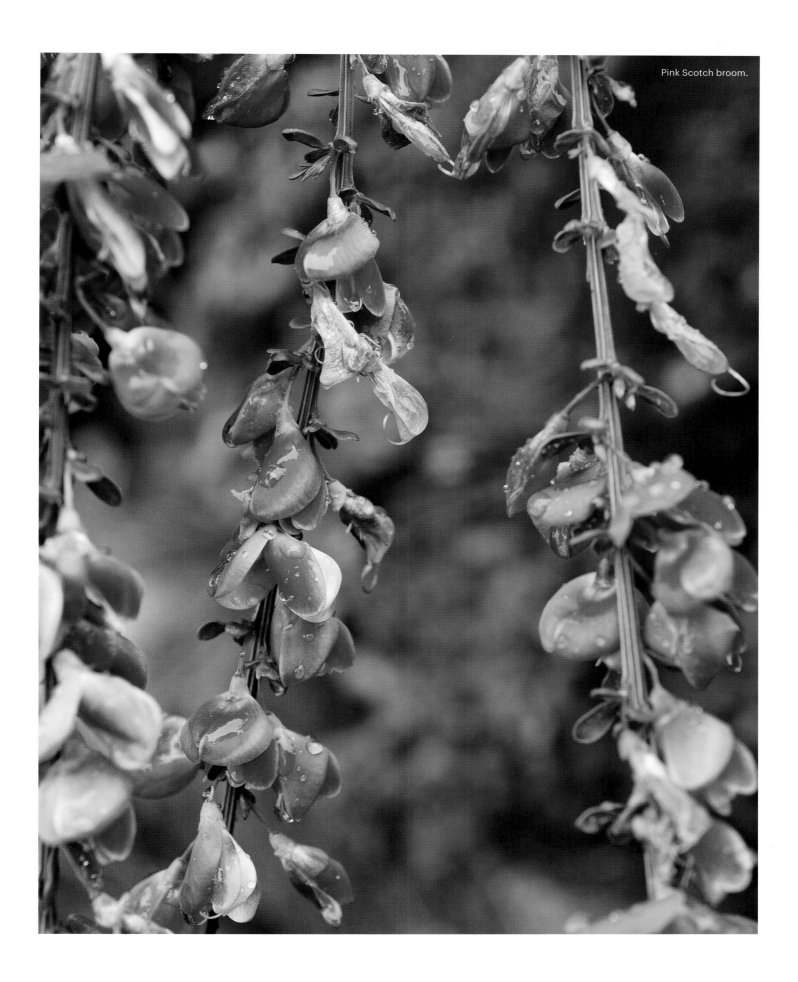

Pink Scotch broom.

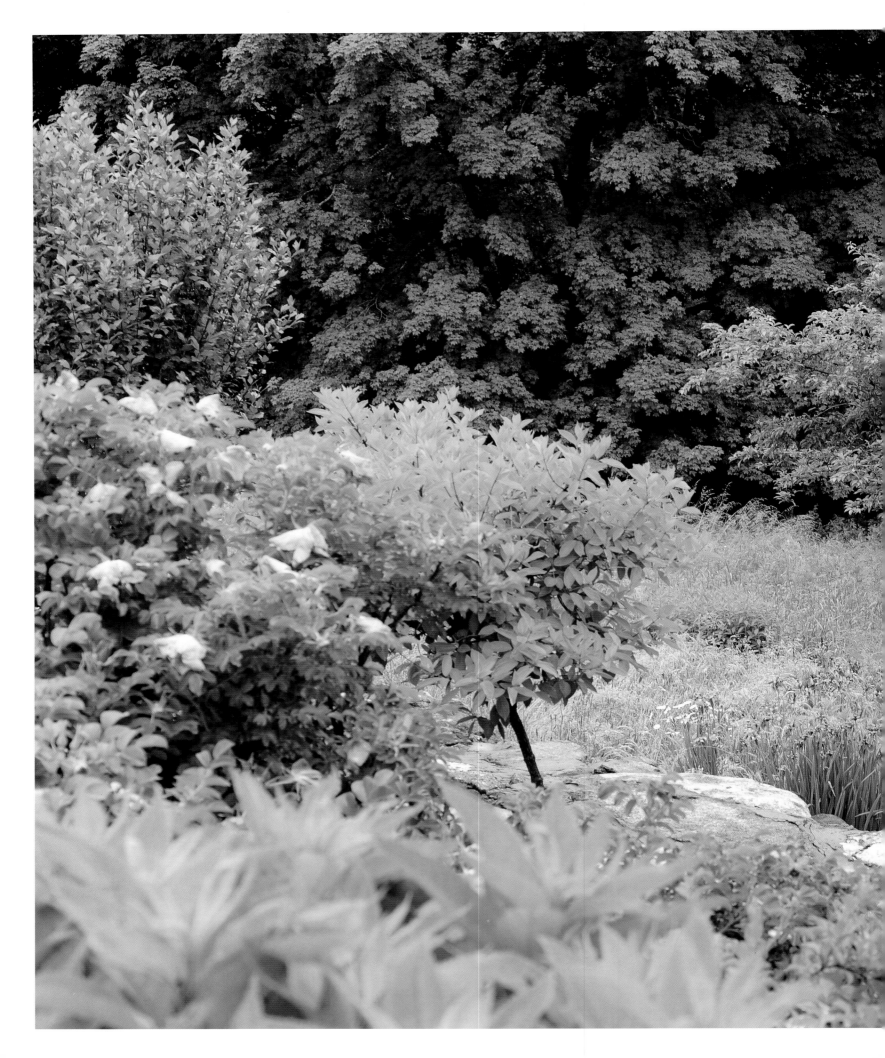

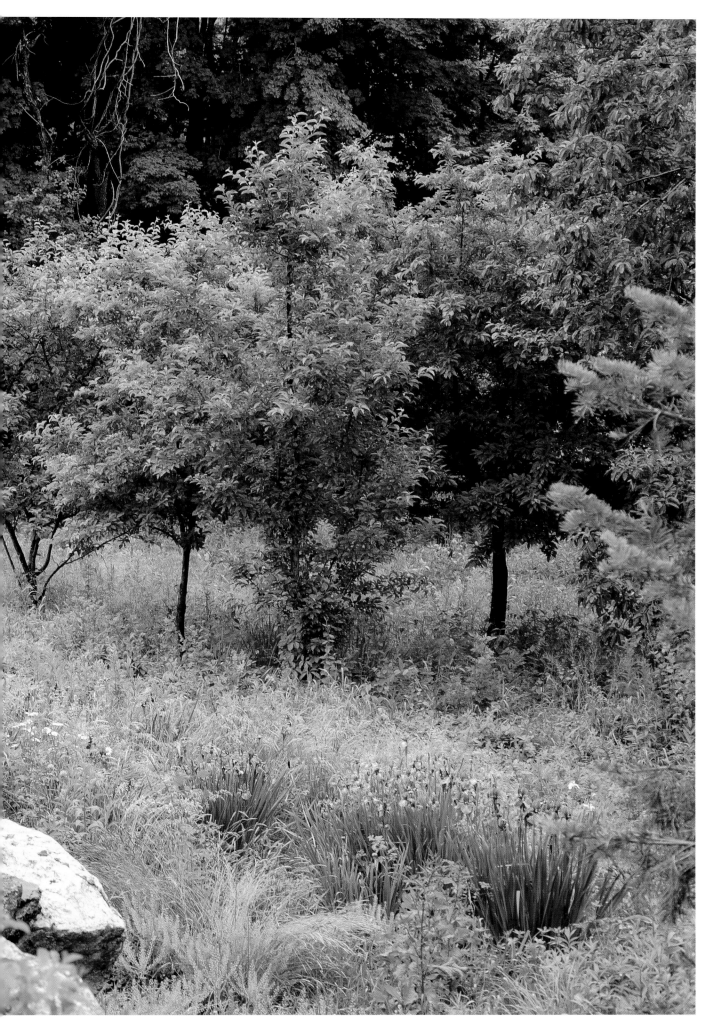

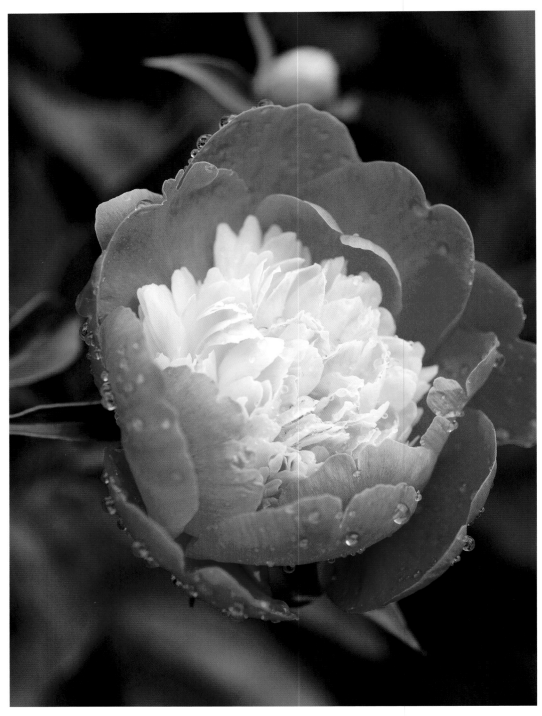

A peony in bloom.

A side staircase ▸
is decorated
with sprays of
peonies.

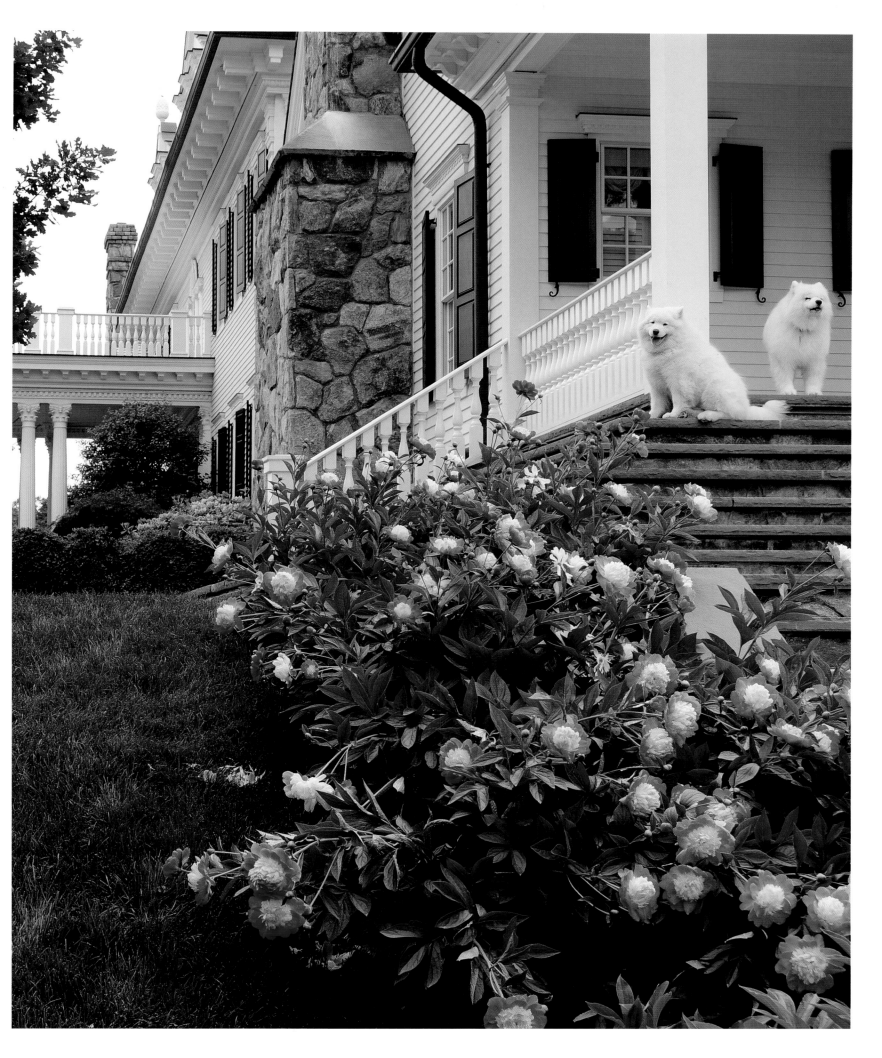

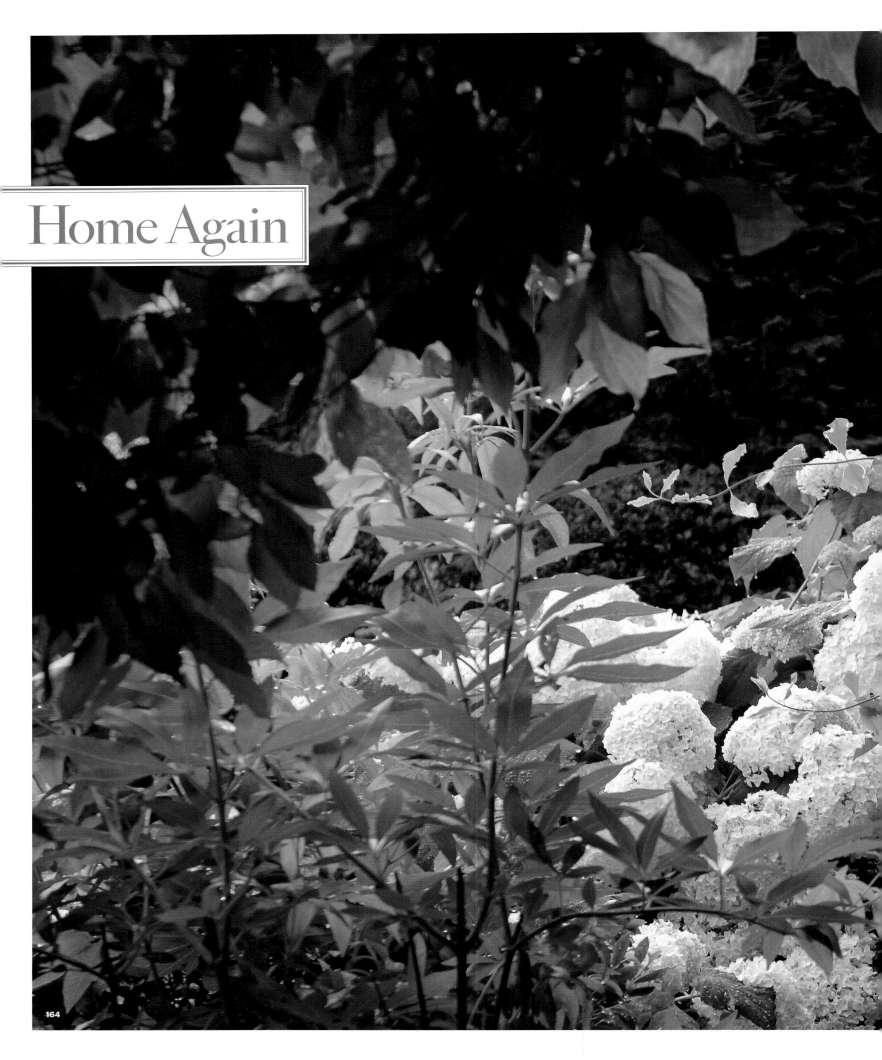

Home Again

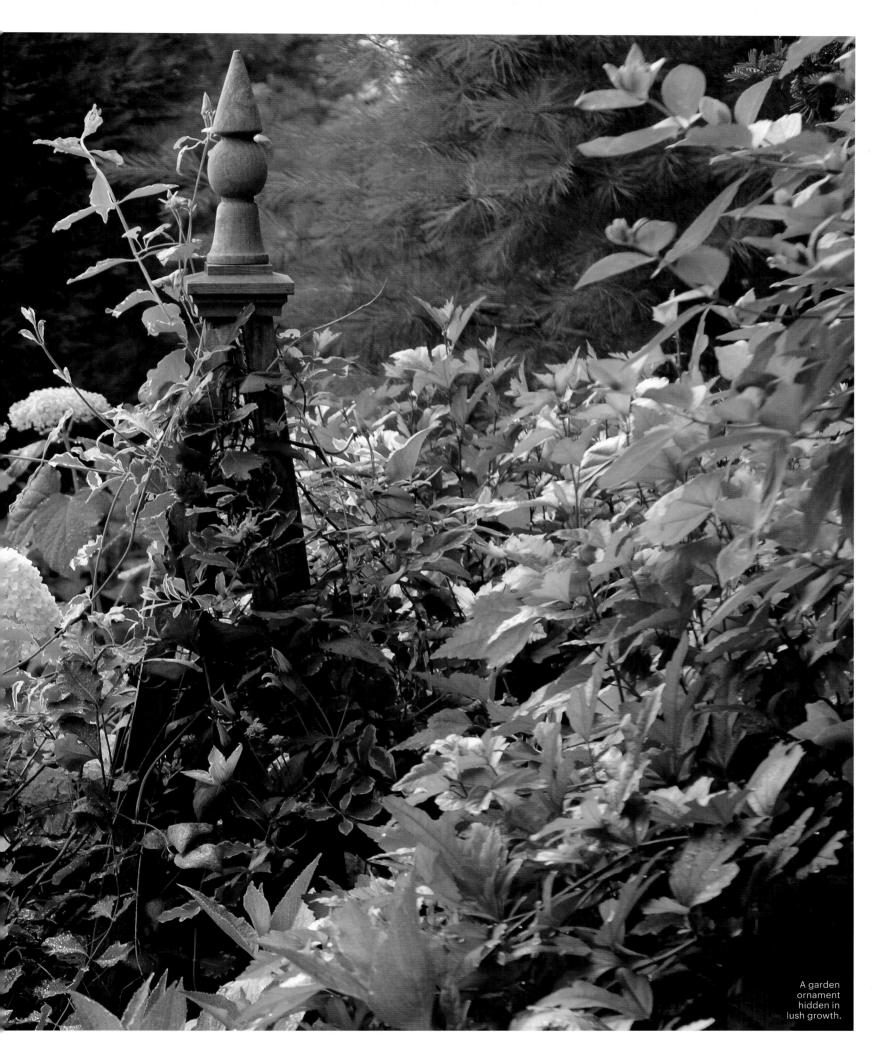

A garden
ornament
hidden in
lush growth.

WHEN fashion industry insiders John Lloyd and Selim Yolac bought this house in Fairfield in 1994, they envisioned it as a weekend getaway from the sartorial stresses of Seventh Avenue. But not long afterward, what proved to be a very transferable agility with textiles and design had yielded a whole runway's worth of looks. Their line of garden silhouettes, each of with its own place on this quiet quarter acre, won them a spot on a local garden tour, the horticultural equivalent of New York's Fashion Week.

The event offered the designers an opportunity to debut their work not only through tours of their knot garden and visits to their diminutive waterfall but also through displays of their sketches and watercolor storyboards arranged on easels in their screened-in porch, which they converted into an impromptu studio. It wasn't long before the phone began ringing off the hook.

The guiding principle to their overall design was to draw the eye outward from inside their renovated Cape Cod to a variety of irresistible views. There is the knot garden of roses and honeysuckle whose entrance is marked by spiraled topiaries of boxwood, and whose winter gem and dwarf English boxwood parterres are filled with lavender. There is the Zen garden, which is centered on an urnlike fountain and bordered by vivid monk's hood, oak leaf hydrangea, and honeysuckle. The two are separated by a wall of European hornbeam that connects them through an arch.

One of the pivotal changes Lloyd and Yolac made to the sloping site was to build a series of terraces, bound by stone retaining walls and carpeted in gravel. The arrangement made it possible to install a miniature waterfall consisting of an upper and a lower pool that cascades into a tiny lily pond filled with koi. It features a cluster of irises and is contained in a dense surround of viburnum, euonymus Manhattan—a nod to their old stamping ground—and winter Carol Mackie Daphne with its delicately variegated leaves.

Out back, they converted a narrow alley into a mossy shade garden, with a footpath paved in brick. It processes through an undergrowth of ferns and a stand of tall cedars whose exposed trunks form a line of redwood columns. Elsewhere on the property there are dwarf Miss Kim lilacs, Constance Spry David Austin roses, an archway made of limelight hydrangea, a pergola entwined with Chinese and Japanese wisteria—finally, they're getting along—and a lovingly cabled multi-trunked white birch.

These days, the couple spends part of the year in Bodrum, Turkey, where they're experimenting with a Mediterranean motif. Otherwise they can be found designing gardens for clients from their new home in Fairfield, not far from this one.

Sometimes you just have to leave a place to realize how much you loved it. ∎

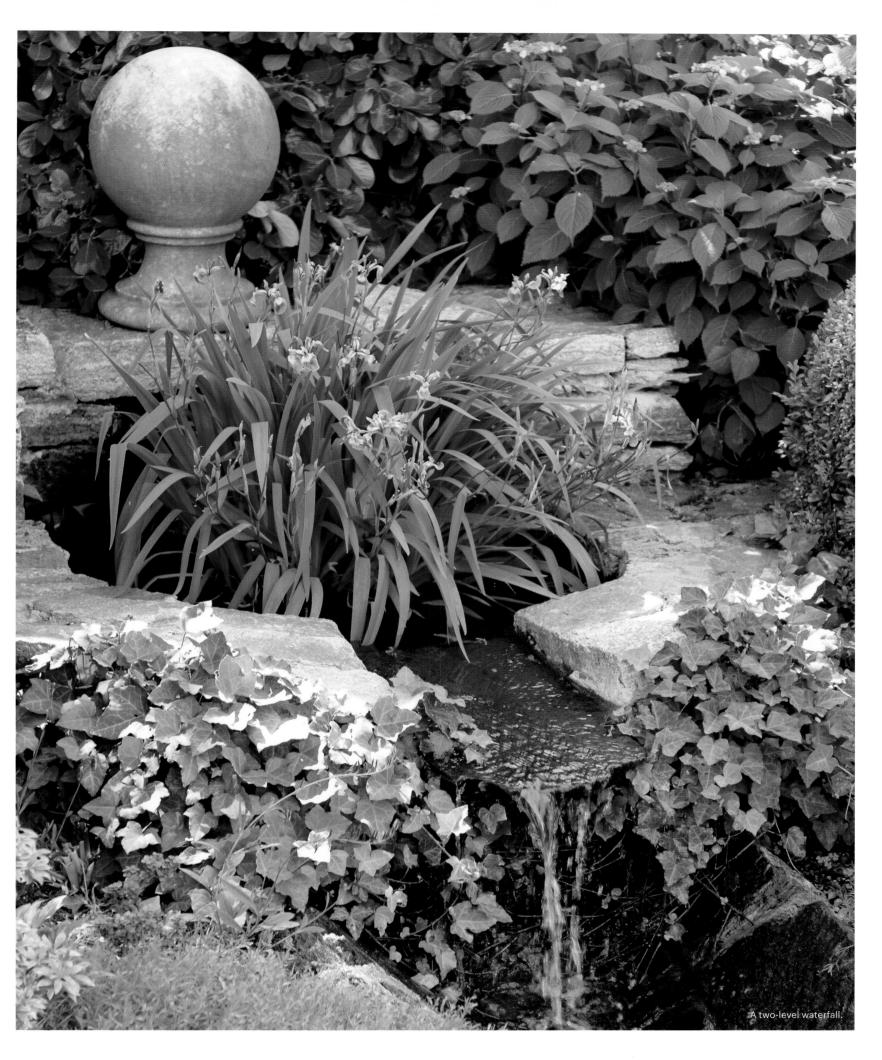

A two-level waterfall.

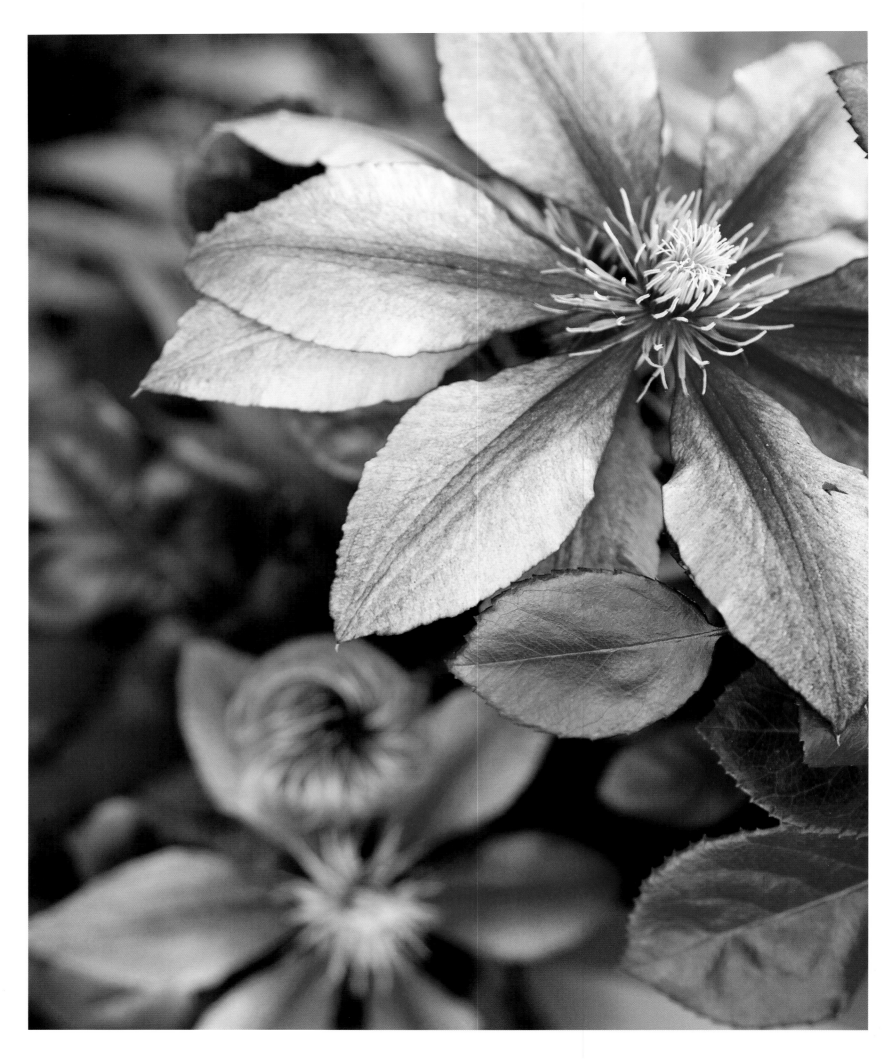

A moss garden
provides a
place to rest in
the shade.

◄ Clematis.

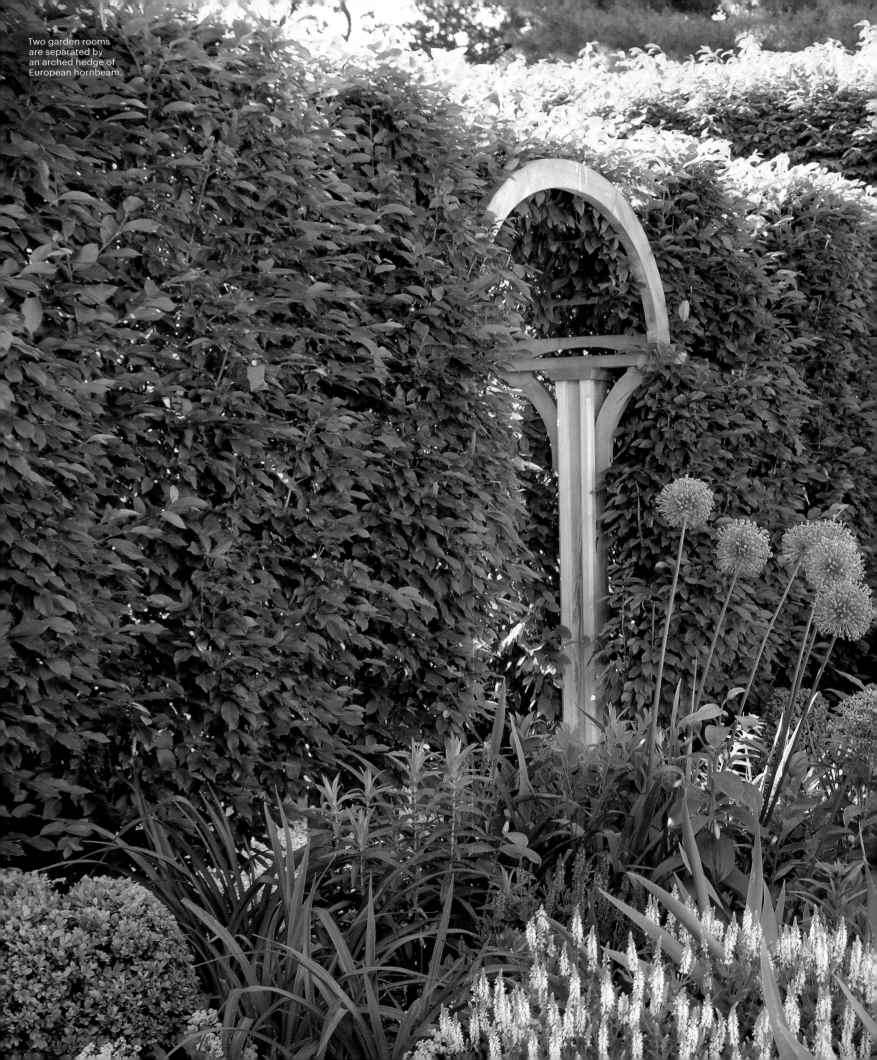

Two garden rooms
are separated by
an arched hedge of
European hornbeam.

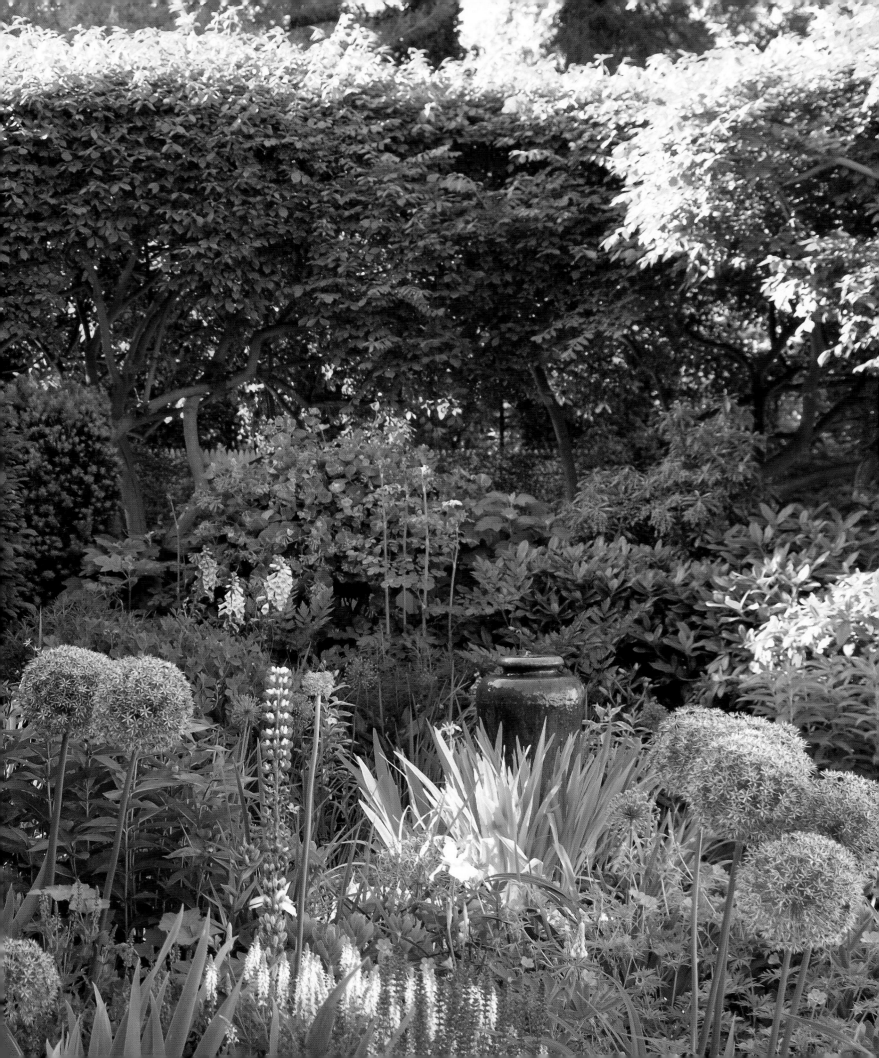

Variegated
Daphne leaves.

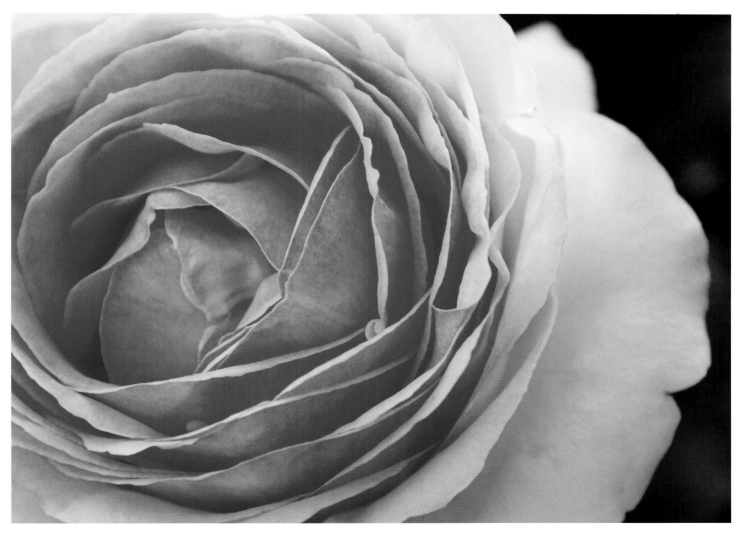

A pale pink rose
from the pergola.

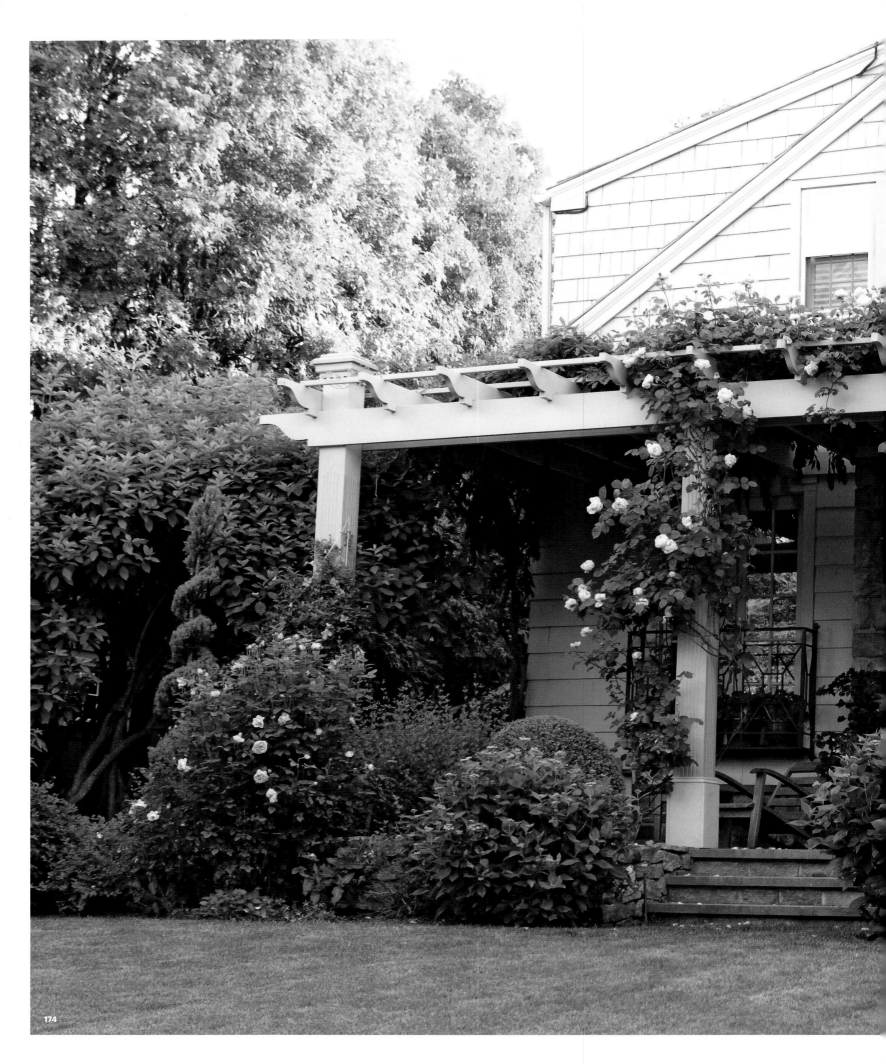

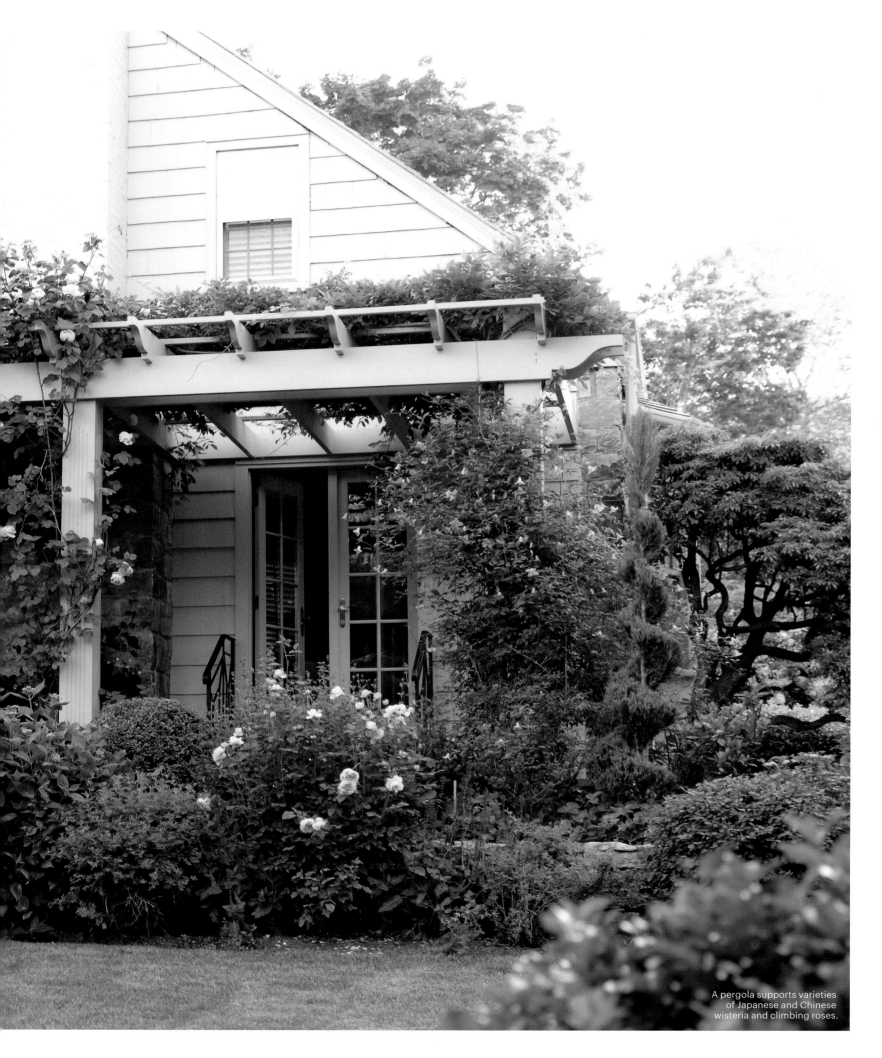

A pergola supports varieties of Japanese and Chinese wisteria and climbing roses.

Historical Reference

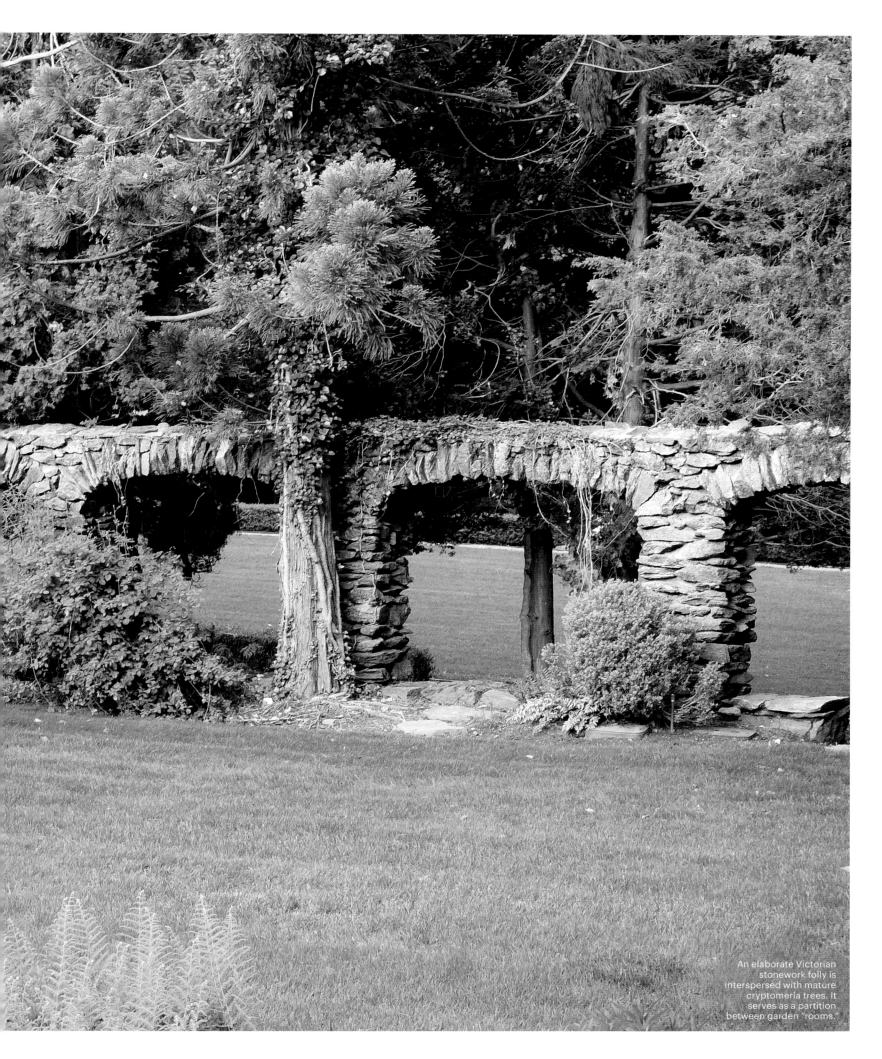

An elaborate Victorian stonework folly is interspersed with mature cryptomeria trees. It serves as a partition between garden "rooms."

WHEN GARDEN DE-signer Phillip Watson signed on to rejuvenate the grounds at Alease Fisher Tallman's home in Greenwich, he was agreeing to keep company in the record books with America's foremost names in landscape architecture and design. Raising the stakes even higher was the fact that the property includes a Colonial Revival house renovated in the early 20th century by renowned architects McKim, Mead, and White. It's the only structure with this pedigree remaining in Greenwich.

Indeed, the contours of the now ten-acre parcel, known as Chelmsford, were given their original shape by a succession of three landscape titans commissioned by longtime resident Blanche Ferry Hooker. Under her supervision, they transformed the property into a gentle-lady's working farm, complete with chickens, dairy cows, horses, strawberry patches, canning rooms, rose gardens, a giant manure pile, and a two-acre vegetable garden rimmed by a low stone wall.

The landscape luminaries with whom she collaborated included Warren H. Manning, a proponent of wild gardens and indigenous species who once worked in the firm of Frederick Law Olmsted; Manning apprentice Charles Gillette, who would later become known as the creator of the Virginia Garden; and Bryant Fleming, another Manning protégé credited with the renovation of several of New York's state parks.

You would think one would grow weary under the weight of a mantle like this, but Watson rose to the occasion. Working within the partitioned outdoor "rooms" mapped out by his predecessors, he cleaned up the croquet lawn, which had been the location of Hooker's experimental vegetable garden, and lined it with footpaths and benches. As a border along the pool, he planted a variety of columbine known as aquilegia woodside, which produces blue, pink, or white blooms, and interspersed small French lilacs with existing old leggy lilacs to produce blooms both above and below. He planted peonies along the path away from the house, and on its south-facing side he built a terraced lawn using existing boulders.

In addition, he reinvigorated the boxwood allee; tended to the mature cryptomeria trees planted at intervals along a Victorian stonework folly that evokes an antique aqueduct; and maintained the frog pond, which is guarded by a statue of Pan, the god of field and forest.

Then Watson, whose specialty is parterres, added a finishing touch to the circular drive where a chest-high rock garden had been: an elaborate design of hearts and filigrees, sculpted from green beauty boxwoods, that is as pleasing in winter, when it is dusted in snow, as it is in spring and summer.

Among his future projects may be the construction of the Gothic gazebo atop the root cellar that appeared in the original drawings but was never built. If history is any indicator, it just may get done. ∎

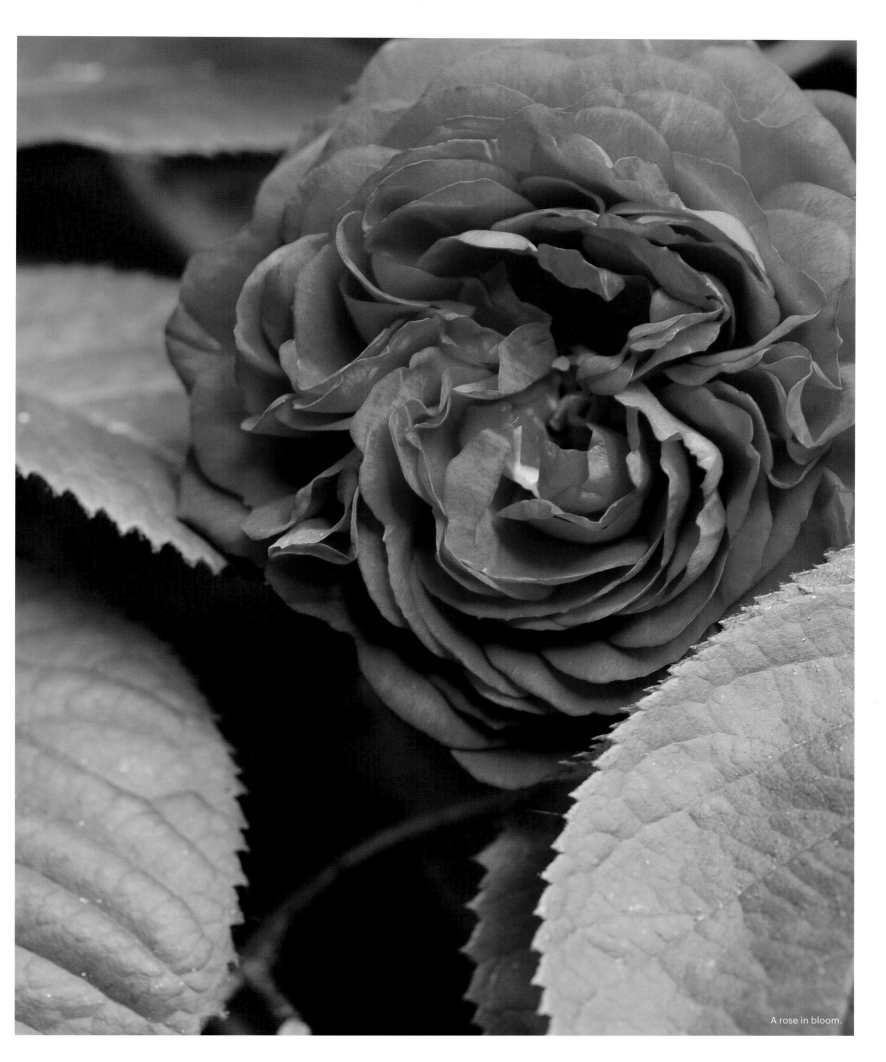

A rose in bloom.

The columns of
the stonework
folly are adorned
in climbing
heirloom roses.

A woodland frog ▸
pond is guarded
by a statue of
Pan, god of field
and forest.

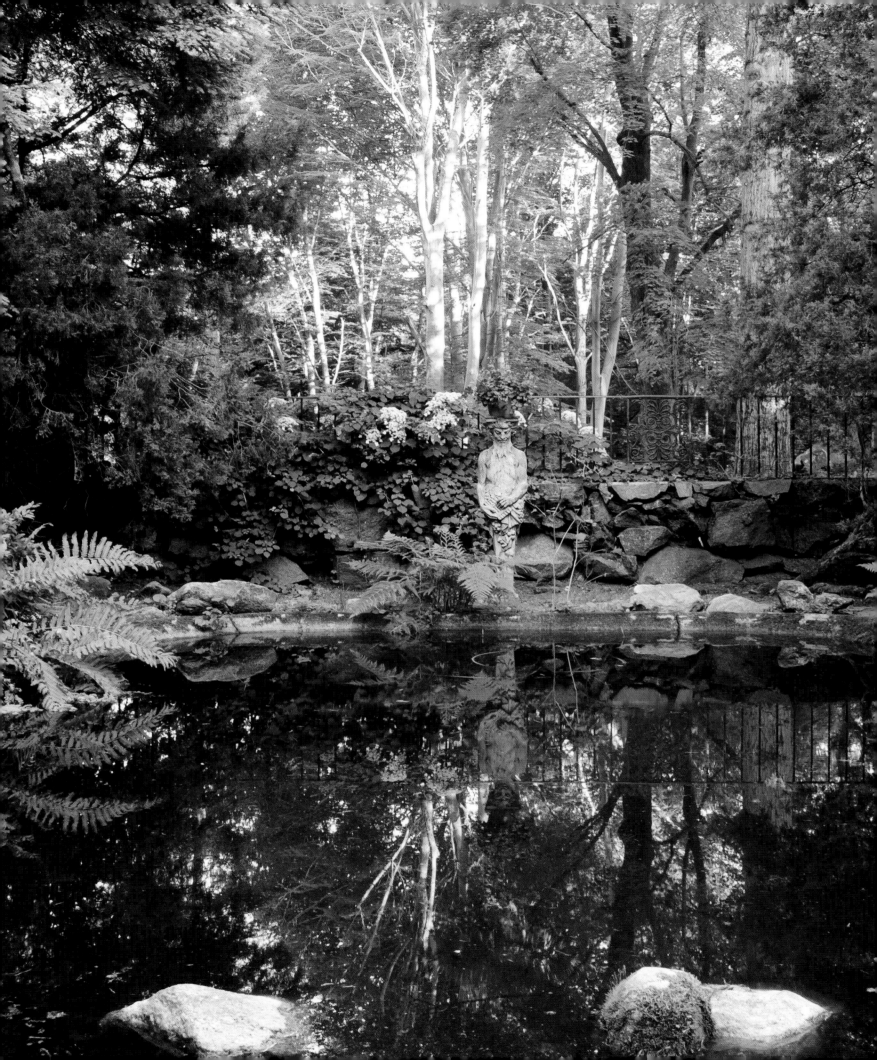

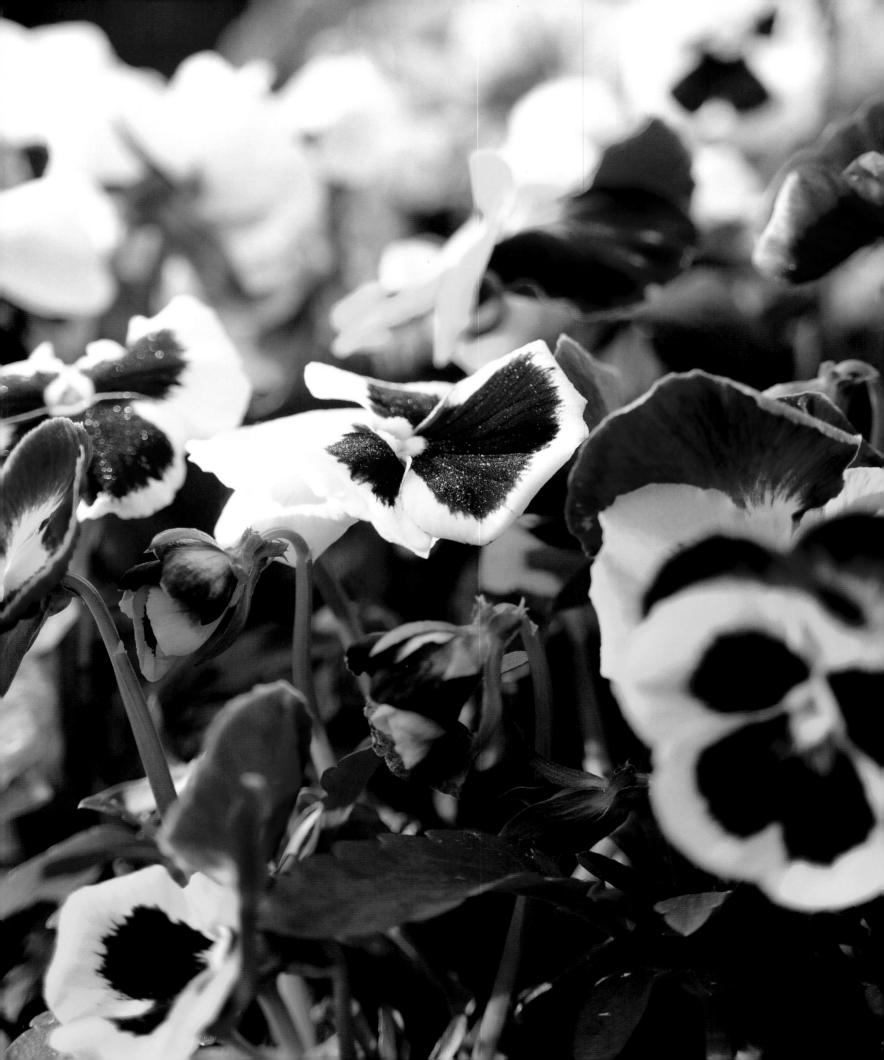

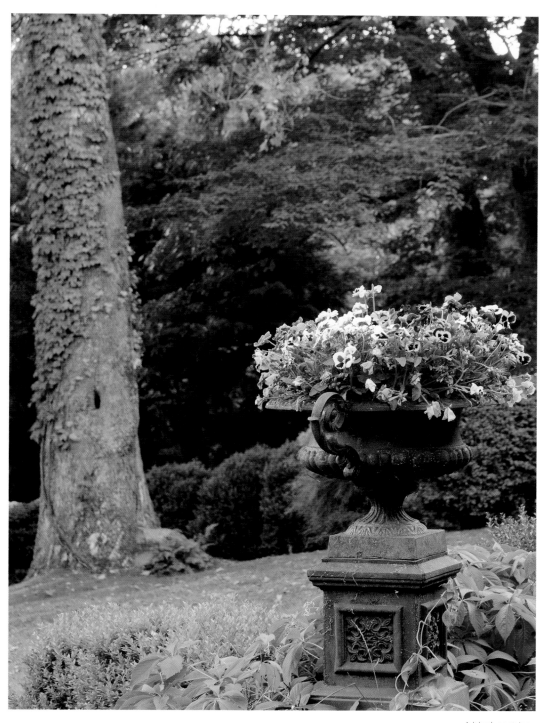

A black cast-iron
urn planted
with a variety of
pansies.

◄ Pansies.

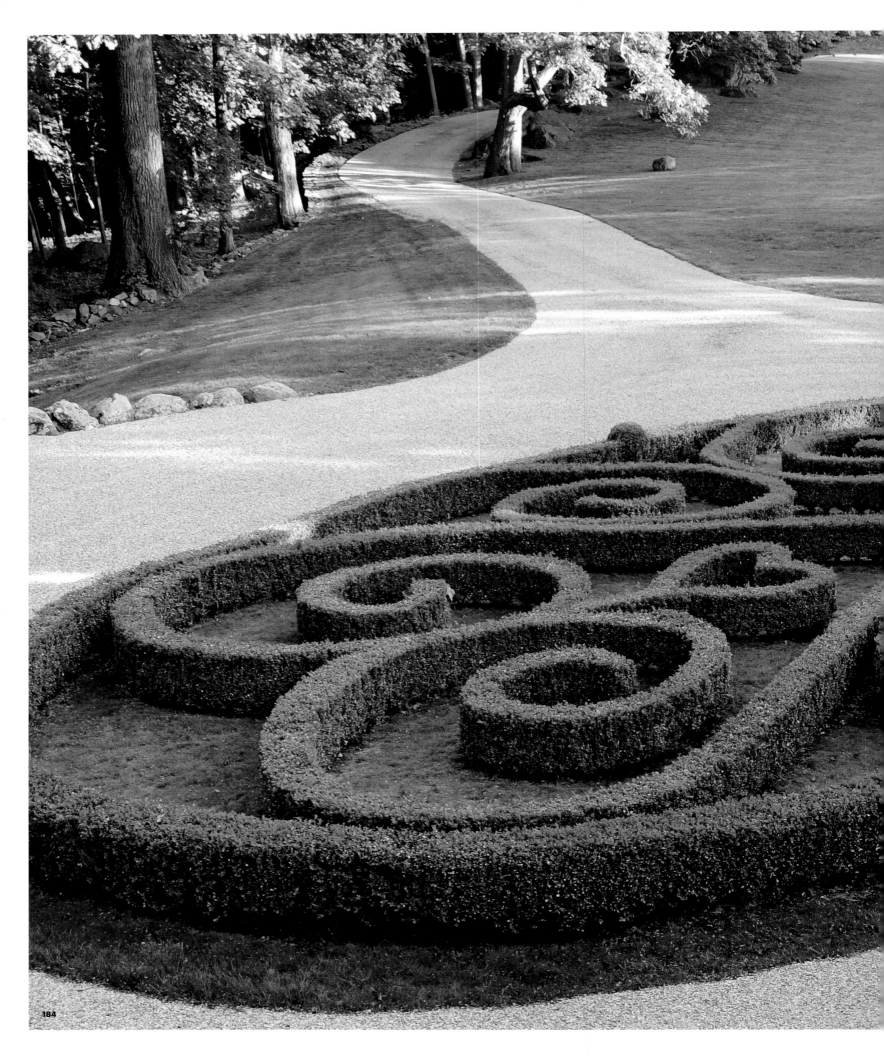

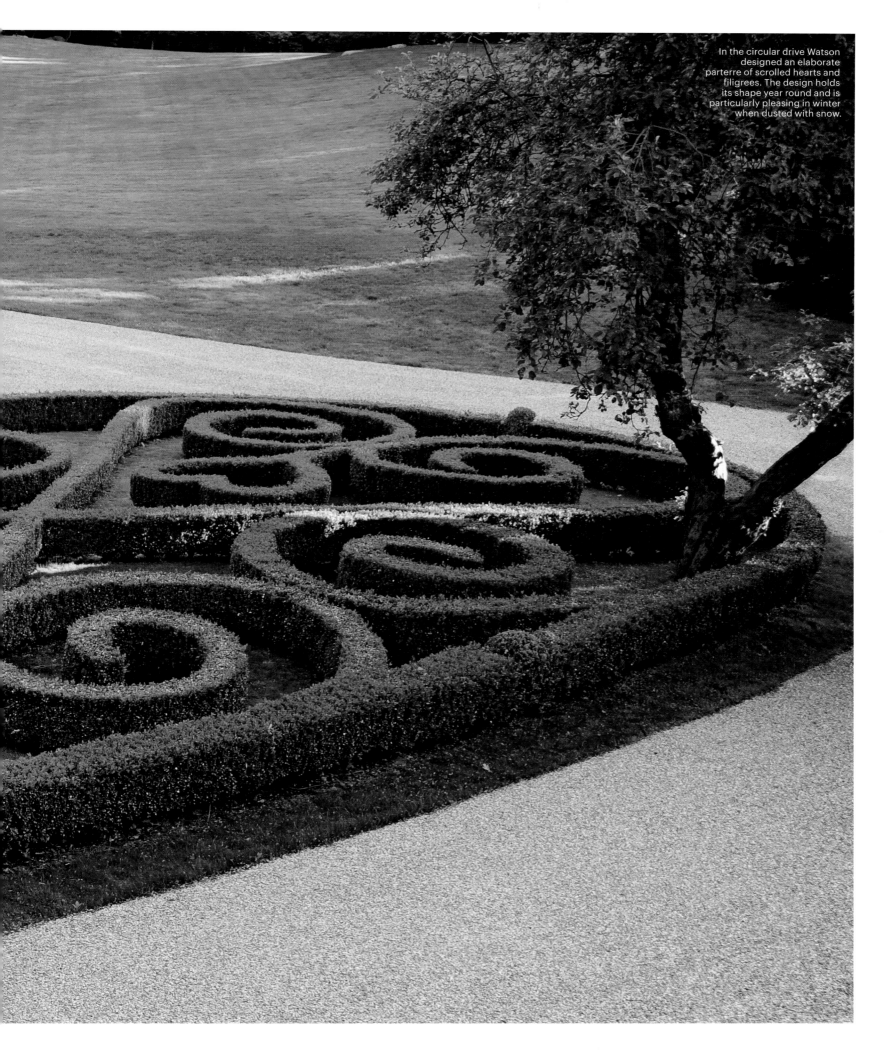

In the circular drive Watson designed an elaborate parterre of scrolled hearts and filigrees. The design holds its shape year round and is particularly pleasing in winter when dusted with snow.

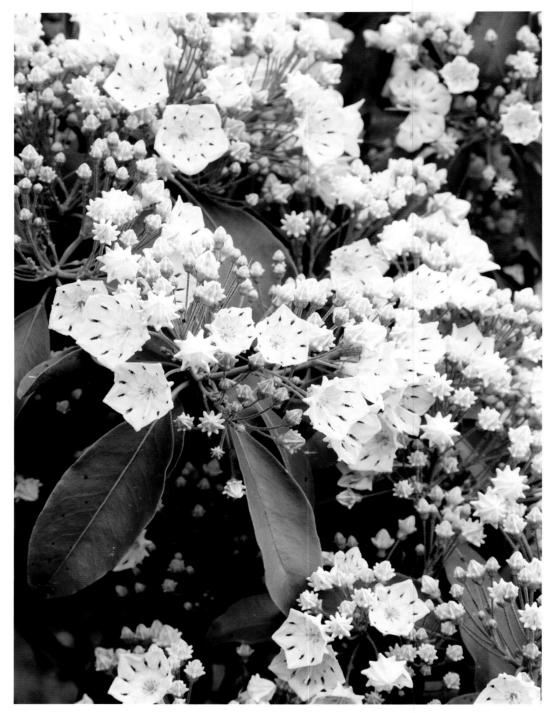

Mountain laurel.

A lush border ▶
follows the
contour of the
land.

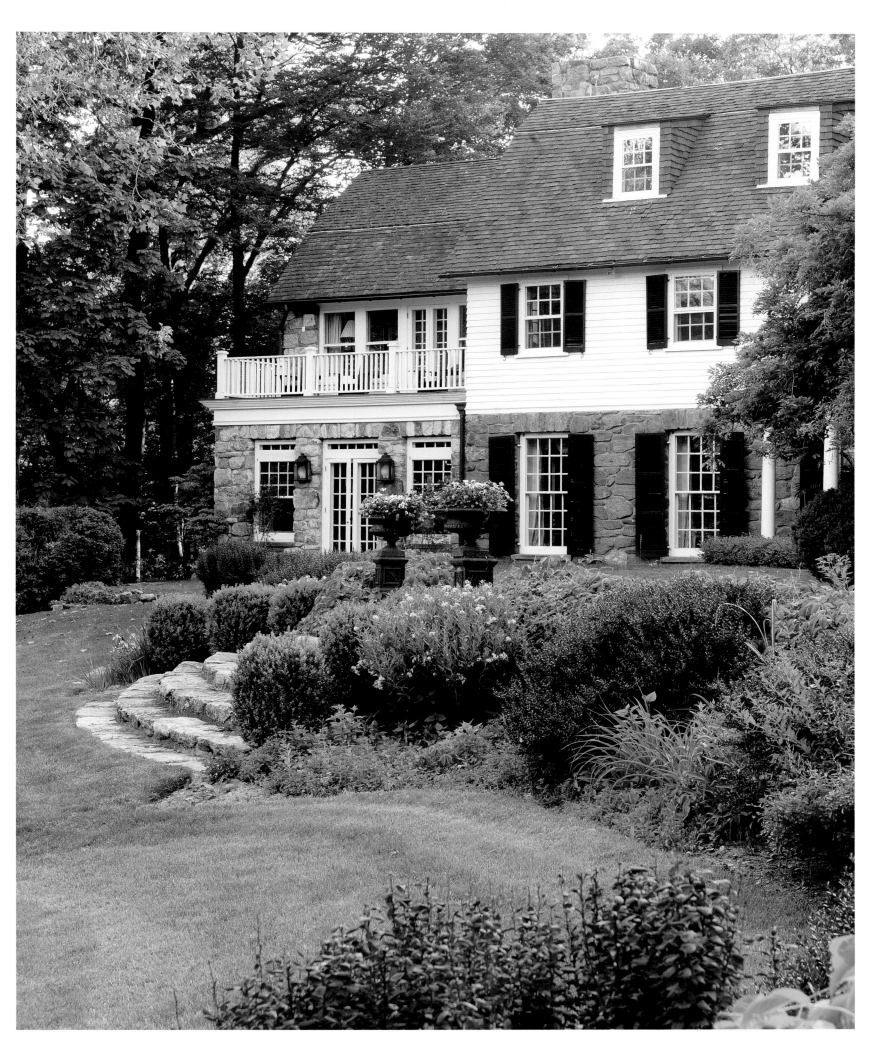

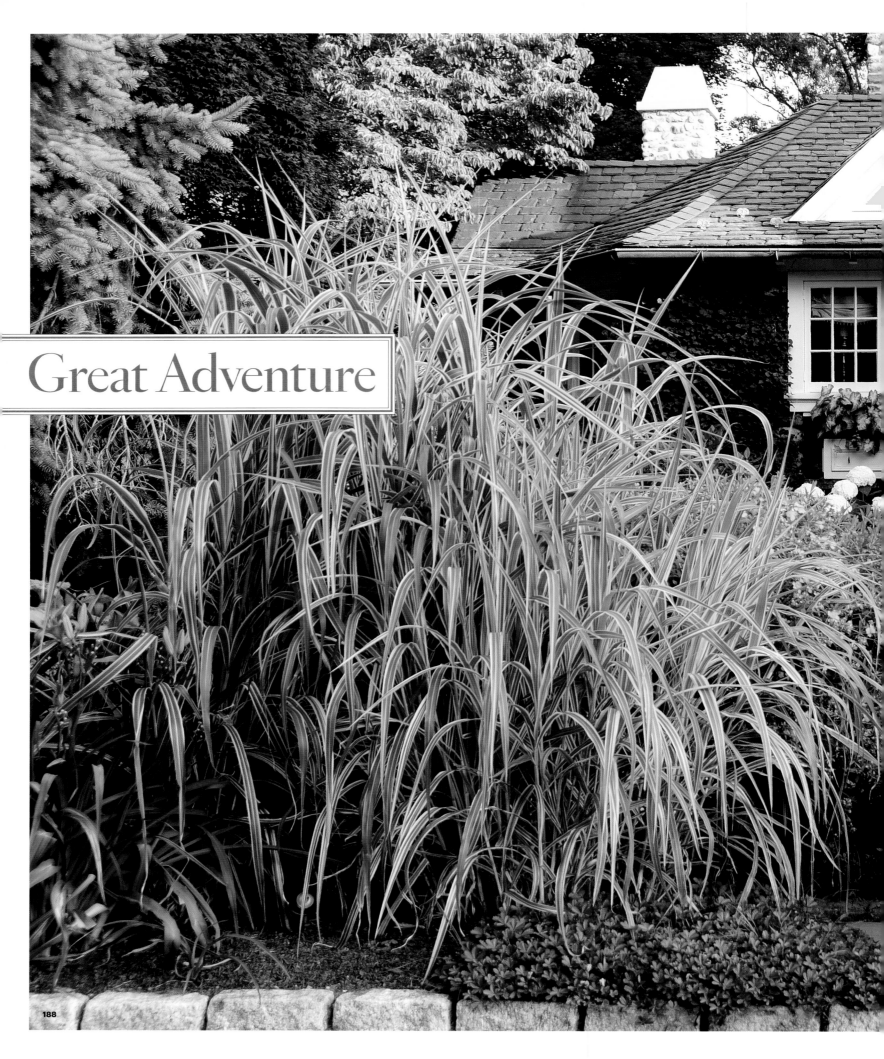

Great Adventure

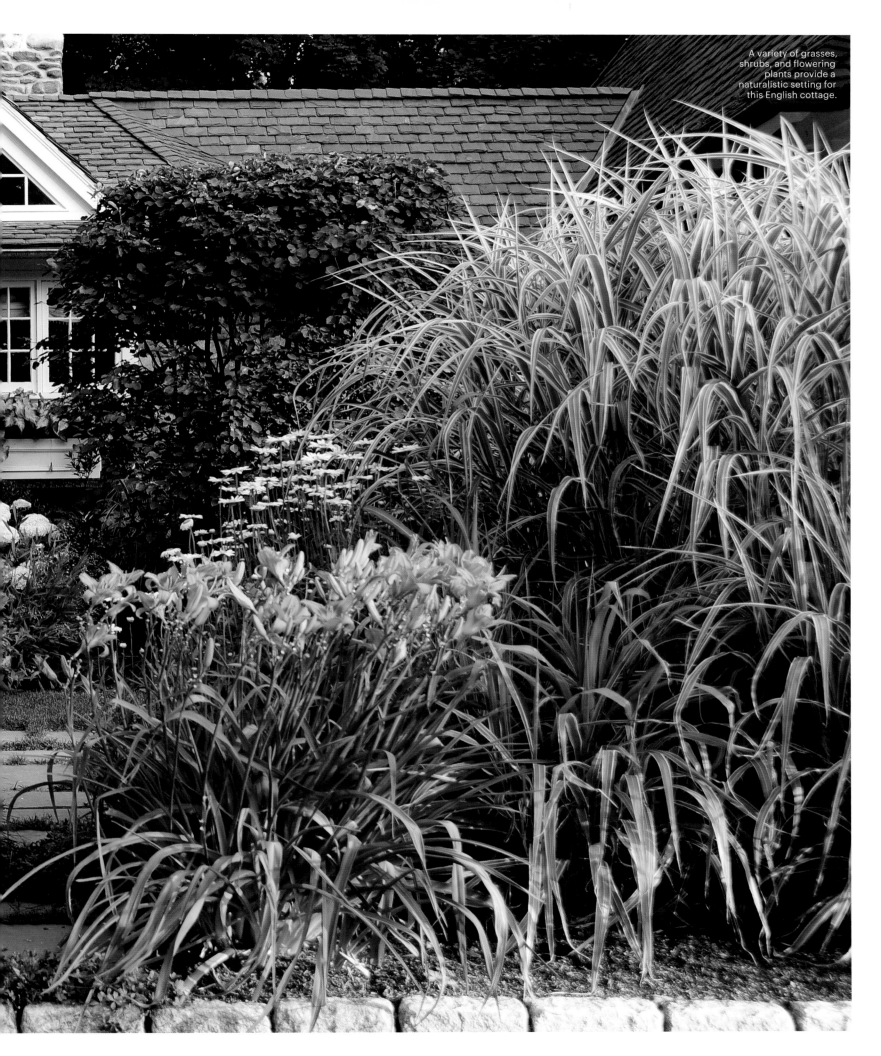

A variety of grasses, shrubs, and flowering plants provide a naturalistic setting for this English cottage.

WHEN Liz Ann Sonders decided to redo the grounds and pool at her home on a cul-de-sac in Darien, she knew two things: she wanted to get as much use out of it as possible for as much of the year as possible—and she wanted it to be fun with a capital F. It was a fitting goal for the grounds around an English cottage that began life in the early 20th century as a recreational hunting lodge or a summer retreat, depending on which record you consult, and that was once owned by physician and banker Col. Howard Nielsen, who may or may not have used it as a place to stash his mistress.

But the site posed a challenge: much of its two acres lay on a gentle slope that rolled from the soft mound where the house sat to a wide flat ringed by thick woods where the previous owners had built a pool.

With the help of landscape designer Carol Guthrie, Sonders was able to transform the property into a multilevel space rich with visual pleasures. Guthrie hand-selected boulders for a rock garden that is anchored with junipers and includes powder puffs of variegated miscanthus that grow luminous in the sunlight, clusters of heavy-blooming Shasta daisies, fiery sprays of daylilies, flower carpet roses, spiky blue Veronica, and soft Russian sage. Her strategy was to choose plants that would "knit" together in a tapestry, and together with the rocks, produce a "spilling" effect appropriate for the water's edge.

Into this rustic setting Sonders built her very own water park, replete with essential amenities such as an extra-wide stone deck that accommodates several chaises, a grill and dining area, a pergola with a retractable awning, a hot tub whose wall provides a platform for backflips into the pool, and a finishing touch: a 52-foot-long serpentine slide.

To meet her client's request for a naturalistic setting, Guthrie concealed the slide among mass plantings of Pfizer junipers punctuated by Cephalo taxus trees, which lend the composition verticality, and used vegetation to create transitional spaces including a walk lined with Annabelle hydrangeas and a staircase whose treads are granite slabs that glint in the light and remain cool underfoot.

Up above, where the house, with its flat-pitched slate roof and fieldstone walls, hunkers down into the land, lush swaths of pachysandra, red leaf Japanese maples, white-flowering shadbush trees, trumpet honeysuckle, and rhododrendrons give it the appearance of a storybook cottage hidden in the woods.

The park is open from April to October. Tickets are going fast. ∎

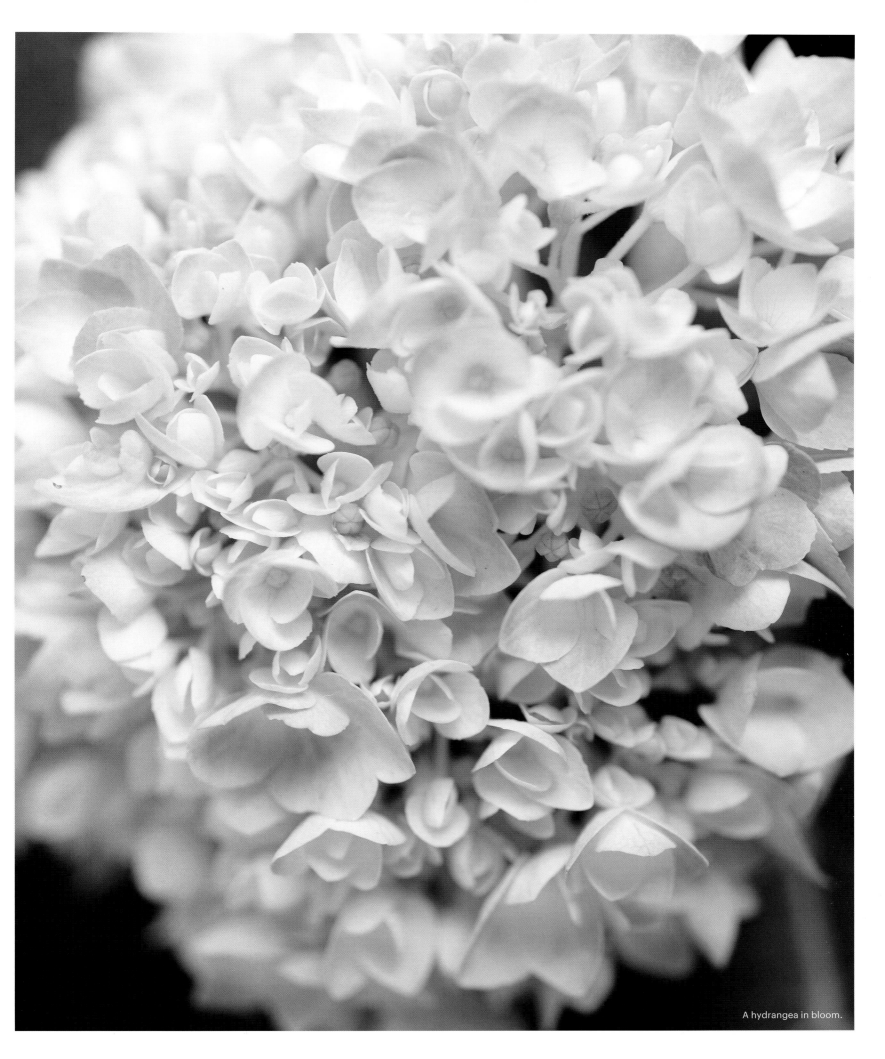

A hydrangea in bloom.

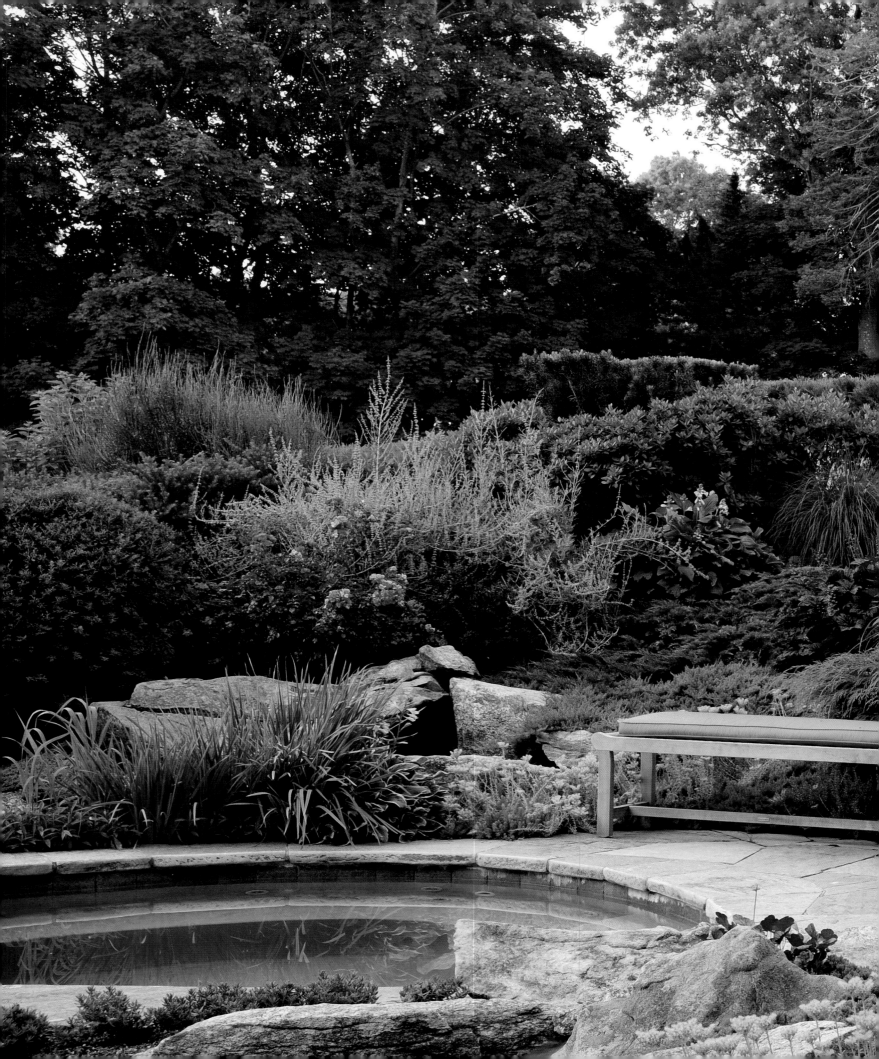

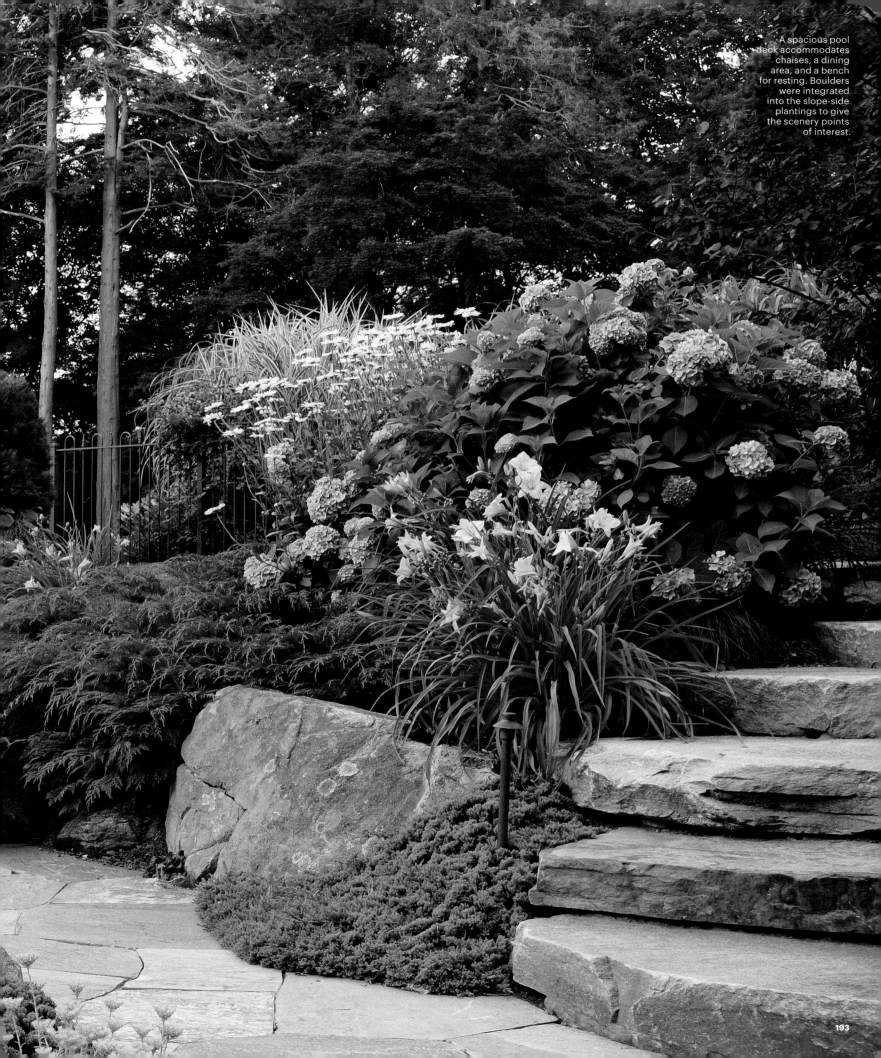

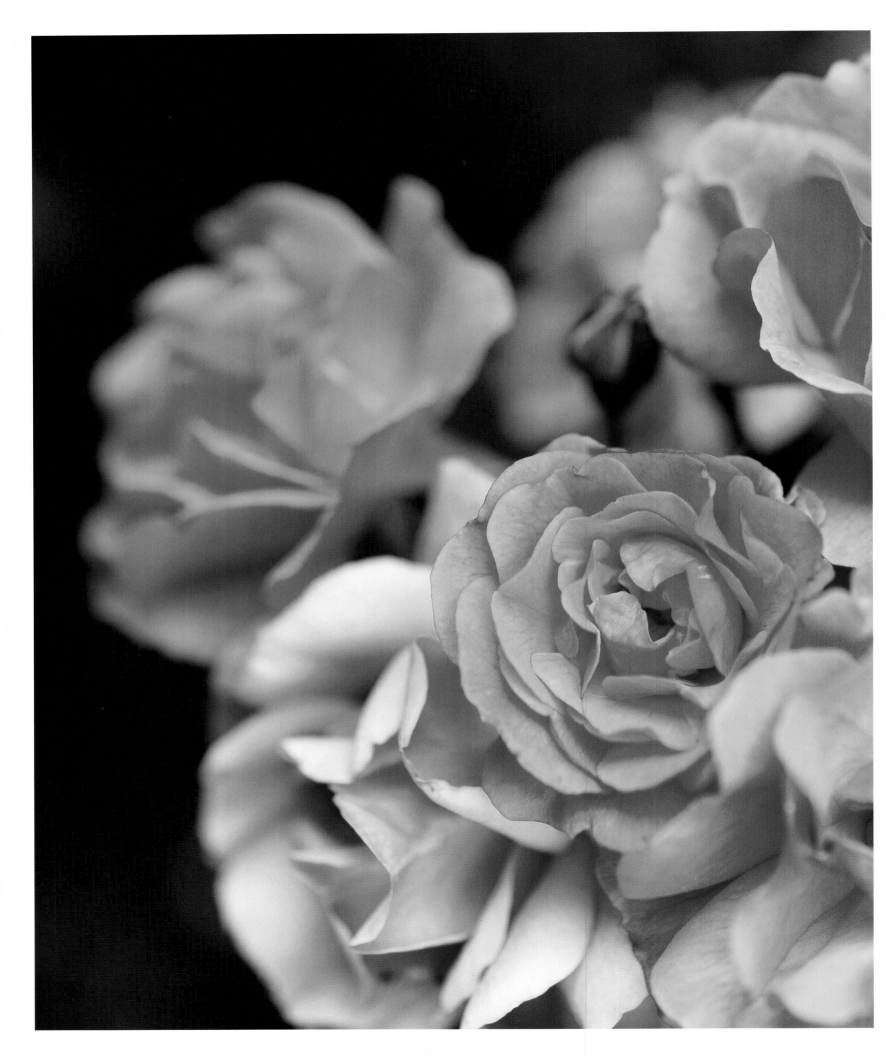

Flower carpet
roses and
Russian sage
add color to the
landscape.

◄ Flower carpet roses.

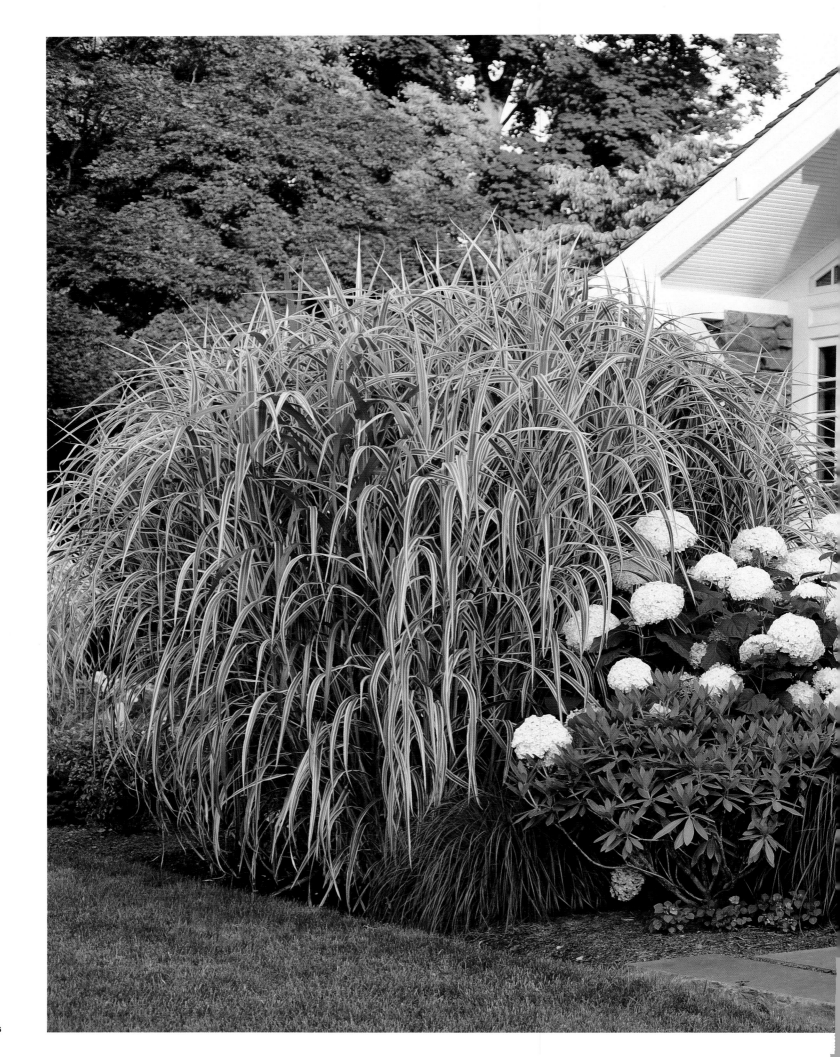

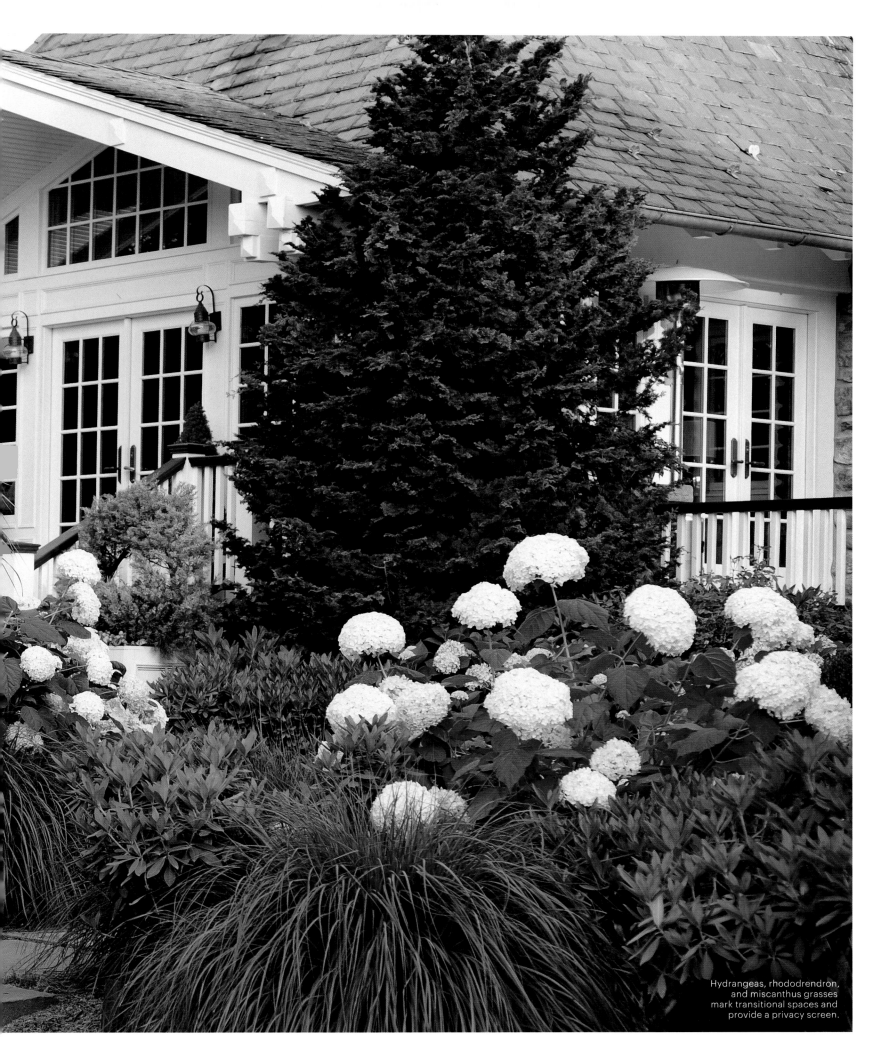

Hydrangeas, rhododendron, and miscanthus grasses mark transitional spaces and provide a privacy screen.

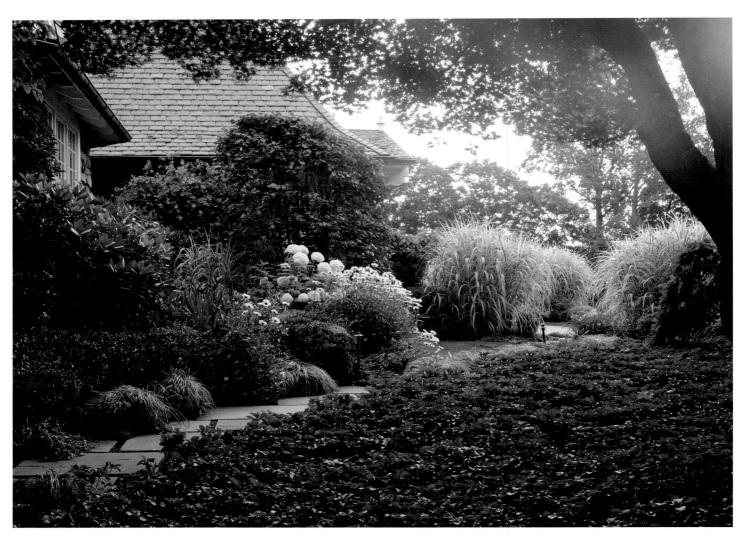

Lush and varied
plantings lend
the house a
storybook look.

A spray of
Shasta daisies.

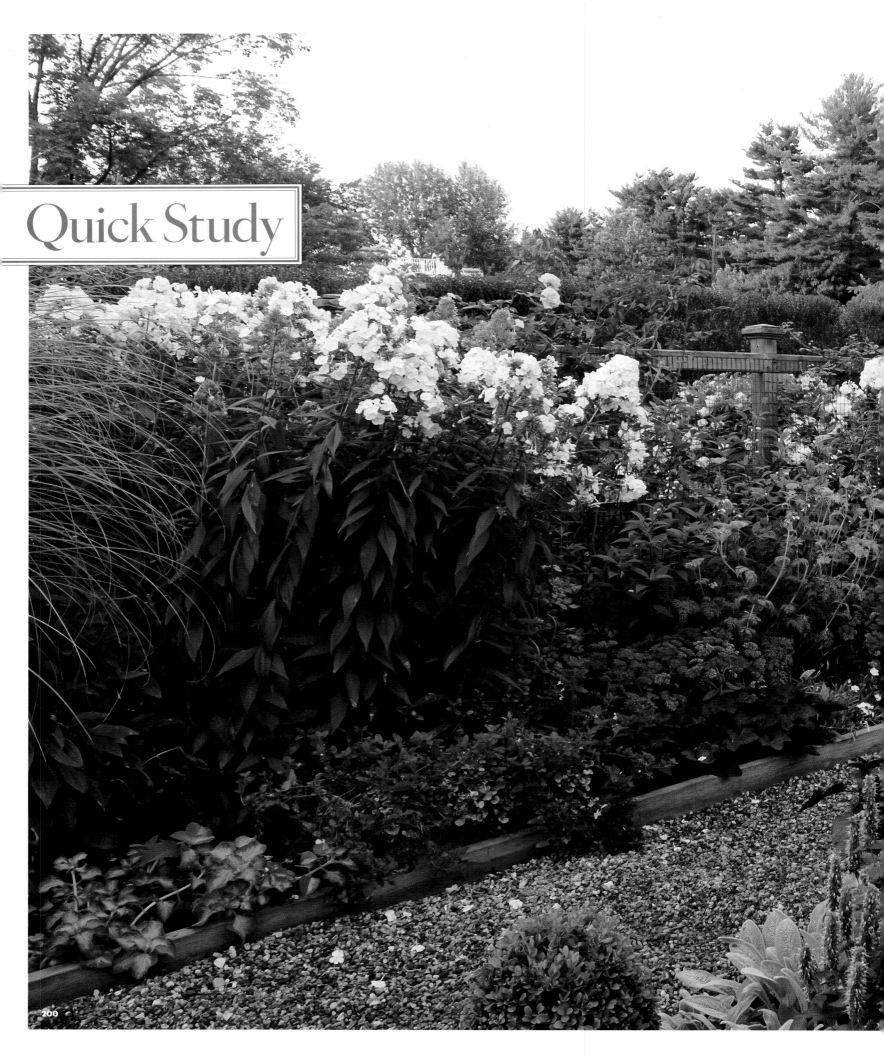

Quick Study

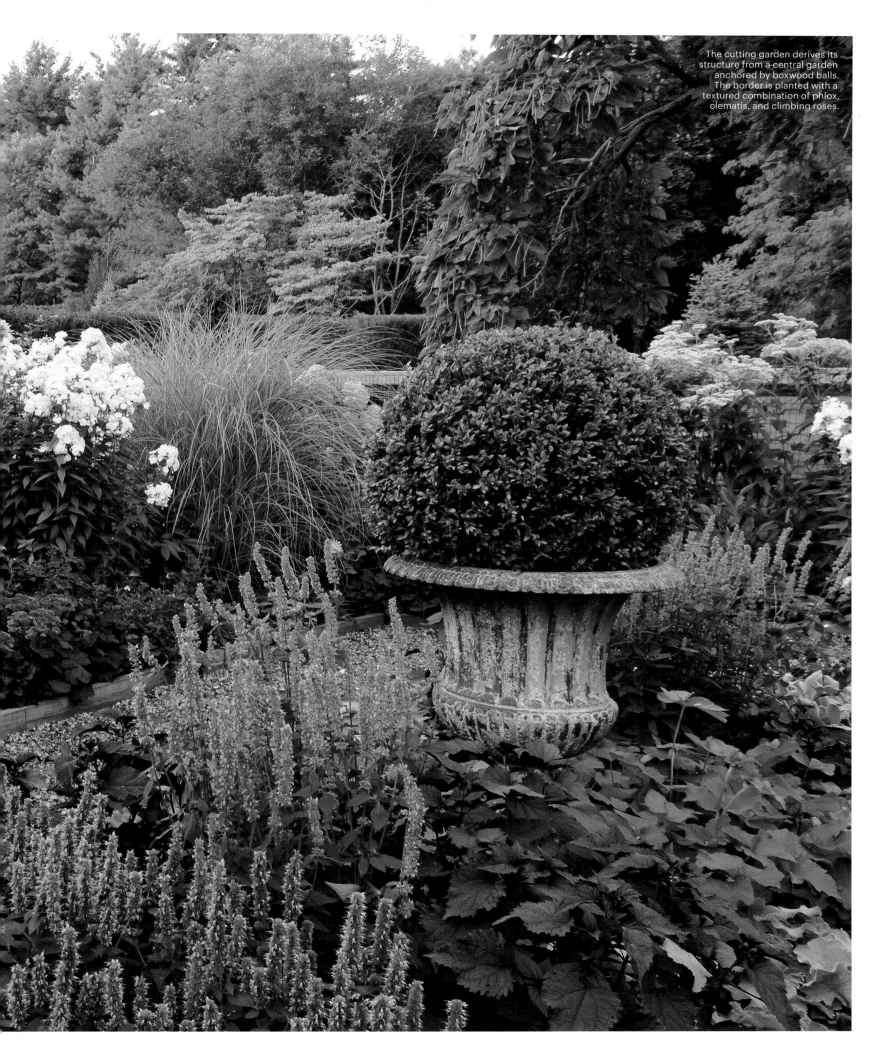

The cutting garden derives its structure from a central garden anchored by boxwood balls. The border is planted with a textured combination of phlox, clematis, and climbing roses.

WHEN SHE AND HER husband were plotting their move back to the East Coast from the wide open spaces of Wyoming 11 years ago, Jennifer Downing says it was the expansive lawn studded with thick-trunked old maples that sold her on this sun-drenched spot in Greenfield Hill.

Once a gentleman's dairy farm with a house built in 1860, the property featured not only a nondescript old garage that they replaced with a barn suitable for guests but also plenty of room for a cutting garden packed with herbs, grasses, and flower blossoms—and a custom potting shed complete with a slatted tabletop, a soil drawer, stacks of clay pots, a water spigot, and a collection of antique watering cans.

Having grown up in the South and the Midwest picking and weeding the gardens of her parents and grandparents, Downing says she had to get used to a "new zone" when she arrived in Connecticut. Joining the Fairfield Garden Club and helping plan trips to gardens in New England, D.C., and Pennsylvania's Brandywine Valley, as well as the public and private gardens in and around Amsterdam, seems to have done the trick. Evident in her design are two guiding principles that produce a soothing effect: adherence to a limited color palette—pinks, whites, and purples and maybe some blue—and clean lines, visible in a neatly edged lawn, a level stone wall, and a uniform privet hedge.

Among the examples of her putting her new knowledge into practice is an intimate rectangular cutting garden, shaded by the drooping limbs of a catalpa tree, that derives its structure from an inner garden anchored by dwarf English boxwood balls like finials and purple pom-poms of allium. She softened the clipped and geometric forms with groundcover-like plantings of lamb's ear and lady's mantle, and ringed the entire garden in winter gem boxwood that terminates in spires of Graham Blandy.

Then, just inside the garden's fence, Downing planted a border of herbs—parsley, basil, lavender, mint, oregano, chives, sage, and thyme, among others—that she says saves her a trip to the grocery store, and a thicket of climbing and flowering plants she enjoys cutting and bringing inside: white and pink climbing roses, Alba luxurians and Betty Corning clematis, sedum, geraniums, phlox, liriope, Annabelle hydrangeas, and peonies.

Downing's newest project is a shade garden where, in an area darkened by taxus trees, she has mixed rhododendrons and hydrangeas with ferns, hostas, and hellebores, which she says have proved very appetizing to four-legged locals. Nice work for a newcomer. ∎

Budding sedum clusters.

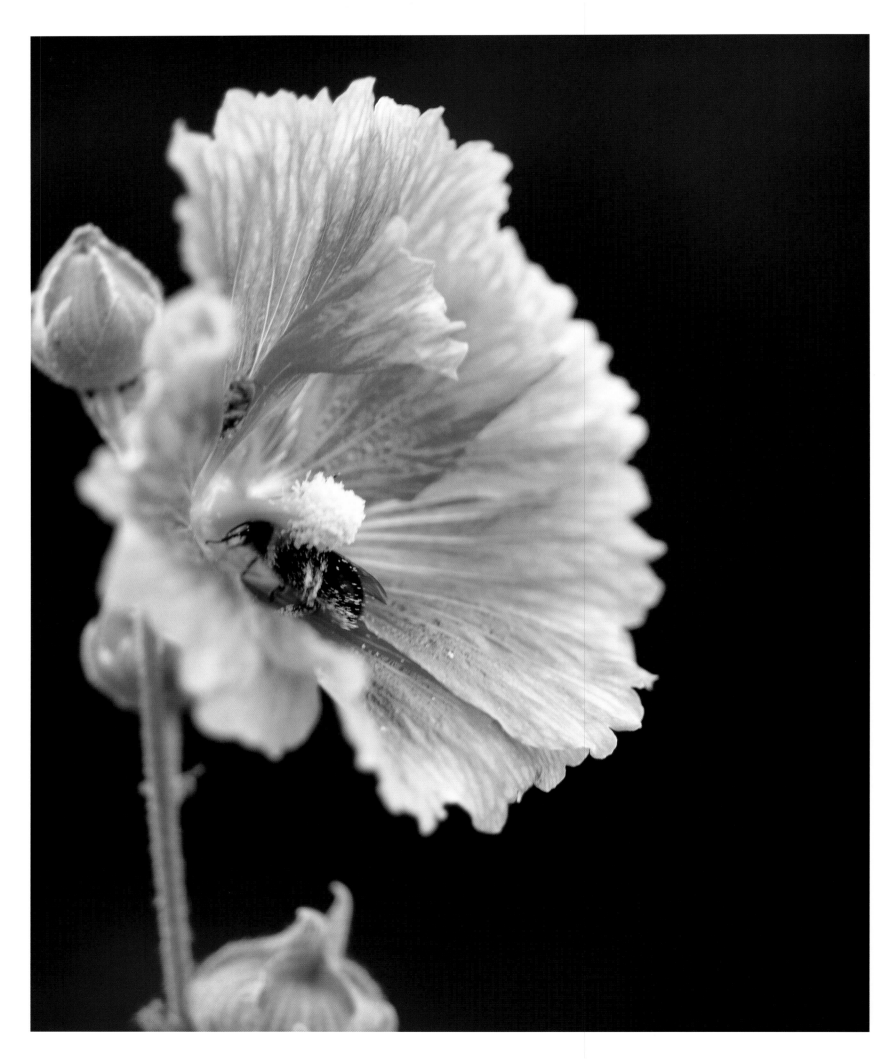

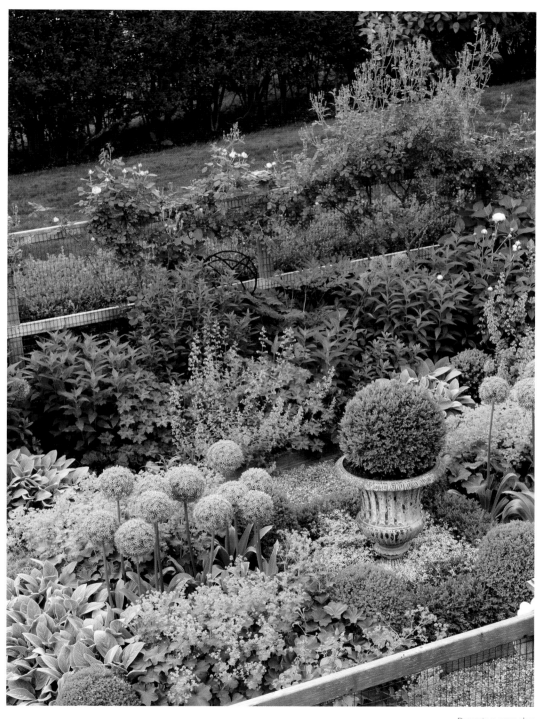

Downing says she
enjoys looking at
her "secret garden"
from above.

◄ A honey bee
goes to work
on a Hollyhock
blossom.

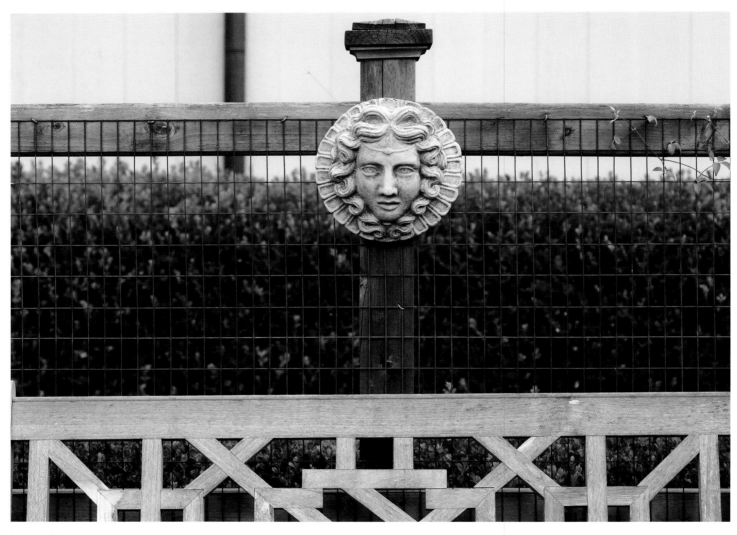

A sun goddess
presides over a
decorative teak bench.

A potting shed just steps
from the garden features
a slatted tabletop,
antique watering cans,
and a drawer for soil.

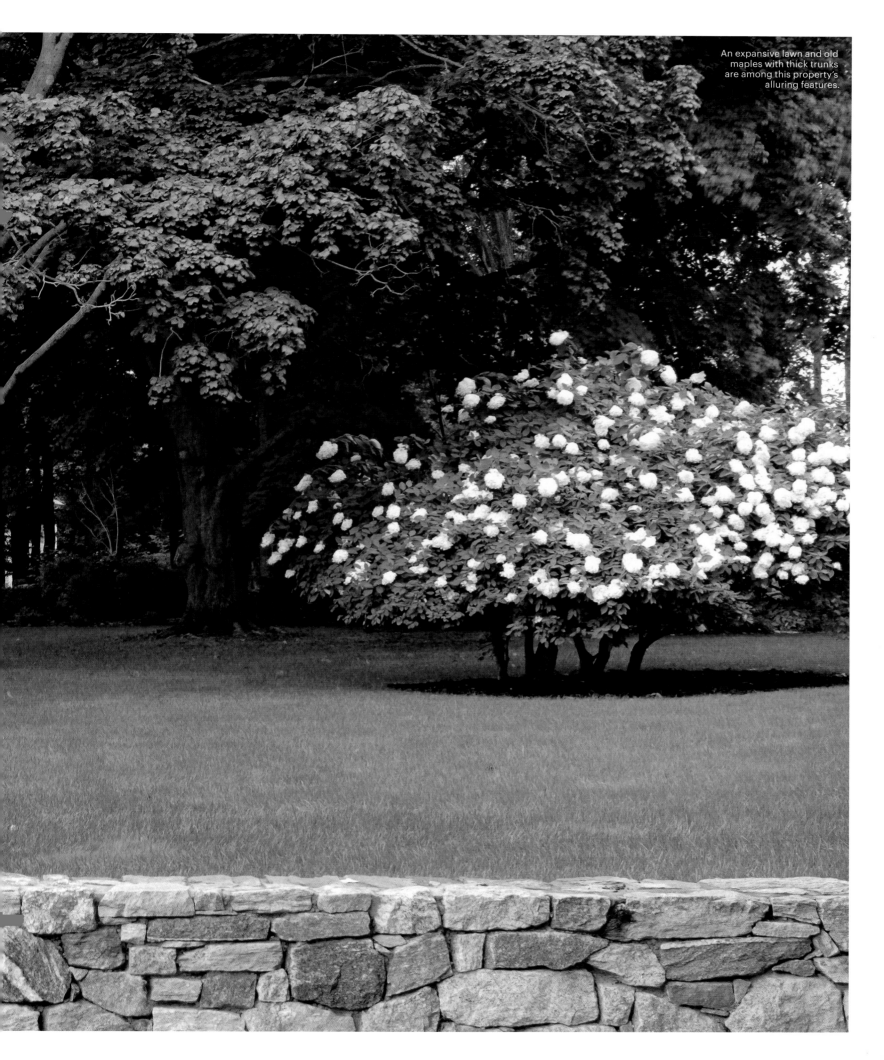

An expansive lawn and old maples with thick trunks are among this property's alluring features.

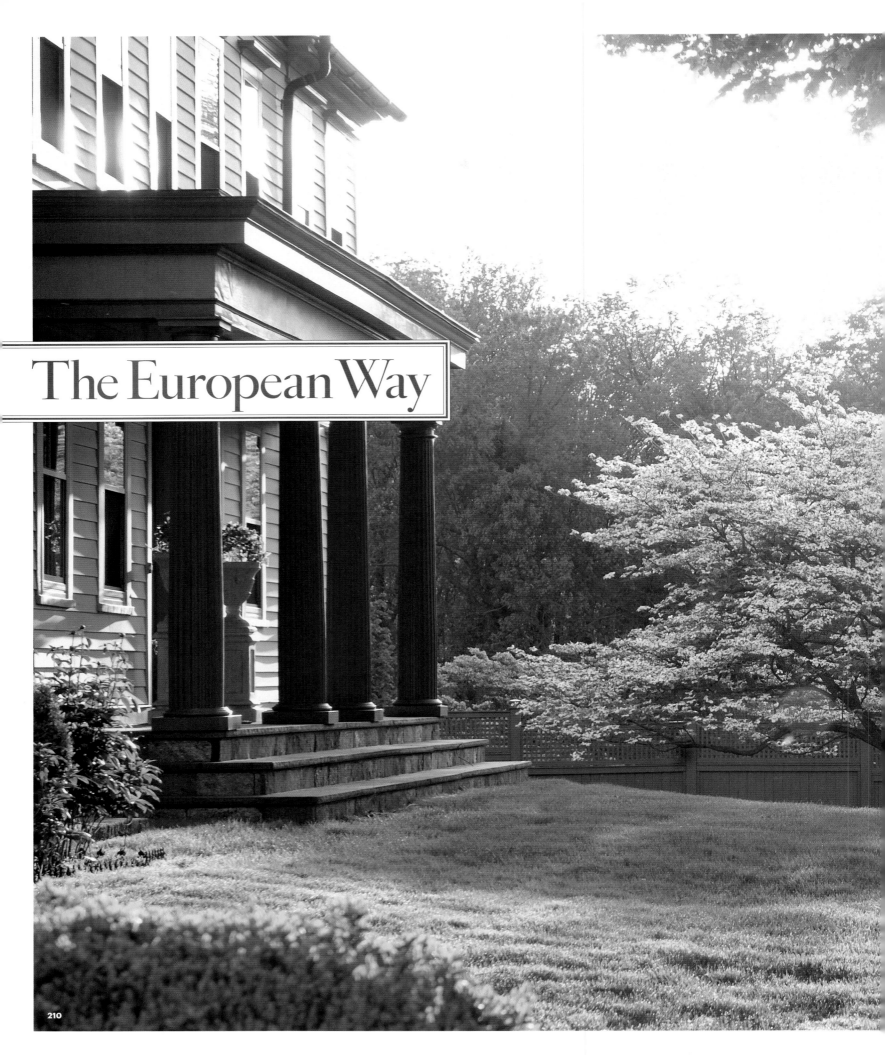

The European Way

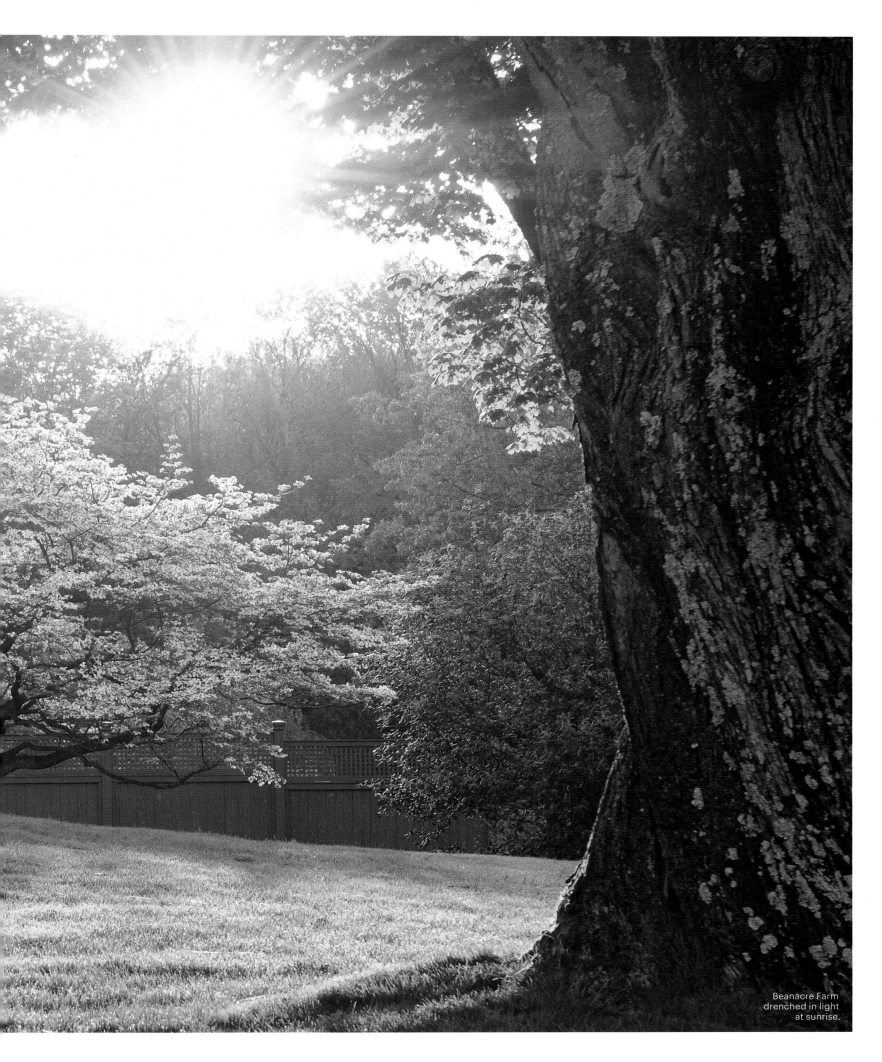

Beanacre Farm
drenched in light
at sunrise.

TO SAY THAT Gerard Pampalone is effusive about his gardens is an understatement. From atop one of Greenfield Hill's highest perches, where he and his wife, Arlene, inhabit a three-and-a-half-acre parcel known as Bean-acre Farm, the self-taught horticulturalist presides over a compound of hedges and shrubs, climbers and creepers, and well-placed hardware—armillaries, benches, tuteurs, and spheres, to name a few—that shows his hand as an ardent devotee of the greatest gardens Europe has to offer.

The names Giverny, Villa Gamberaia, and Jacques Wirtz pepper this gentleman farmer's speech the way ornamental roses decorate his gardens, and a brisk walk about his property reveals that what he has learned more than anything else on his seven garden tours in France, Germany, Holland, Belgium, Italy, Scotland, and Ireland, is that structure is essential.

Sixteen years ago, when he and Arlene bought the property and the house that dates to 1862, the gardens were in a shambles. Today, taken together, they convey the sense that under his clippers, nature has, at least temporarily, been tamed.

In the "West Garden" he divided the growth into eight intersecting borders—four red, four blue—of flowering bulbs and perennials he planted from seeds obtained across the pond. The garden's underlying structure derives from 26 boxwood spheres, four wooden obelisks capped with silver finials, a pair of arbors, four columnar tuteurs, and a pair of 12-foot corkscrew junipers.

The "Rose Garden," a secret enclave snugged up next to a red barn and enveloped in hemlock and privet that dates to the 1930s, is a place intended for tranquility and meditation, though Pampalone admits he's too busy staking, pruning, watering, and feeding to have time for either.

Marking the entry is an arbor cross-draped with two climbers, Constance Spry and white dawn, which also dates to the 1930s. They are under-planted with Queen Elizabeth roses, blue mirror delphinium, white Galahad delphinium, and pale blue Campanula portenschlagiana. In the center of the garden is a rondel consisting of a stone orb fountain that sits in a whispery ground cover of lamb's ear and lady's mantle. It is hedged in a ring of low-growing boxwood. Each of the four quadrants that radiate out from the rondel features yellow, pink, red, or white roses—as well as tuteurs that support climbing roses, Elsa Spath clematis, and Alice du Pont mandevilla. At the far end is a "living bench" with a stone seat and a backrest and arms of juniper and English box, respectively.

Pampalone's favorite feature of all, however, may be the conservatory rooftop he and Arlene built on top of their bedroom and through which his garden is the first thing he sees when he wakes up. What a way to start the day. ∎

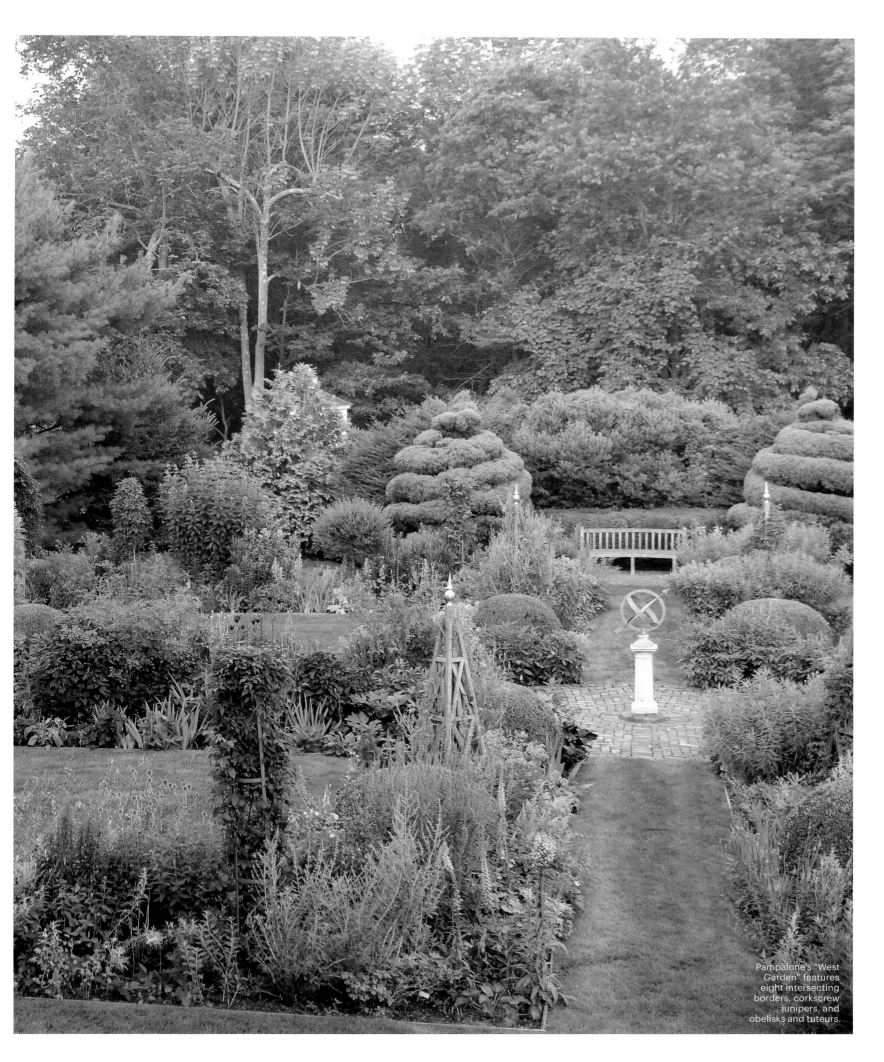

Pampalone's "West Garden" features eight intersecting borders, corkscrew junipers, and obelisks and tuteurs.

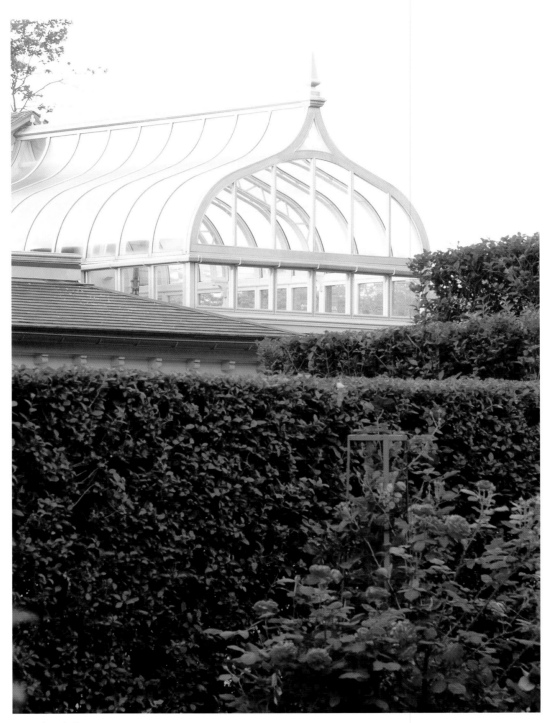

Pampalone built
a conservatory
rooftop on top of
his bedroom.

A Tess of the ▶
D'Urbervilles
David Austin rose.

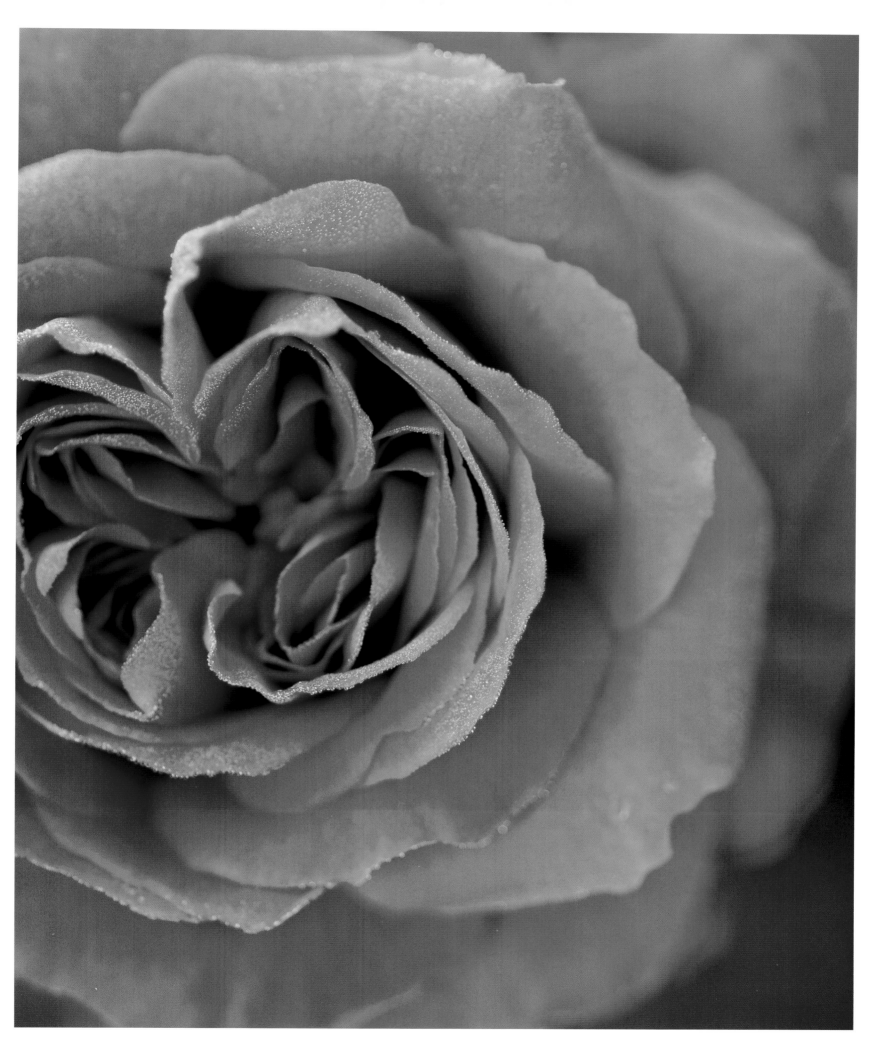

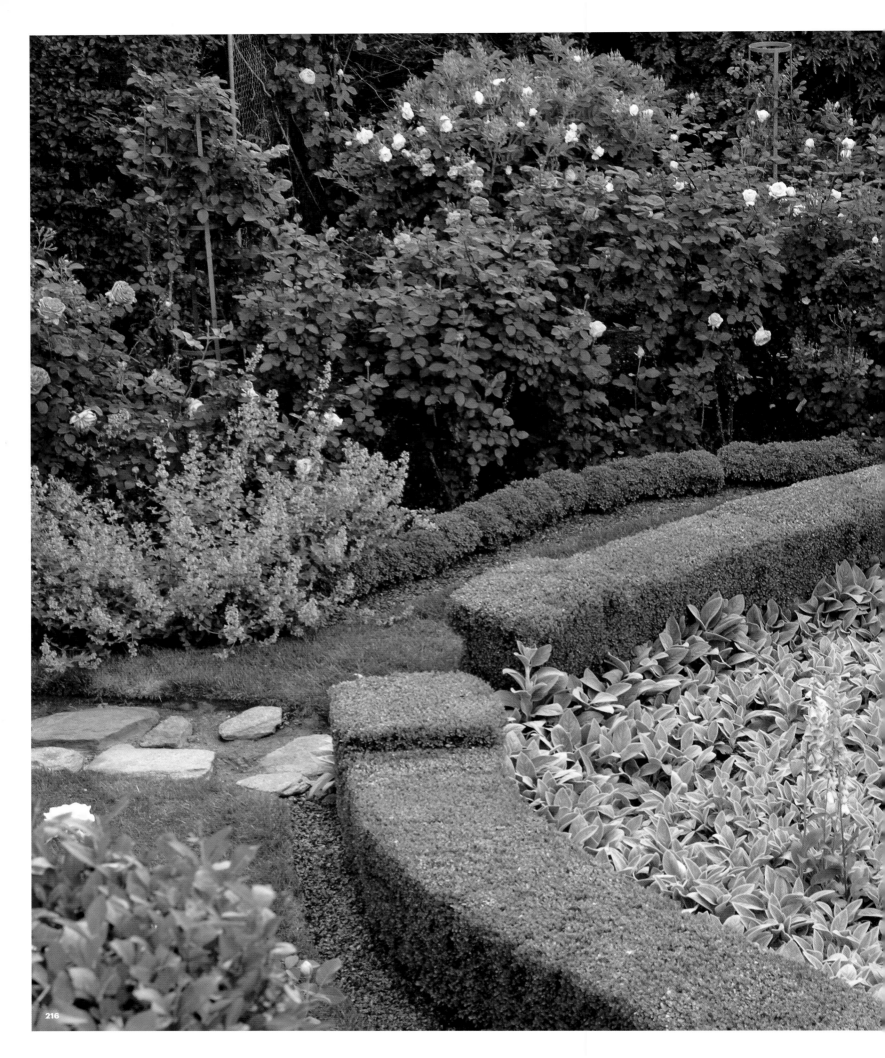

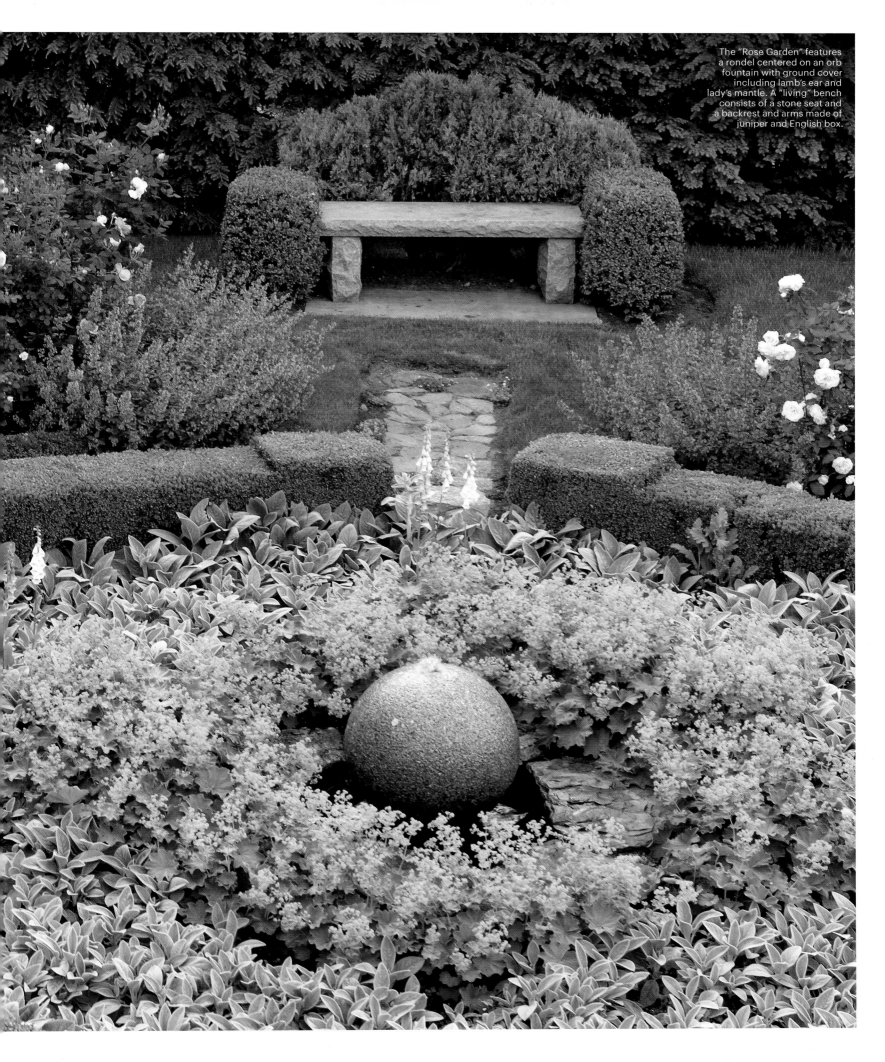

The "Rose Garden" features a rondel centered on an orb fountain with ground cover including lamb's ear and lady's mantle. A "living" bench consists of a stone seat and a backrest and arms made of juniper and English box.

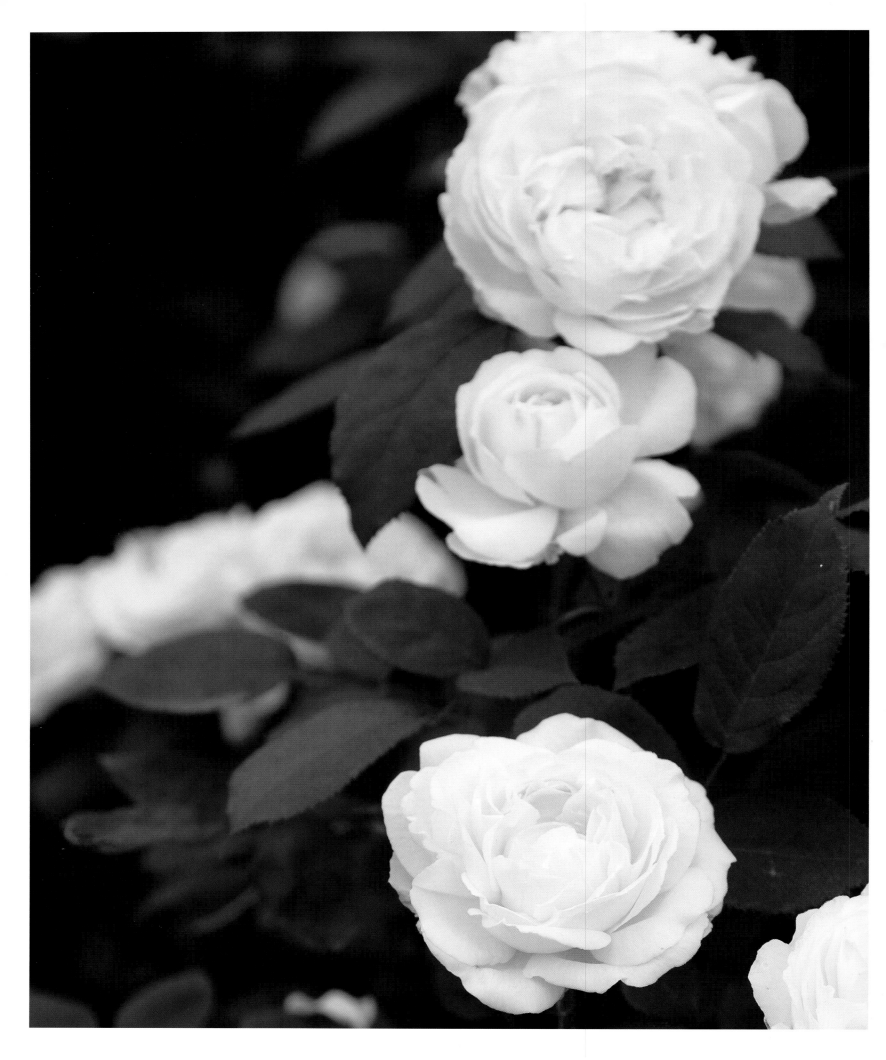

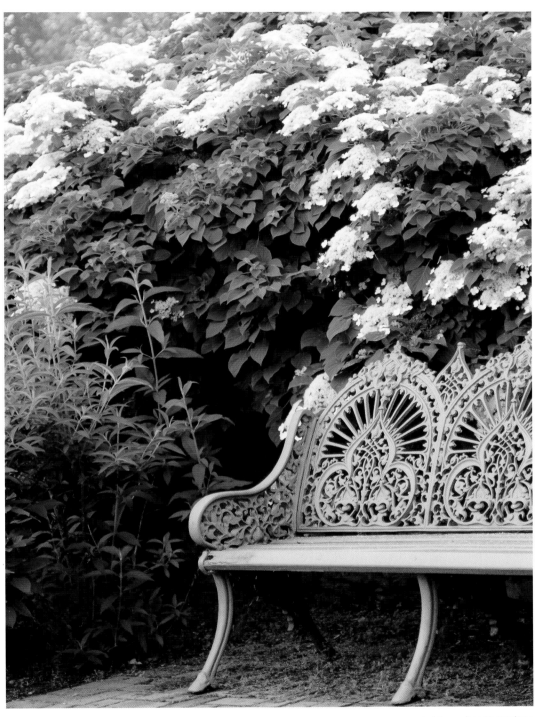

In his gardens Pampalone
includes places to rest and
take in the beauty.

◄ A Winchester
Cathedral
David Austin rose.

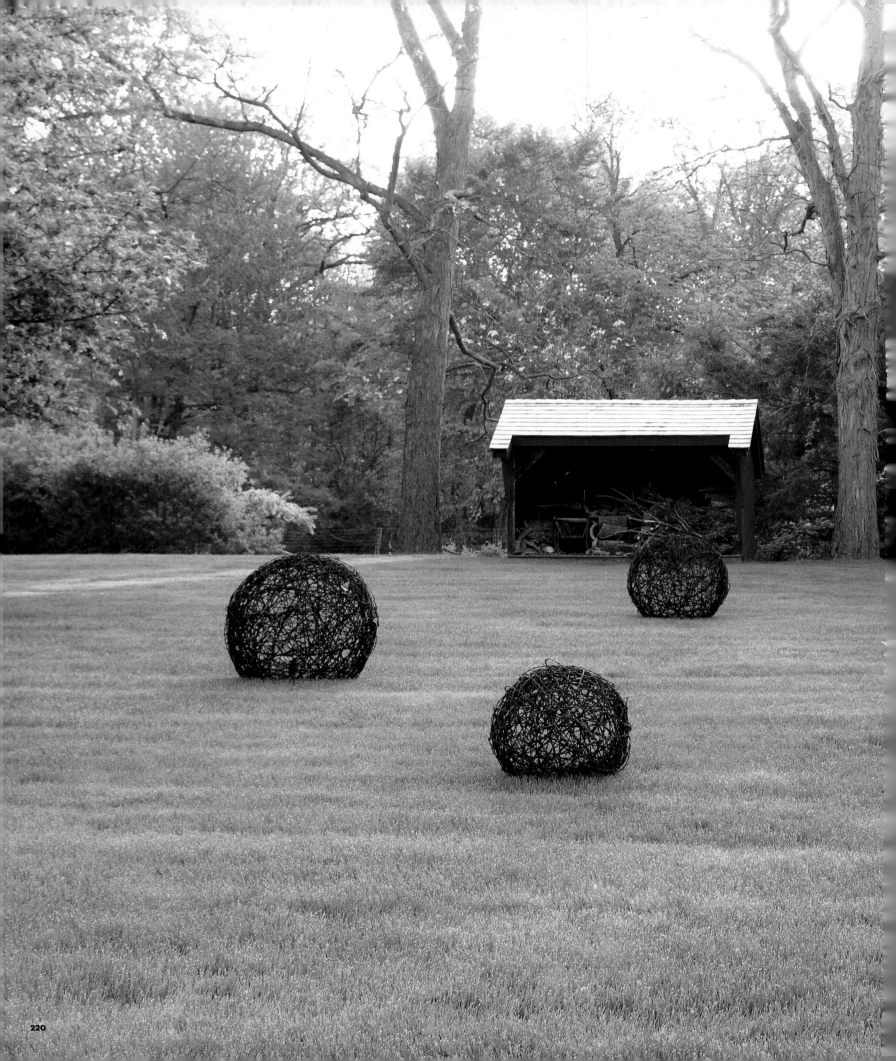

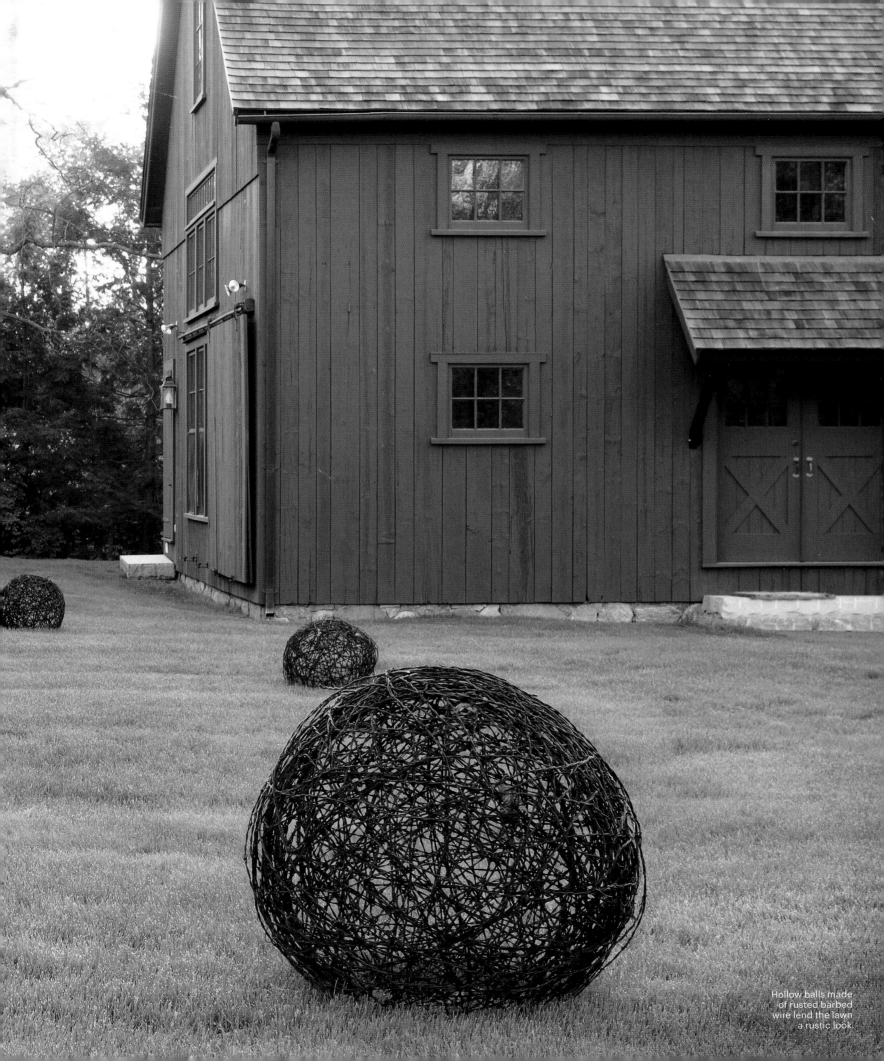

Hollow balls made
of rusted barbed
wire lend the lawn
a rustic look.

Acknowledgements

LIKE EVERY CREATIVE ENDEAVOR, this one could not have been achieved without the help of many people. My thanks to: Suzanne Gannon for your melodic prose—alive and energized and a perfect fit for the places you're describing; to my talented designer Andy Omel for your tireless efforts in getting this just right and doing it with style, grace, and unending eagerness; and to my dear friend Charlie Melcher for your guidance and honesty, not to mention all the support from your wonderful team at Melcher Media.

I have to acknowledge the incomparable Amy Vischio for starting me on this path, and for the consistent assignments to photograph many of these remarkable places. You are a visual powerhouse with an unerring eye, and your art direction of my work throughout the years in *athome*, *Westport*, *Greenwich*, *New Canaan*, and *Stamford* magazines has been a gift. Further, to the rest of the creative team at Moffly Media—Holly, Kate, Venera, Garvin, everyone—my gratitude for all of your time and attention, as well as for your company. It's a continuing pleasure to work with you. To Ronny Carroll and Yvonne Claveloux, thank you—always—for showing up and for doing it with a calming spirit and meticulous taste. And to Bolivar Rosero, many thanks for never complaining, always going with the flow, and for the occasional reminder that 'no one lights better than God.'

Finally, nothing I do happens without the support and love of my friends and family. The most special thanks to Jessica Waldman for being there for me from the beginning (literally) and for your limitless confidence and encouragement in this project and all that I set out to accomplish, and to Ann Weiner for sharing those creative genes and for your boundless time, focus, thoughtful critiques, and counsel—artistic and otherwise. To my husband, Howard Bass, thank you for being the perfect partner and always showing even more than the appropriate level of enthusiasm. You are my champion. You are my dream. And last, but surely not least, to Ilysa, Benjamin, Michael, and Emily—having you in my life is the ultimate perspective. You are my motivation and joy and fill every day with laughter and light. I adore and admire you and know that you will be able to experience and appreciate all of the wonders of our world. ∎